# Wine People

First Published in the USA in 2001
by The Vendome Press
1370 Avenue of the Americas
New York City, NY 10019

Text © 2001 Stephen Brook

Library of Congress Cataloging-in-Publication Data

Wine people/ edited by Stephen Brook.
p. cm.
ISBN 0-86565-248-1
1. Vintners—Biography. I. Brook, Stephen

TP547.A1 W56 2001
641.2'2'0922—dc21
[B]2001026208

Printed in Italy

# Wine People

Stephen Brook

The Vendome Press

# Table of Contents

# INTRODUCTION

This book is a collection of portraits of individuals involved in all aspects of wine production and consumption. It is by no means restricted to proprietors and producers, but includes wine merchants and traders, wine writers, a collector, an auctioneer, and a sommelier. People are attracted to wine for all kinds of reasons. Some inherit properties and perpetuate the skills and traditions handed down to them by their forebears. Other start from scratch, by abandoning lucrative careers in order to create wine estates, or by transforming existing properties in the wish to improve quality to the greatest possible degree.

Wine is more than a business; it is a culture that binds together the aristocrat and the peasant, the producer wedded to his soil and the sharp-eyed city merchant, the cautious grower and the extravagant consumer. It is a major source of conviviality. A raised glass can bring down, if only temporarily, national boundaries. Wine unites continuity and flux. It remains essentially the same product enjoyed on the slopes of the Caucasus mountains and around the Mediterranean shores four thousand years ago and yet it is constantly evolving, steadily improving in overall quality and gradually shifting in style to meet the supposed tastes and expectations of consumers. That is what makes wine so fascinating a subject. A simple product of nature, the fruit of the vine, it is none the less moulded by humankind. No two vintages are ever identical, giving wine its infinite variety, and even the most skilled oenologist needs to adapt his techniques from year to year to extract the very best that the vintage has to offer.

This book aims for diversity: the grand and the modest, the rich and the struggling, the standard-bearers of tradition and the bold innovators, old men and young women. Every single subject has been interviewed and as far as possible ideas are presented in the words of each individual. Vine-growing, of course, is a steady, quiet, laborious application of the craft of farming and not everyone involved in viticulture or winemaking is necessarily articulate or even thoughtful. So,

inevitably, the subjects presented here tend to be those richly endowed with opinions and views and ambition.

The parade of personalities is deliberately international, but even so it has proved impossible in a book of limited size to include individuals from every single wine-producing region of significance. If Chile or South Africa or Argentina are absent from the book, this is not to be taken as an implied judgment on the quality or importance of those regions. The central focus of the book remains European, and rightly so, but voices are also heard from as far away as Oregon and New Zealand.

## The Great Estates

Although Alexandre de Lur-Saluces is no longer the proprietor of Château D'Yquem, he remains its general manager, continuing to ensure that the very high standards he set over the past thirty years will be maintained. As owner and manager, respectively, Corinne Mentzelopoulos and Paul Pontallier have run Château Margaux as a team for seventeen years. Jean-Michel Cazes runs his own estates in the Médoc, but has just retired from his job running the fine portfolio of international estates owned by the insurance company AXA. Lalou Bize-Leroy, a dynamic and formidable personality, owns and manages an estate that many would argue has become the finest in Burgundy – with prices to match.

In Tuscany Piero Antinori has expanded the family holdings into many other parts of Italy, seeking to match high quality with sensible pricing. From his fiefdom in Barbaresco, Angelo Gaja has now invaded the best wine regions of Tuscany, where he will undoubtedly try to set the pace as he has done in his native Piedmont. For decades Miguel Torres was synonymous with wine from Catalonia, combining a truly international approach to wine production with an intense desire to preserve indigenous grape varieties.

At a very young age, Claire Villars inherited a clutch of Médoc estates, after her parents died in a climbing accident, and is now in the vanguard of those who have turned around once neglected properties. Another untimely death, that of Théo Faller in Alsace, left his widow

and two daughters to run the enchanting Weinbach estate, as they still do over twenty years later. Equally beautiful is the Scharzhof estate in the Saar region of Germany, where the Müller family specialises in sweet wines of the most ravishing quality.

Last, but very far from least, is Robert Mondavi, still at the helm of the winery he founded in 1966 and expanded into a major player in Europe and South America as well as California.

## Wine Creators

Bruno Paillard became the only person in recent years to found a new champagne house. Jacques Seysses gave up a career in banking to make wine in Burgundy, where, rather to his surprise, he has now become a father figure to dozens of the best young producers in the region. At a much older age, Henri de St Victor abandoned a career in pharmaceuticals to become a grower and winemaker in Provence, where he is now regarded as one of the very finest producers in Bandol.

Jim Clendenen, of Santa Barbara County in southern California, takes his inspiration from Burgundy and Italy, bucking the current Californian trend for wines of overwhelming richness rather than elegance. Randall Grahm is equally iconoclastic, believing that California is far better suited to Mediterranean varieties than to the revered varieties of northern France. He is also well known for his mordant wit, which enlivens his labels and newsletters. Al Brounstein, in complete contrast, worships at the shrine of Bordeaux and created one of Napa Valley's most beautiful and esteemed Cabernet Sauvignon estates, which he continues to run despite a long coexistence with Parkinson's Disease.

Gian Annibale Rossi, as master of a vast estate near the Tuscan coast, initially showed more interest in horse-breeding than wine, but now the stylish wines from Terriccio are internationally acclaimed. In the Rheingau Bernhard Breuer has been the leading advocate of high quality wines, co-founding the Charta Association to show that Rheingau wines are both great in themselves and very compatible with fine food. Ernst Loosen performs a similar role in the Mosel, shaking up complacent attitudes and himself producing wines of stunning quality.

The reputation of Austrian wines plummeted to zero after the glycol scandal of 1985, but within a few years Alois Kracher was in the forefront of those who demonstrated that the sweet wines of eastern Austria could be the equal of the most celebrated sweet wines of France and Germany. Tokaj was reborn as a wine after the end of Hungarian Communism in 1990, and István Szepsy has brilliantly united the best traditions of the past with the most innovative ideas of the present.

## THE WINEMAKERS

Jacques Peters is responsible for the quality of each of the millions of bottles that bear the Veuve Clicquot label, a responsibility he carries with passion and immense skill. Véronique Drouhin was raised in the heart of Burgundy, but was entrusted with creating the family-owned domaine in Oregon, which now produces some of that state's finest wines. Bruce Guimaraens is a director of the legendary port house of Fonseca, but his real passion has been viticulture and winemaking, roles he has now bestowed on his son David, the current winemaker for Taylor and Fonseca. At a very different port estate, Ramos Pinto, João Nicolau de Almeida also worked on radical advances in viticulture and promoted the production of fine red table wines as well as ports.

Kym Milne was one of the first flying winemakers, a much maligned breed of skilled technicians who have acted as magicians in transforming wines once of local interest only into internationally successful brands. Like the Australian Milne, Steve Smith of New Zealand holds the coveted Master of Wine diploma, combining the careers of viticulturalist and winemaker.

## THE BUSINESS OF WINE

Pierre Lawton is an unconventional man in a conventional trade: the Bordeaux négociant, in his case specialising in the tricky Far East market. In complete contrast, Kermit Lynch has abandoned Bordeaux for the idiosyncrasies of regional French wines, which he has imported

into the United States for decades, banging the drum for wines of individuality and personality. Georges Duboeuf, the 'king of Beaujolais', started his career by peddling his wines from his bicycle basket; today he presides over a large empire that has preserved the world's affection for the wines of Beaujolais.

Two Londoners, Stephen Browett and Michael Broadbent, represent different poles of the wine business. Browett, a former van driver, co-founded the colossally successful Farr Vintners, specialising in trading fine Bordeaux throughout the world. Michael Broadbent, for many years the suave auctioneer of fine wines at Christie's, has made a career of charming winelovers into putting their cellars on the block, and of persuading another generation of winelovers to buy them.

## THE CRITICS

Robert Parker, without any doubt, is the most influential wine writer ever, a power that he has not really sought but manages to live with anyway. Jancis Robinson represents a different and equally valid school, more interested in education and enlightenment than in assessing each new vintage as it comes along. Len Evans, British-born but in every other sense an irreverent Australian, is an enthusiast as much as a critic – and a restaurateur, winemaker, wine judge, and educator besides. James Halliday, a fellow Australian, is less flamboyant but equally diverse in his abilities, producing annual wine guides as well as readable introductions to wine technology.

## GASTRONOMY: WINES FOR PLEASURE

Noel Bajor presides over the vast cellars of the major hotels and restaurants of Monte Carlo, including Alain Ducasse's celebrated Louis XV. His job is to give equal service to the billionaire diners who have drunk the costliest wines in existence and to the young couple who have saved for months to afford a great gastronomic experience. Hardy Rodenstock from Germany is the world's foremost wine collector, who, with showmanship as well as generosity, has shared the rarest wines from his cellars with the finest palates in the business.

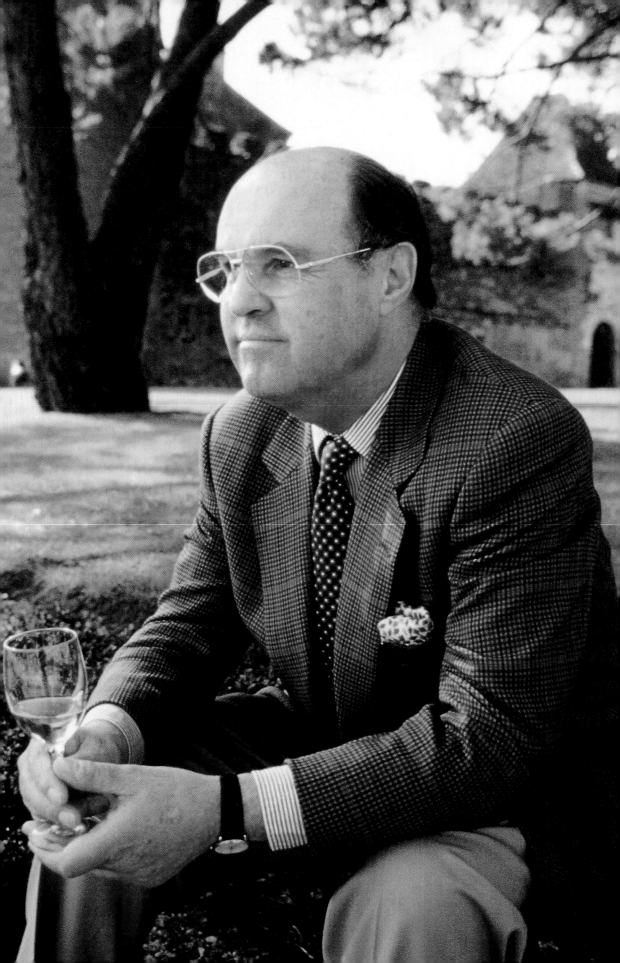

# THE GREAT ESTATES

## Alexandre de *Lur-Saluces*

As well as body language there is château language. Just take a look at the location of Château d'Yquem and you instinctively know this is the top dog of the Sauternes region. Partly medieval and walled, it sits proudly and impassively on top of its hill, with the vineyards flowing down all the slopes. The Eyquem family acquired the property in the sixteenth century and in 1785 a scion of the Lur-Saluces family – then occupying Château de Fargues a few miles away – married the Eyquem heiress and to this day there is still a Lur-Saluces at Yquem.

Comte Alexandre de Lur-Saluces is not an easy man to know. Reserved and rather formal, he gives the impression that there is some vast gulf between himself and those around him. His staff still call him 'Monsieur le Comte' as if the French Revolution had never taken place. Yet, despite this apparent stolidity and gravity, no one would deny that he has administered the estate brilliantly since he took over in 1968 in his mid-thirties. Earlier in the 1960s there had been some poor vintages and some Yquem was bottled that was not worthy of the name. Since Comte Alexandre has been in charge that has not been allowed to happen again. He has kept Yquem at the very highest quality level. A few other Sauternes properties sometimes approach its majestic splendor as a wine; none surpasses it.

Sauternes is a difficult wine to make. Growers must wait for botrytis (noble rot) to attack the grapes and this doesn't happen every year. Even when it does occur, it usually does so sporadically, requiring the harvesters to make repeated pickings. A harvest at Yquem can often take two months to complete. As the grapes need to be extremely ripe

by the time botrytis attacks, yields are very low. At the great estates of the Médoc, yields of sixty hectolitres per hectare (around four tons per acre) are commonplace. At Yquem the average yield is nine hectolitres. No wonder the wine is expensive (although compared to Le Pin or Pétrus it could be considered cheap). Today the wine is in demand, but it was not always thus.

Comte Alexandre recalled the difficult times he went through after taking over the management of Yquem. 'In the 1960s the quality of Yquem was not sufficiently recognised and few people understood the nature of botrytis and the difficulty of making such a wine. Also, Sauternes in general was sold at very low prices. The early 1970s were tough: we released no Yquem in 1972 or 1974, so there were financial problems too. So we had to make cutbacks. We no longer added compost to the vineyards, nor could we make the investments we wanted. But gradually I was able to build up stocks and increase prices. By the late 1970s we were feeling more positive and we have been evolving ever since. I have never been tempted to lower standards. Nothing has changed for the worse at Yquem.'

If the winemaking team are unhappy about any barrels for any reason, they will be eliminated. It is not unusual for a sizeable proportion of the crop to be sold off to wholesalers. Indeed there have been vintages in which about 80 percent of the crop has been sold off. This represents an enormous financial sacrifice, but were Yquem to start compromising its quality, its reputation would suffer grievously. It's a costly policy etc. It's a costly policy but Yquem has never wavered. Comte Alexandre recalls how, when the 1990 vintage was ageing in its new oak barrels, a sharp-eared employee heard a faint bubbling sound. The cellarmaster was alerted and discovered that sixty barrels were re-fermenting, which would increase the alcohol and diminish the sweetness of the wine, thus wrecking its delicate balance. The barrels were immediately removed and the contents sold off. That decision must have cost the château about $3 million, but it ensured that the 1990 Yquem is a truly great wine.

The count is still running Yquem, but he no longer owns it. His firm, rather shy manner conceals a stubborn streak and when he discovered that the luxury goods group LVMH was hoping to take over

*14*

the estate, he fought them off with amazing tenacity and determination. The great estate was owned by a number of shareholders, including many members of the Lur-Saluces family. Eventually enough of them were persuaded, to the dismay of Comte Alexandre, to accept LVMH's offer for their shares, thus putting an end to family ownership of the property in April 1999.

Yet Comte Alexandre does not seem too unhappy with the final outcome. LVMH under Bernard Arnault has acquired the majority holding in Château d'Yquem, but Comte Alexandre stays on, with his highly experienced team, to manage the property. It is even on the cards that his son Bertrand, despite some shell-shock after the bruising battle over the property, will take over when Comte Alexandre eventually decides to opt for a quiet retirement. When I wondered whether he felt constrained in his decision-making now that LVMH is breathing down his neck, he laughed and replied: 'If anything, Bernard Arnault is less free than I am. After all, I have been at Yquem for over thirty years and have a very experienced team at my disposal. That's why he has given me carte blanche as manager of the estate.'

When the vineyards of Sauternes were classified in 1855, a special category had to be devised for Yquem – *Premier Grand Cru* – since its wine was so superior to all others. It still rules the roost, essentially unchallenged. The drawback is that Yquem can appear to be a national monument rather than a wine that can and should be drunk with pleasure. 'It's true that some people are in awe of Yquem,' the count concedes. 'There are so many references to it in great literature, it's expensive, and so people feel afraid to drink it. Yet I want to retain the image of Yquem as a luxury product. It's not a supermarket wine.'

Indeed, it is an attempt to reach perfection in liquid form and, as long as Alexandre de Lur-Saluces is keeping a watchful eye on all that goes on at Yquem, we can look forward to some more stunning vintages of this astonishing wine.

*Overleaf. "pourriture noble",*
*or noble rot, sweetens the grapes*
*of Chateau d'Yquem.*

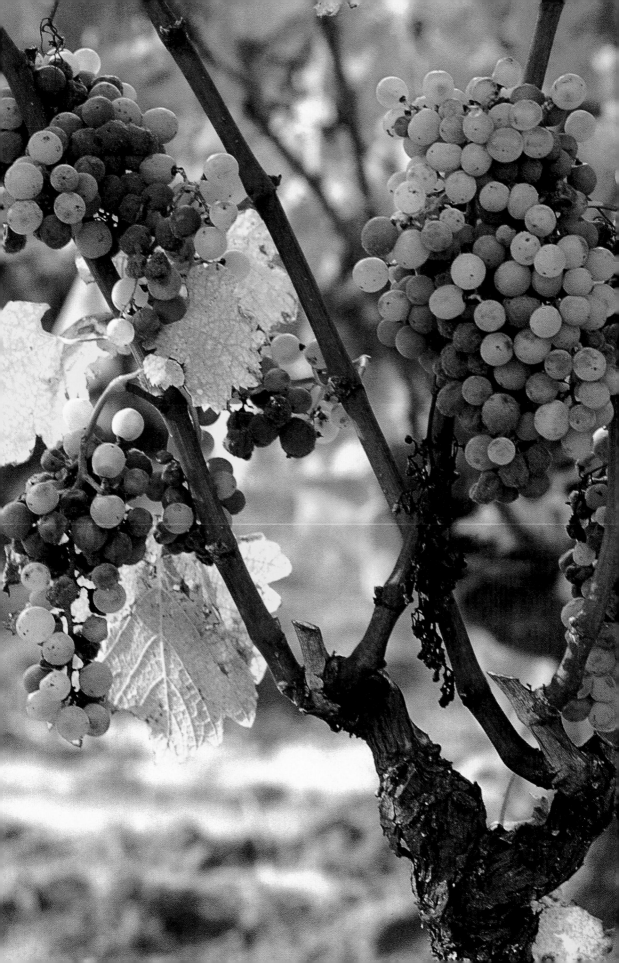

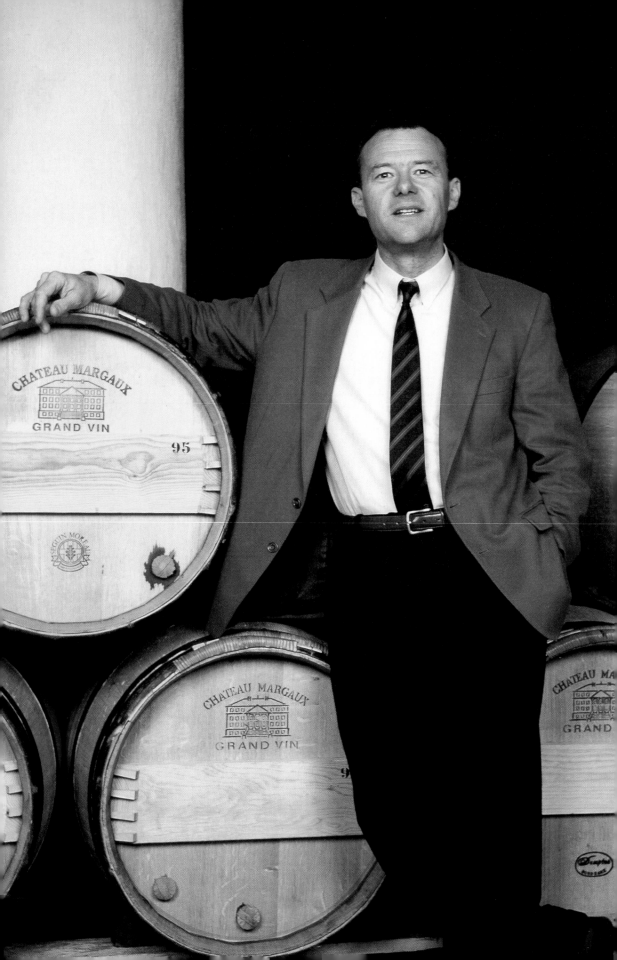

# Corinne Mentzelopoulos and Paul Pontallier

ost of the Bordeaux first growths are more celebrated for their precious soil than for their châteaux. Lafite is a pretty little country house, Latour a gloomy mansion that has been uninhabited for years. This is because many of these great properties have been run by absentee owners. Château Margaux, however, is everything we expect from a Bordeaux first growth: a palatial country manor at the end of a long stately drive.

The offices are tucked away in a tangle of buildings near the cellars and this is the domaine of director Paul Pontallier and his staff. The owner of the estate, Corinne Mentzelopoulos, lives most of the year in Paris, but spends about three months at the château each year. It was her father André, a Greek immigrant who became proprietor of 1,600 grocery stores and a clutch of commercial buildings in Paris, who bought the property inexpensively in 1977, immediately recouping a third of his investment by selling off much of the wine in the cellars.

'This was a bad time for Bordeaux,' recalls Corinne, 'and Margaux had been on the market for two years. My father went to see the then owners, the Ginestet family, and had lunch at the château, which had been unoccupied for three years. After lunch they shook hands and that was it. He just fell in love with the place and starting spending money on it right away, before the boom of the 1980s. By the time the great vintages of the 1980s began, he was ready. At the beginning there were some who didn't take him seriously, possibly for snobbish reasons, since he spoke French with a strong Greek accent. But they soon realised he was serious. I'm very grateful to him, as it's such a privilege to look after Margaux.'

André Mentzelopoulos died in 1983 and Corinne, still in her twenties, took over. 'When I first came here in 1983 I didn't believe in *terroir*. Our team would show me a parcel and tell me that this particular patch of gravel always gave the best wine. How could that possibly be so, I wondered? But of course they were right. One day I woke up at the château and looked out of the window. The Gironde had flooded and there was water everywhere. I phoned the *chef de culture* in a panic. He told me not to worry. I soon discovered that every single vine and all the estate buildings were untouched by the water. Two, three centuries ago, those who created the estate simply knew the terrain and how to avoid such problems.'

In 1984 the estate director was due to retire and Corinne made an imaginative choice of a successor: Paul Pontallier, who despite his youth came equipped with a doctorate on the barrel-ageing of red wine and two years' experience teaching oenology in Chile. Nearly two decades later Paul seems scarcely to have aged at all and carries his responsibilities lightly. His primary job is to focus on the winemaking, while Corinne looks after commercial matters. Although it's not difficult to sell a wine of this calibre, neither of them takes the market for granted and they devote a considerable amount of time to travelling the world presenting the wines of Margaux. In addition Pontallier is the co-owner of Domaine Paul Bruno in Chile, in partnership with Bruno Prats, the former owner of Cos d'Estournel. With a southern-hemisphere harvest six months earlier than in Bordeaux, there is no clash of duties.

'Although we don't really need to promote our wines,' says Paul, 'I believe it is very important to communicate our wine culture. Knowledge about wine is now much greater than before, as is the choice of fine wines worldwide, and the press is far more professional. That makes it all the more important for us to share our knowledge and our passion for the wine we make. I don't think we can afford to stay in Bordeaux and ignore the consumers.'

Paul Pontallier admits that vinifying Margaux is not that difficult. 'The crucial task is to ensure that we have the best possible grapes to work with, given the conditions of each vintage. But I don't want to sound complacent. We have our own research department here – I'm

not the only Ph.D. at Château Margaux! We're always looking at new techniques, such as reverse osmosis and concentrators. But remember we're not starting from zero – we already know quite a bit about oenology!

'Of course things have changed in the years I have been here. There is much more attention to detail, and our selection policy is stricter. In 1982 about seventy percent of our production was bottled as the *grand vin*, the rest as Pavillon de Margaux. Now it is around forty-five percent, even in a fine vintage such as 1996. Also, we are under more scrutiny than before. Fifteen years ago in the spring after the vintage a few journalists and merchants would have come here to taste the new wine. But now we have five hundred visitors in one week and I have had to spend all my time answering their questions and listening to their comments on the wine. This is a new kind of pressure.'

As journalists are keen to pronounce on the 'wine of the vintage', does that constitute yet another form of pressure? 'We're not really in competition with the other first growths. We are all trying to excel, to do better than we have done before, but of course we are all different. Margaux, Lafite, Latour – these are all completely different wines, so there is no meaningful sense in which we compete with each other. What does it mean to be *better* than Lafite? What we want to do is to make the best Margaux possible.'

Paul Pontallier enjoys teamwork, and has surrounded himself with well qualified experts. 'Corinne is involved too – after all, she owns the company – but she doesn't interfere. I certainly keep her informed and, if a number of options are before us, I explain what they are and which we favor, and why.' Corinne adds: 'I like to participate in blending, but I don't take the final decisions. On the other hand, decisions about selection have a financial dimension, so I have a say in that. And of course I have the final say on pricing.'

This youthful pair seems to be an ideal team, and their remarkable accessibility – both to wine professionals and wine consumers – has helped them to project the image of Château Margaux as a wine with the same elegance, vitality, and staying power as themselves.

*Overleaf. The magnificent cellars of Château Margaux, in the Médoc, shelter a king's ransom of splendid wine in a naturally controlled environment.*

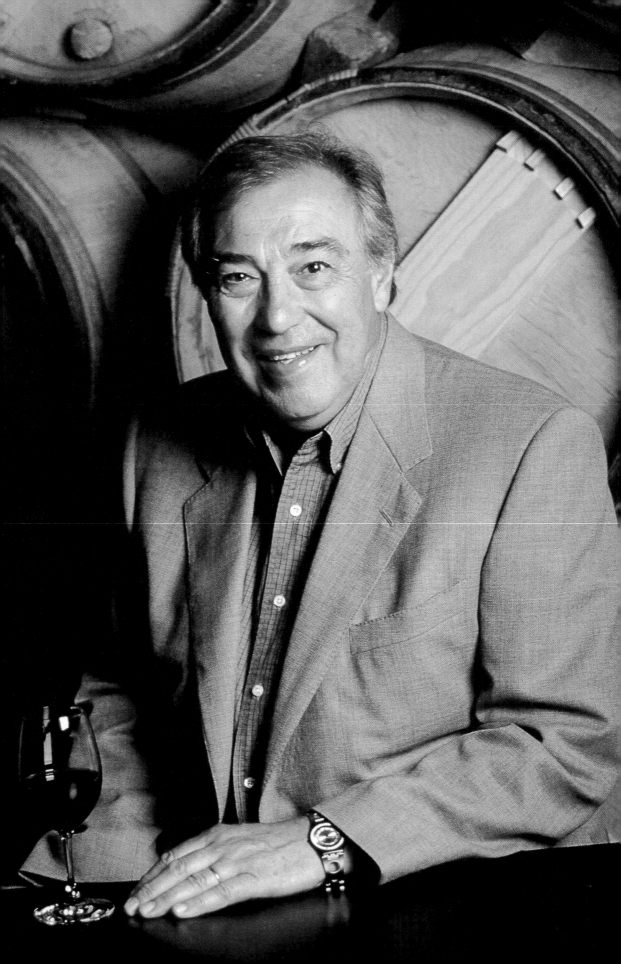

Jean-Michel Cazes is not a typical Bordeaux château proprietor. For a start he actually lives at his property, the fifth-growth Château Lynch-Bages in Pauillac. What's more, he welcomes visitors to the estate, where trained guides ensure an informed tour of one of the best wine properties in the Médoc. And, most surprisingly of all, Cazes, despite his phenomenal success, has hung on to his day job running an insurance office in Pauillac.

Lynch-Bages came into the hands of the Cazes family in the 1930s, a dire time for Bordeaux proprietors, but a shrewd time to acquire an estate – as long as making it pay was not essential. Jean-Charles Cazes did make it pay, and so did his son André, who took over running the property in 1966. He too had other jobs, being an insurance agent as well as mayor of Pauillac for forty-one years. André's son Jean-Michel always knew that it would be impossible to earn a living from the family's vineyards alone, so he was launched into a successful career with IBM in Paris when the summons came to take charge of Lynch-Bages in 1973.

He couldn't have picked a worse time. 'I arrived here just in time for the Bordeaux crisis and the oil crisis. Prices were plummeting. It was also a time of major technical changes. People were just beginning to understand crucial winemaking processes such as malolactic fermentation, and many négociants were telling us they wouldn't accept wines – such as many 1972s – that hadn't gone through malolactic. It was a way for them to wriggle out of their agreements, as their businesses were in peril. We had very old equipment here, and no temperature control, so it wasn't possible to heat the *cuverie* and ensure

the wines went through malolactic. So this forced us to renovate. The problem was that this happened just when we had no money, as my father had bought out his brothers' shares in 1971.'

None the less the quality of the wine improved rapidly, propelling Lynch-Bages in the 1980s into the ranks of the so-called super-seconds. The vineyards consistently yielded rich luscious grapes that were transformed in the Lynch-Bages cellars into a wine that is dark, powerful, ripely tannic, occasionally burly, sumptuously but not excessively oaky, and very long-lived. A similar attention to detail turned the family's other main property, Château Les Ormes de Pez in Saint Estèphe, into one of the finest *crus bourgeois* of the Médoc.

But Jean-Michel Cazes was never the kind of person to restrict himself to one or two activities alone. He also set up a small négociant business. 'In the late 1970s I had dealings with a bank that was proposing to acquire wines as an investment for individuals. I helped to organise this, supplying not only my own wines but wines from many top properties of Bordeaux, who were happy to sell wine in this way. Négociants weren't interested in this kind of activity. As this business grew, the Crédit Lyonnais proposed that I set up a company to regulate the stocks and administer the business, which is how I formed the Compagnie Médocain. This also enabled us to sell wines on behalf of clients as well as purchase them. I did everything myself till 1983, at which time I took in a partner and we expanded into a much larger négociant business, which developed brands such as Michel Lynch in the late 1980s.'

But this was small fry compared with what was to come. Cazes had been a schoolfriend of Claude Bébéar, the head of AXA, one of France's most powerful insurance companies. 'In 1986 Bébéar contacted me to ask for my advice on his proposed purchase of Château Cantenac-Brown. I was happy to advise him, although the deal fell through. But then Pichon-Longueville here in Pauillac came on the market and I helped him to acquire it for AXA.' The two men then created AXA Millésimes, an umbrella company to administer the properties the insurance company was acquiring, such as Petit Village in Pomerol, Cantenac-Brown (acquired in 1989), and Suduiraut in Sauternes, as well as a wine estate in Tokaj in Hungary, Domaine de l'Arlot in

Burgundy, and the great port house of Quinta da Noval in the Douro Valley. In addition they transformed the mansion of Château Cordeillan-Bages into the Médoc's best hotel and restaurant.

In 2000 Jean-Michael Cazes, now aged sixty-five, announced he would retire from his position at the head of AXA Millésimes. It is hard to utter the words 'Cazes' and 'retirement' in the same breath, but the workaholic Jean-Michel is confident that he will have plenty of new activities to occupy his volcanic energies. None the less, I suspect he will greatly miss working closely with his long-term winemaker, the versatile and amazingly gifted Daniel Llose, as together they have resuscitated properties such as Noval and created from scratch what is today one of the great estates of Tokaj at Disznókó.

At the very least he will continue to be one of the public faces of the Bordeaux wine industry. An indefatigable traveller and communicator, with a natural flair for showmanship, he has done a great deal to counter the prevailing image of Bordeaux as stuffy and arrogant. As Grand Master of Bordeaux's principal wine fraternity, the Commanderie du Bontemps du Médoc, Graves, et Sauternes-Barsac, he presides over the stunning pageants and banquets such as the 'Fête de la Fleur' which link Bordeaux wines with social glamour. Such projects as the guided tours of Lynch-Bages and the creation of amazing neo-Baroque, and totally hi-tech, new cellars at Pichon-Longueville – also open to visitors – have made some of the top properties of Bordeaux accessible to wine lovers.

'I've always encouraged people to visit our estates, as people carry away good memories of the experience and they then become ambassadors for our wines. We receive 15-20,000 people at Lynch-Bages each year. But we need to do this kind of thing well and we devote a lot of resources to training our guides properly. Together with Pichon and Cantenac-Brown, we have twenty guides in all, and we also offer free tastings of bottled wines.'

As Jean-Michel Cazes slowly retreats from the foreground, his genial enthusiastic omnipresence will be greatly missed. But, like his venerable father André, long retired but still visible, Jean-Michel is unlikely to remain far from the center of events in Bordeaux.

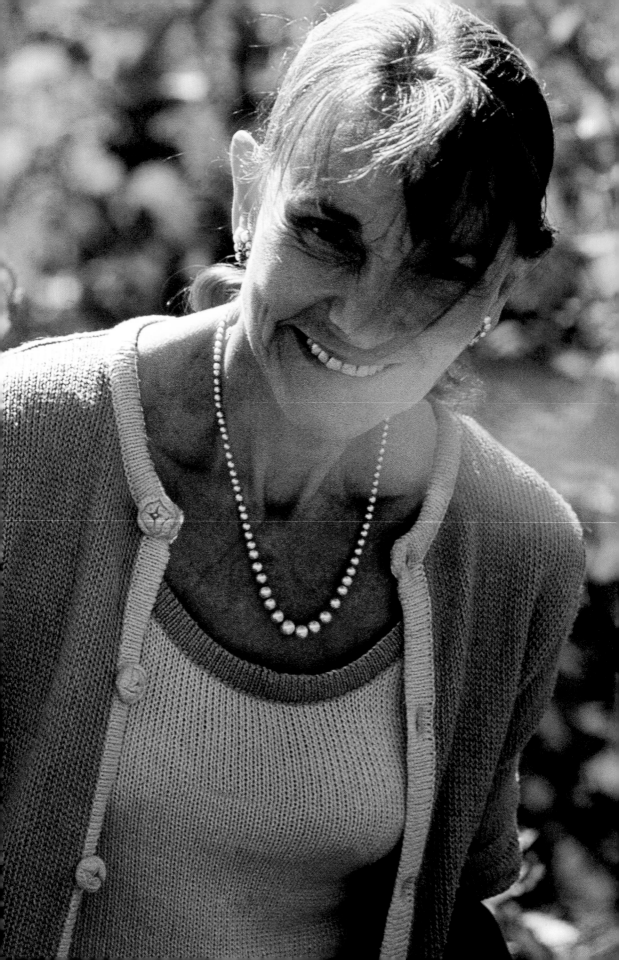

# Lalou $\mathcal{B}$IZE-$\mathcal{L}$EROY

$\mathcal{I}$t's not easy to create a new domaine in Burgundy, where the vineyards are divided up into mostly tiny parcels and handed down from generation to generation. The only feasible method is to buy an entire property that comes on the market, which is exactly what Lalou Bize-Leroy did in 1988, when she acquired the Charles Noëllat estate. The domaine wasn't famous for its wines, which were unremarkable. It was the vineyards that she was after. Then she bought Domaine Philippe Rémy for the same reason.

She now had a magnificent collection of vineyards, fifty-seven acres in all, including parcels in such famous *crus* as Chambertin, Musigny, and Richebourg. She began producing her wines to the most exacting standards, and selling them at the most outrageous prices. But even the most hard-bitten of tasters and merchants had to admit that the quality was superb. In addition she continued to release wines from Maison Leroy, a négociant business founded in the nineteenth century, which she has helped to manage since 1955.

But there was a problem. Lalou Bize-Leroy was also a co-owner of the most legendary estate in Burgundy, Domaine de la Romanée-Conti. There was a perceived conflict of interest and much argument about how the DRC wines were being distributed. In a very bitter dispute, Lalou was ousted from the management team at DRC.

At least that has enabled her to devote all her attention to the Domaine and the Maison that bear her family name. From the start she converted her viticultural practice to biodynamism (Domaines Leflaive and Lafon have since followed her example). It can be briefly defined as an extreme form of organic farming. 'Biodynamism alone

doesn't account for the quality of the grapes,' she says, 'but it certainly contributes to quality by improving the soil and conserving the purity of the fruit.' The other major factor is yield. Most estates would be cropping their Pinot Noir at thirty-five to forty hectolitres per hectare (about two and a half tons per acre); her yields can be as low as ten. By pruning very short to control yields, she eliminated the need to 'green-harvest' (cutting off bunches during the summer to assist ripening).

The winemaking is simplicity itself: careful selection at the winery, removing any grapes with imperfections; no destemming; a slow fermentation; *pigeage* (punching down the cap) using the time-honored technique of stomping on the cap of skins and stalks; ageing in new oak for about fifteen months; and bottling without filtration. A tour of her cellars with a glass in one hand soon demonstrates that the secret of the wines' quality derives from the vineyard. Her wines have all the typicity the textbooks write about, but which is so rarely encountered in Burgundy. Her Musigny has amazing finesse, her Chambertin considerable power, her Volnay Santenots tremendous intensity as a consequence of the age and small production of the vines. And so it goes on, from barrel to barrel.

Lalou herself is a great admirer of her own wines, continuously exclaiming on their merits as she tastes. Yet her enthusiasm is fully justified. These are among the great wines of the world. Yet she feels herself beleaguered, especially since the bust-up at DRC. Her prickly personality keeps other growers wary of her and she says she is never invited to taste at her neighbors' cellars. Surrounded constantly by her adored dogs, who go everywhere with her, she can seem a vulnerable figure, alternating between sentimentality and determination. She is driven, and she knows it. When I asked whether she is still (well into her sixties) pursuing her passion for rock-climbing, she nodded and replied: 'Il faut, il faut se pousser' – which can be broadly translated as 'Oh yes, one has to keep at it' – implying duty as much as pleasure.

She can be defensive, especially when eyebrows are raised about the very high prices she charges. She points out that her yields are exceedingly low, reducing severely the quantity of bottles she can sell, and that demand is very strong. If the quality were not there, she could

not obtain the prices she asks. 'People think Domaine Leroy is just *Grands Crus*, but it's not true. We have Bourgogne as well and many village wines. I want show that even the modest appellations can produce excellent wine. Bourgogne Rouge at twenty-five hectolitres per hectare can be delicious, and overcropped Chambertin can be terrible. The secret is to work at it every day, and every year presents different challenges.'

She seems to have the same affection for her vineyards as for her dogs and family. 'To have low yields you have to be severe at pruning and remove buds. Sometimes it can be painful to do this, to cut the poor vine right back, but it's the only way. And I don't find it the case that the vine compensates the following year. My vineyard workers were sceptical at first when I introduced biodynamism and very low yields. They even made fun of me, but now they understand that everything we do is aimed at improving quality.

'I don't know if there is a limit to low yields. What I do know is that the old vines give the best wines. In Volnay Santenots I have some old vines that are also diseased. They are nearing the end of their lives. I hate to see these old vines suffer, but I know that they give wonderful wine. So I do everything I can to keep them alive, even though they only produce fifteen hectolitres per hectare.'

She has never wavered in her commitment to biodynamism, even though in 1993 a severe attack of mildew nearly destroyed her crop. 'Once you have seen what biodynamism can do for the vines, then there is no turning back. You tell me that Laurence Faller has converted a third of Domaine Weinbach to biodynamism. I find that hard to understand – why just one third? But then I do understand: she needs to be cautious at first and see what difference it can make. She should hear this story. In my house at Auvenay I have an old camellia plant. The farm is high up, so the plant must come indoors for the winter. It struggles to survive, but I have found that using medicinal plants has kept it young and vigorous! There's a synergy between plants.'

Hocus-pocus or a profound intuition about cosmic forces? It's impossible to say, but, given the intensity and beauty of her wines, Lalou Bize-Leroy must be doing something right.

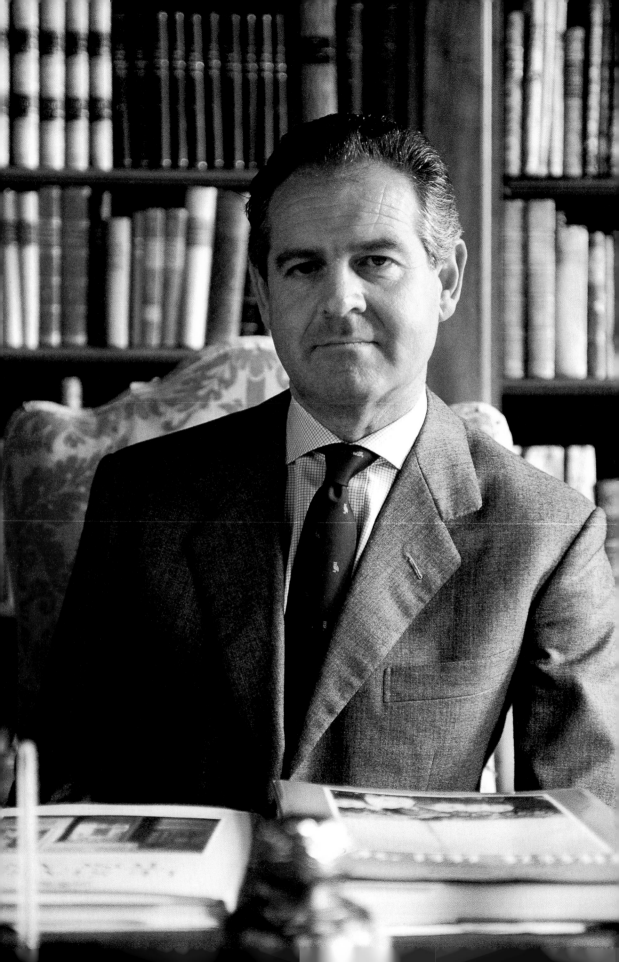

# Piero Antinori

Not everyone lives in a palace named after their family,
located in a square of the same name in the heart of Florence.
Marchese Piero Antinori has had time to get used to it, as the family
has been in the wine-producing business since 1385, if not earlier.
Twenty-six generations later, they are the owners of 3,200 acres of
vineyards, of which 2,400 are in Tuscany, the Antinori heartland.
Whereas his cousin Lodovico, owner of the Ornellaia estate in south-
ern Tuscany, seems easily distracted by the pleasures of a jet-setting
lifestyle, Piero is more serious, even modest and, when he dashes
around the world, it is invariably to promote, present, or talk about
his wines.

'It was a natural thing for me to become involved in the wine busi-
ness. It was assumed that unless I had a clear alternative in mind, and
I didn't, then I would join the business. I grew up in a world of vine-
yards and cellars, so it all seemed entirely normal to me. Even when I
was studying economics at Florence University I was also working in
the family business. My first responsibility was in sales to southern
Italy, which was a tough market in those days. When I travelled
abroad it became obvious that Italian wines in general didn't have a
good reputation. Retailers and restaurants in southern Italy often did-
n't know what Antinori was. But I wasn't discouraged.

'My father was mostly involved in the commercial and marketing
side, building up the brand, especially abroad. I started out doing the
same, but as the years have gone by I have become more and more
involved and interested in viticulture and production.' It helped to
have the inspired oenologist Giacomo Tachis as part of the Antinori

team since the early 1960s. The great breakthrough in Italian wine-making, the creation of Tignanello, was a joint venture between the two young men.

'It came about because of the poor image of Chianti, especially abroad. In the 1960s the old viticultural practices of the past, such as sharecropping, were being replaced by major estate reorganization, which involved planting productive clones and other poor plant material provided by unprepared nurseries. The result was a lot of poorly made, lean, light, acidic wines and I knew we needed a wine that broke away from this.

'The very first Tignanello was made in 1970, but was a Chianti Classico named after our best vineyard. 1971 was the first Tignanello under that name alone. The main difference between it and a Chianti was that it contained hardly any white grapes and was aged in *barriques*. We made 10,000 cases, which was a lot, so we were taking a big commercial risk, especially since the wine was expensive. But it proved an incredible success, especially in Tuscany. We were greatly helped by writers such as Luigi Veronelli, who shared my view that the new wine needed to be given a new identity. In a way we had grasped what the consumers were looking for, but did so unconsciously.'

The sheer quality of Tignanello was an implicit rebuke to the constraints of the Chianti DOC regulations and other producers across the face of Tuscany were swift to follow Antinori's example – hence the wave of so-called 'Supertuscans' that so intrigued the wine-drinking world in the 1980s. Tignanello initially contained no Cabernet Sauvignon, but from the late 1970s about twenty percent was blended in.

Although Antinori produce a sumptuous Bordeaux blend called Solaia, Piero doesn't share the adulation that so many Italian producers show for Cabernet and new oak. 'In the 1970s it made sense to add Cabernet to give more character and concentration. Now the progress we have all made in growing our Tuscan grape Sangiovese is so great that we don't need Cabernet to improve it. I would like to see us focusing more on Sangiovese, though there is no reason not to make fine Bordeaux blends too. Similarly *barrique*-ageing became a fashion, but it should never be seen as an end in itself. Often producers put the

word *barrique* on the label to justify higher prices, a process encouraged by the so-called 'international' taste in wine. But it's gone too far. Put Cabernet in new oak and it soon becomes impossible to distinguish the country of origin. We once organized a blind-tasting to see whether anyone could identify the origins of top Cabernets, and very few could. My belief is that a great wine needs a personality and should reflect a *terroir*. But it's the oaky wines that continue to get the high ratings, so I fear this will be forgotten.'

Piero Antinori, despite his calm relaxed manner, has energetically taken the company in many new directions. In the early 1980s he helped to create Atlas Peak, an estate high above Napa Valley dedicated in large part to the elusive goal of producing a fine Californian Sangiovese. Ten years later he acquired the Piedmontese firm of Prunotto, which is now run by his daughter Albiera. Quite recently there has been a joint venture with Chateau Ste Michelle in Washington state, a ferociously expensive Bordeaux blend called Col Solare. His coastal estate of Belvedere, once devoted to a cheap and cheerful rosé, is now the source of a rich supple Cabernet-based wine called Guada al Tasso and a delicious white from Vermentino.

But the future, for Piero Antinori, lies in southern Italy, where the firm has invested heavily in vineyards in Puglia and Sicily. 'Tuscany will always be central for us, but the south has an ideal climate and good soils and ample water in the right places. I believe one day the south will produce great wines, but they will be more in a New World style. So our initial goal in our vineyards there is to produce premium rather than super-premium wines. But first we need to transform the viticulture, especially in Puglia, which is still best known for inexpensive mass-produced wines.'

Antinori's striking achievement, like Mondavi's, is to have managed to combine large-volume production with high quality. The range of wines is extraordinary, but whether it's an Orvieto from Umbria, a Chianti from Tuscany, a Barbera from Piedmont, or a Cabernet blend from Washington state, each wine has a distinct personality of its own. Piero Antinori will make sure it stays that way.

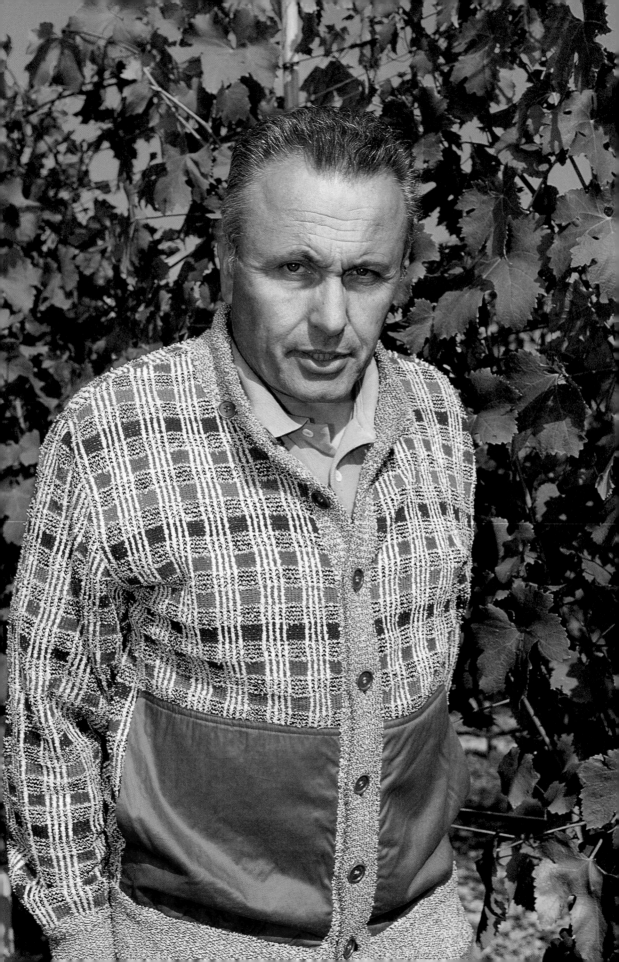

# Angelo GAJA

he sensuously rounded hills of the Langhe, the region within Piedmont that is home to the top growths of Barolo and Barbaresco, were once a rustic backwater. The wines were renowned, but rarely as good as their reputation. Today wineries vie with one another to sell bottles of Barolo at $100 a throw, and Swiss winelovers guide their Mercedes up the steep lanes in search of fine bottles to take home with them.

If one man should take the credit for this transformation of the Langhe, it has to be Angelo Gaja. Over and over again he has bent and broken the rules, introducing new ideas, upsetting cherished traditions. Not everyone applauds the results, but it is indisputable that the quality of the wines now emerging from the Langhe is far higher than thirty years ago.

Angelo was born in Barbaresco in 1940 and studied oenology locally in Alba. 'I graduated in 1961 but my father didn't let me work in the winery until 1968. This meant I spent seven years in the vineyards, which was a very good thing. At that time new products were being introduced against mildew and other diseases. These were synthetic chemical products and they encouraged vigour in the vine. At first they seemed miraculous. But during the 1970s we realised that this miracle was not all that it seemed to be. This explosion of growth was clearly stressing the vines. In some cases the size of the grapes doubled. This was clearly not going to give good quality. So we began to retreat from the use of such treatments.

'At the same time there were changes in the winery in the late 1970s. The most important was the introduction of steel tanks and temper-

ature control. This proved particularly important for Nebbiolo which is the grape variety from which Barolo and Barbaresco are made. It ripens late and nights are cold up here in the hills. We would pick the grapes in the morning and before we had steel tanks we simply had to wait for the grapes and must to warm up. Sometimes it could take a week before fermentation began and during that week there were all kinds of risks: bacterial infection, oxidation, both leading to bad aromas. That couldn't happen today, because we can control this period of maceration.

'It was only in the 1980s that we realised the error of our ways in Piedmont. We returned to less aggressive products in the vineyard and reduced the use of fertilizers. Not just at Gaja, but all over. And practices such as green-harvesting for all our sites to reduce yields are no longer considered controversial.'

It was his decision to start oaking his Barbarescos in 1978 that caused the most controversy, but he plays down the opposition. 'Our decision to use *barriques* was not greeted with hostility. My father was the leading producer in Barbaresco so Gaja was always regarded with respect. But in those days there wasn't that much contact between growers.'

It was his decision to plant French varieties in Piedmont that really set the cat among the pigeons. 'I planted Cabernet Sauvignon in 1978 and 1979. My father was unhappy about using a fine site in Barbaresco for a French variety, which is why the wine is called Darmaggi, which is local dialect for "What a pity!" I also planted Chardonnay and Sauvignon Blanc, which we still produce. I admit that the decision to do so was in part a marketing ploy and not just curiosity. The wine in demand from Piedmont was Barolo and we didn't have a Barolo at that time. With only Barbaresco on our wine list it was very difficult to penetrate markets such as the United States. This was the period when growers in many parts of the world – Tuscany, California, Australia – were having great success with Cabernet Sauvignon, so I thought it was worth a try. The first vintage of Darmaggi was 1982, so it's still something fairly recent for us. Another reason I planted French varieties was to show that our *terroir*

could make great international wines too. It made people who knew little about Barbaresco take us seriously.

'Perhaps it was presumptuous of me, but I wanted to increase the quality and reputation of Piedmontese wines. The image of Italian wines at that time was flat. There simply wasn't a hierarchy of quality as there was, say, in France. What I wanted to do was help construct a pyramid of quality, with the *crus* as great wines. Fortunately, with the overall improvements in quality from 1985 onwards, the poor image of Italian wines began to change.'

In 2000 he caused a furore by announcing he was labelling his three great Barbaresco *crus* as mere regional table wines. Suspicions were immediately aroused that he was doing this so that he could blend in varieties such as Cabernet, but he has strenuously denied this. Instead, he says, he will magnify the image of his regular Barbaresco, which has become overlooked because of the attention given to his costly *crus*. 'In my father's day, Barbaresco was the only wine he ever made and it was highly regarded. By removing the DOC from my *crus*, my Barbaresco will be, once again, the only Gaja Barbaresco. It will increase the prestige of the region, not diminish it. Anyway, twenty years ago similar decisions, such as planting Cabernet or using *barriques*, were significant because I was the first to take them. But today I am far less important. I like to think my wines are among the best, but I recognize there are a dozen or more other producers now at the same level.'

Angelo Gaja is brilliant at marketing and never lacks for media attention. The fact that he has won international and domestic acceptance for his very radical approach is proof of his promotional flair. But he takes a more modest line. 'I am not primarily a businessman. I'm an artisan and I like to have my finger in many pies and to be actively involved. I have been invited over the years to participate in all kinds of joint ventures – in California, Chile, and other places – but have always said no. All these offers merely opened my eyes to other possibilities in Italy.' Hence his purchase of the Sperss vineyard in Barolo, an estate in Montalcino and an immense project on the Tuscan coast in Bolgheri. As he enters his seventh decade, Angelo Gaja gives the impression he is just getting into his stride.

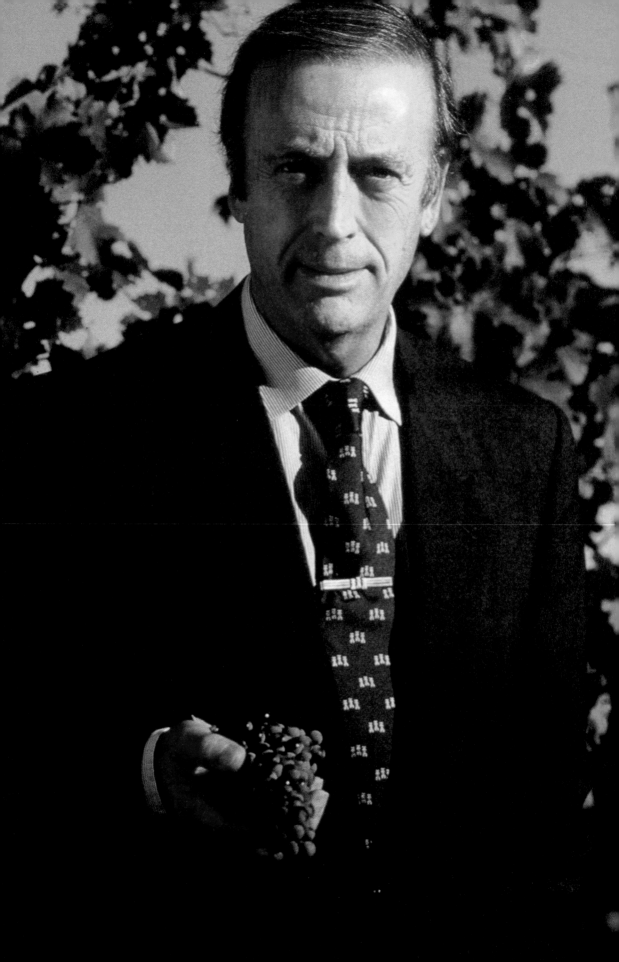

*I*t is unusual that one individual can come to personify an entire region, but until quite recently the Penedès region inland from Barcelona has been identified with the name of Torres. Now a few other producers are establishing a reputation, but they still remain in the shadow of Torres. The family had been involved in winemaking for decades but their small estate was sold in 1935 and Torres was primarily a négociant business, buying and blending wines before selling them under brand names.

Old Miguel Torres was a patriarch of the old school, who expected his children, even as adults, to do what they were told. None the less, when Miguel returned from his studies in Dijon in 1962 and proposed that the firm start to vinify their wines, his father agreed. The logical consequence of this was the purchase of vineyards. Throughout the 1960s Miguel planted mostly French varieties such as Sauvignon Blanc and Cabernet Sauvignon. 'We conducted experiments to see which grape varieties would work best here, and it was obvious that Cabernet was king. But we also made many mistakes, planting Riesling in the wrong spots, for example. We didn't think too much about soils in those days – climate seemed much more important. Once we realised a variety wasn't working where we planted it, we soon eliminated it. We also worked with local varieties such as Parellada. It normally gave rather dull wines, but when we fermented it cool it had much more freshness and everyone loved it.'

It was Miguel Senior who came up with the brand names that have long been synonymous with Torres: Black Label, Gran Coronas, Sangre de Toro (bull's blood), and Viña Sol. Indeed old Torres was

exceptionally skilled at marketing. 'Once a week,' Miguel explains, 'the lawyers would come to his office and discuss registering and protecting our wines. He even insisted on doing so in India where we sold next to nothing. But he was far-sighted and now the names of our wines are protected in an expanding global market.'

The flagship wine was always Black Label, now known as Mas La Plana, a rich Cabernet Sauvignon that won international acclaim when the 1970 vintage triumphed over Château Latour in a tasting organized by the French *Gault-Millau* magazine. 'This tasting was of huge importance to us. It didn't have much impact in Spain, where at that time few people had even heard of Latour, but it put us on the map internationally and helped us to sell our whole range of wines.'

The Torres business has grown steadily ever since. Today the family owns 5,000 acres, as well as properties outside Spain. The range of wines has also grown, with the introduction in the 1980s of a premium Chardonnay called Milmanda and a good Pinot Noir called Mas Borras. In 1998 a Merlot called Atrium was added to the range. But the bread-and-butter wines remain the very popular Viña Sol, Coronas, and Sangre de Toro, which have always combined high quality with reasonable pricing.

Despite the steady increase in production and fortune – by 2000 Torres was producing two and a half million cases of wine and five million bottles of brandy annually – there were clear tensions within the family. Miguel's sister Marimar headed off to California, marrying an American wine writer and establishing her own vineyard and winery in Sonoma. Miguel himself, needing a breather, took a sabbatical in 1981. He spent a year at Montpellier in southern France, studying viticulture. There he learnt about the hundred or so varieties that had flourished in his native Catalonia before phylloxera wiped out most of the vineyards.

This set Miguel, who had hitherto been best known for his French-style wines, on a new course. 'I decided to try to revive production of our indigenous varieties. But first I had to find plant material of good quality. There are very few vine collections in Spain, so I started advertising locally to ask farmers with strange varieties in their vineyards to let me know. We have now found five or six authentic old Catalan

varieties and have replanted them. These include Monastrell, which is Mourvèdre, and white Grenache, which is popular in Roussillon but disappeared from Penedès because it wasn't suited to sparkling wine production. We have Roussanne and Vermentino, which we think originated in Catalonia, and Samso, which is related to Cinsault, and Garró. We use most of these varieties in our Grans Muralles.'

Grans Muralles is the costliest wine in the Torres portfolio. It is a slatey fifty acre vineyard in the Conca de Barbera subregion. The vineyard belonged to the Cistercians until the eighteenth century, when it was confiscated by the state and sold off to a Catalan family. In the 1940s the last descendant sold the vineyard to another monastic order. 'When it came on the market in the 1980s I was able to buy it,' recalls Miguel, 'but I had to travel to Rome to get a special papal dispensation!' The wine, which is excellent, was first made in 1996, from Monastrell, Garnacha, Samso, and Garró. Miguel Torres admits the wine, at $75, is expensive, 'but the production is very limited. I think the trend towards very expensive wines from Spain can be justified, especially from estates with a long tradition behind them, such as Vega Sicilia. In general this development is positive for wine. I'd rather see some overpriced wines on the market than a range of wine coolers.'

Miguel Torres travels incessantly. He has to monitor his ventures in neighboring Priorato, his eight hundred acres of vineyards in Chile, as well as keeping a brotherly eye on the Miramar Torres winery in California and on a new venture in China. He also travels to promote the wines, even though they are already well known internationally. 'It's very important to keep promoting the wines, to consumers as well as professionals. That is also why we are so keen to offer tours of our winery and to encourage educational ventures such as our cultural centers. Our winery tours help visitors understand and respect wine. It's important for our image.'

What he still likes best, however, is tasting and blending his wines, especially at harvest time when he can check the quality of each vat during and after fermentation. He can't avoid being deeply involved in administration and marketing, but it's wine itself that still fascinates Miguel Torres.

*Overleaf. Oak casks and oversize bottles at the Torres winery in Catalonia, Spain.*

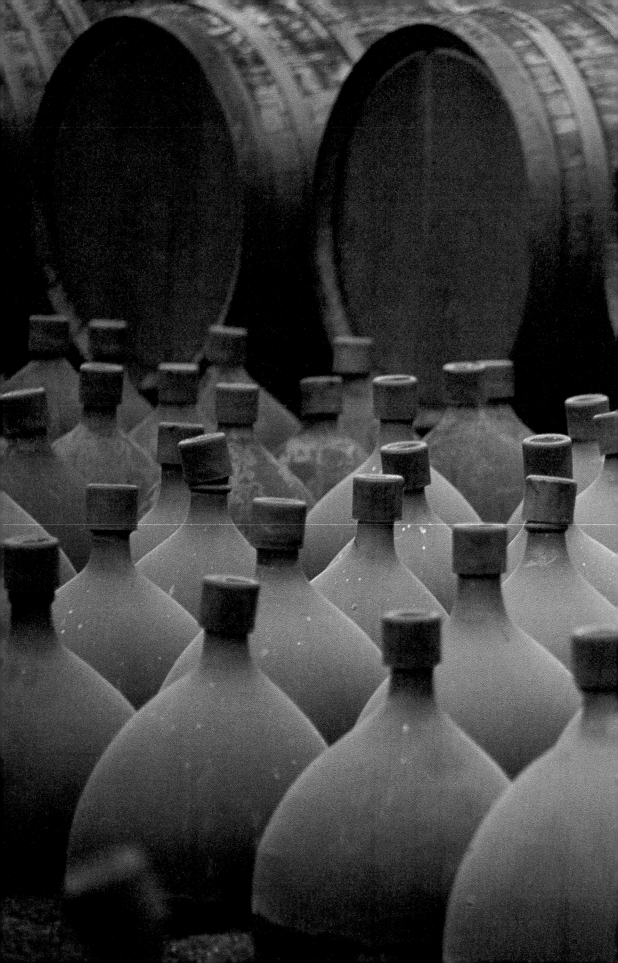

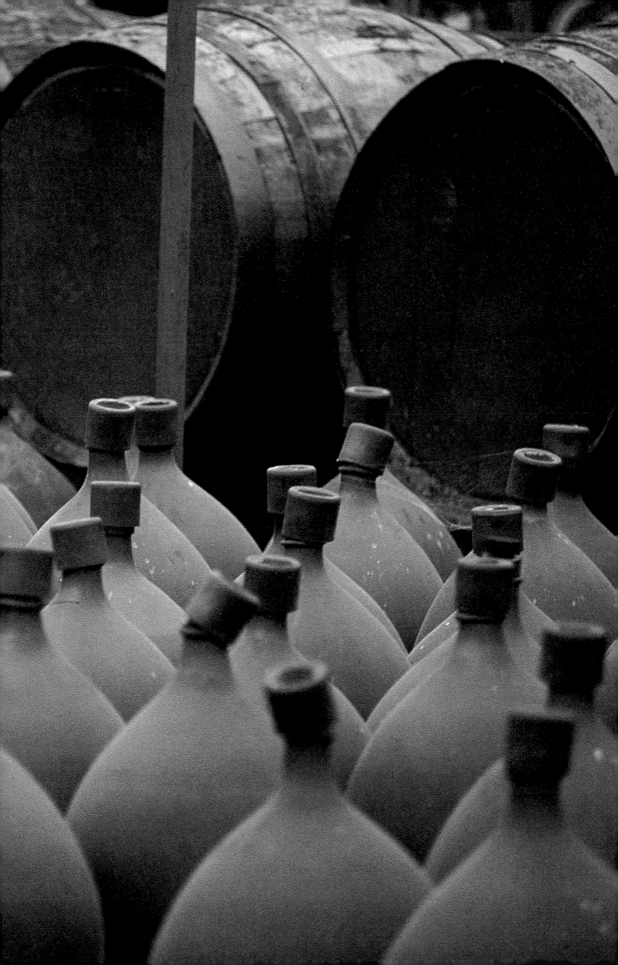

# Claire VILLARS

There aren't a lot of pretty young women running a handful of prestigious châteaux in Bordeaux these days. Growing corporate ownership of important properties means that more and more estates are run by administrators, who, however skilled at their jobs, are not always the most colorful of people.

Although Claire Villars was born in 1967 into a family embedded in the wine business in Bordeaux, it was never her intention to work in wine. She studied science at university and then went to Paris to begin a doctorate on the scientific aspects of art restoration. There she received some terrible news that was to transform her professional as well as her personal life.

Her grandfather, Jacques Merlaut, ran the powerful Taillan group of négociant businesses as well as châteaux, and his daughter Bernadette, Claire's mother, had been in charge of the highly regarded *cru bourgeois* estate of Chasse-Spleen since 1976; over the next fifteen years the group acquired more properties in the Médoc. Then in 1992, at the height of her powers, both Bernadette and her husband were killed in a climbing accident. Claire immediately returned to Bordeaux. Even though she had no professional experience of the wine business, her grandfather urged her to take over her mother's role. She felt she had no choice but to agree.

'So, as a very inexperienced twenty-four-year-old, I found myself not only in charge of Chasse-Spleen, but of two classified growths, La Ferrière in Margaux and Haut-Bages-Libéral in Pauillac. At first my role was one of communications, but I didn't find this enough, especially because of my academic training. I was far more interested in

the technical and winemaking side, but it was hard to make room for me as I had had no formal training in oenology. I wasn't particularly interested in the commercial side, but my grandfather instructed me and I couldn't have had a better teacher.

'By the end of the 1990s everything had changed. We had acquired more properties: Citran, Cos d'Estournel, and Gruaud-Larose. We have had to take on more staff and have someone supervising each estate and looking after each team of workers. So today it's easier to delegate, and it's necessary too. Uncle Jean looks after Gruaud-Larose. Uncle Antoine decided he too wanted to be involved and has moved into Citran. My sister Céline is now at Chasse-Spleen, and I look after Haut-Bages-Libéral, La Gurgue and Ferrière. I'm very happy with these developments because there was a period when I simply had too much responsibility.'

Claire never found that being a woman was an obstacle. 'That never really gave me any problems, except perhaps on the technical side. I may have had my own ideas about winemaking, but it wasn't always easy to get them across in châteaux where men had grown used to being in charge for many years. I think my age was more of an obstacle than being a woman. After all I had some credibility because of my academic training. But when it comes to presenting and marketing our wines, especially abroad, then it's a positive advantage being female and young!'

In 1994 she met Gonzague Lurton, one of the many children of Lucien Lurton, a man who owned even more properties than the Merlauts. They soon married, forming an alliance between two remarkable families. Gonzague has his own property to run in Margaux, the second-growth Château Durfort-Vivens. His personality differs from hers: less effervescence, and a stubborn determination to put Durfort-Vivens back on the map, but on his terms.

Both of them are well aware that it is no longer possible to sit in Bordeaux and wait for the world to come to you. The wine buyers of the world now have infinite options. 'In Bordeaux there is still an old-fashioned mentality, and complacency too. It's changing of course, as a new generation travels much more and meets many more people from the world of wine in all countries. But among older people there

was still an attitude that Bordeaux was supreme and always would be, so there was no reason to go out and sell our wines. This is compounded by the fact that proprietors don't sell wine directly, so to the older generation there didn't seem any compelling reason to travel and promote. But now that's changing, and not just among young people.

'I myself often travel to other wine regions. I have been many times to Chile, to Australia, to South Africa. More and more these countries are offering competition to our wines, and we have to understand and appreciate them. I think it's essential to know these foreign markets, and even though we sell our wines through négociants, I like to know who is importing our wines worldwide and to have contact with them.'

In a region that sometimes seems dominated by greed, Claire Villars takes a more level-headed view. 'The instability in the Bordeaux market which many outsiders find frustrating is largely the result of pride and rivalry between the proprietors. If your neighbor puts up the price, then you feel obliged to follow suit, whatever the quality of the wine. I've never taken that approach. I have no interest in upstaging my neighbors. On the other hand, we have to acknowledge that the major châteaux, whose wines are always in demand and always fetch high prices, are the properties that lead the way and set the standards for all Bordeaux. But sometimes ever rising prices can seem to be just greed, and that's dangerous.'

Claire is making steady progress at Haut–Bages–Libéral, a wine often more noted for its assertive tannins than for its elegance, and La Ferrière is widely recognized as a once under-achieving property that is now making some excellent wines at sensible prices. With her clear-eyed international perspective, Claire Villars knows that Bordeaux cannot rest on its laurels. Nor can it continue relentlessly to raise prices whatever the quality of the vintage, at least not without harming its long-term reputation and prestige. But the old ways are slowly changing and, if she and Gonzague Lurton are typical of the next generation coming to the fore in Bordeaux, then the region should enjoy a secure and lustrous future.

# The $\mathscr{F}$ALLER family

$\mathscr{N}$ear the village of Kaysersberg, a walled vineyard surrounds a handsome old manor house that dates from 1724. The house is approached along a short drive which is lined with rose bushes and crosses a bridge traversing the stream known as the Weinbach, from which the domaine takes its name. The house was a convent until the French Revolution, when it was secularised and sold to a lawyer from Colmar.

Visitors to the domaine are ushered into one of the many small panelled rooms in the front of the house and invited to take a seat at a table. Then, two or three at a time, wine bottles will be brought in by one of the Faller family and samples poured. Some of the rooms have two or three doors and, to the bewilderment of visitors not used to the time-honored system devised by the Fallers, a tasting here can take on overtones of a French farce, with people whizzing in and out of doors in unpredictable sequences.

Domaine Weinbach has been in the hands of the Faller family since 1898. It was run for many years by Théo Faller, until his untimely death in 1979. Ever since the property has been managed by his widow Colette and her two daughters, Cathérine and Laurence. Cathérine takes care of most administrative and commercial matters, while Laurence is the winemaker. Colette is usually around to look after clients, though one never quite knows which combination of the delightful family will be on hand to receive visitors.

The core of the domaine is the Clos des Capucins, the walled vineyard named after the monastic order that once owned the property. Planted on flat land, the Clos is not counted as a *Grand Cru* site, but,

since it is known to have been producing grapes since the ninth century, it has clearly enjoyed a fine reputation over the years. Monks usually knew what they were doing. The best vineyards, however, are the *Grands Crus* that are visible from the Clos. There is Schlossberg, with its elegant floral Rieslings; and Furstentum, which is ideal for Gewürztraminer.

Domaine Weinbach produces a confusing range of wines, most of them named after members of the family. Cuvée Théo always comes from the Clos. Cuvée Sainte Cathérine is made from late-picked grapes, though it is not a *vendange tardive*. Then there are the *Grand Cru* wines, such as Schlossberg, but there can also be a Schlossberg Sainte Cathérine. And so as not to leave anyone out, there is also a late-harvested Cuvée Laurence.

Laurence Faller, a very attractive young woman with a keen intellect, did not become the estate's winemaker out of a sense of family duty. 'I studied to be a chemical engineer at Toulouse, where they also had an oenology course. So I took that course after I finished my other studies. I passed the diploma and came back to Kaysersberg, where I have stayed ever since.'

In 1999 she took the decision to convert part of the estate to biodynamic cultivation. This somewhat mystical approach to grape farming has been fervently adopted by some of the greatest estates in France, including Leroy and Lafon in Burgundy and Deiss in Alsace. But Laurence is cautious. 'We have only converted seventeen of our fifty-seven acres to biodynamism. We'll take it slowly and see how it goes. The rest of our vineyards are organic anyway, so the differences aren't enormous. I find that in Alsace as a whole there is a move towards greater awareness of the importance of our soils.' Colette, who one might have expected to be more wary and conservative, has welcomed the decision to try biodynamism. 'Certainly. Anything that can improve quality is worth pursuing. There can be problems when the owners are keen on the system but can't persuade their vineyard workers to see the point of it. Fortunately our team were happy with the idea too.'

In Alsace there has always been a local tradition of producing late-harvest wines in outstanding vintages, and the best are known as

*Sélection de Grains Nobles (SGN)*, which, in theory at any rate, are picked grape by grape, selecting only fruit that has been attacked by noble rot. The result should be very sweet and unctuous. In 1989, a year that yielded SGNs of exceptional richness, the Fallers devised a new category for their very top wines in this bracket: *Quintessence.* Other Quintessence wines were subsequently produced in 1991 and in every vintage from 1994 to 1999, although not from all the permitted varieties. Quintessence from Gewürztraminer and Pinot Gris are more common than from Riesling, which doesn't reach the same high ripeness levels as easily as the other two varieties.

These sweet and costly rarities can be difficult to sell, and the domaine's reputation rests as much on its drier wines as its sweet ones. They have a wonderful elegance and even bottlings that have a hint of sweetness are usually balanced by a fine firm acidity that gives the wines their zest.

Somewhere on the estate is a small distillery, from which Laurence produces a range of fruit *eaux-de-vie* which, alas, I have never encountered, not even after a substantial Alsatian lunch in the enormous kitchen that extends through much of the rear of the house. Colette Faller recalls how, thirty years ago, winery workers would go to the hillside village of Bonhomme for lunch and then scour the woods nearby for wild raspberries that were subsequently distilled.

If some of the arcane arts of distillation are no longer practicable, there remains a satisfying and cogent blend of tradition and innovation at Weinbach. Enormous care is taken with harvesting, which explains why there are so many late-picked wines in the range. No cultivated yeasts are used during fermentation, which is allowed to take its time; some casks may still be gently bubbling away eight months after the harvest. And the wines are still bottled with one of the most distinctive labels of France, a label of such charm that it sometimes seems a shame to disturb the harmony of the package by ejecting the cork and pouring the wine. But the taste of the wine soon encourages one to put such foolish qualms aside.

# Egon MÜLLER

At the foot of one of the steepest hills you will ever see, the Scharzhofberg, stands the lovely faded yellow manor house of the Scharzhof. The hill is planted with one of the great vineyards of the Saar, a region that is almost too cool for viticulture. Yet on these steep slopes, Riesling, and Riesling alone, does ripen in most years, when it delivers an almost unequalled intensity of flavor.

Egon Müller, the latest of that name to make the wines at Scharzhof, is sure the hill was planted in Roman times, although there is no documentation to support it. 'We know that by 700 it was monastic property. But Scharzhof was unusual in that it consisted only of the vineyards,' Müller explains, 'and not of forests and farmland as well. So it must have been of outstanding quality to have been worth conserving on its own. By the time of the French Revolution this was part of Luxembourg, so in 1797 it was secularized by the French, at which time it was bought by my great-great-great grandfather. After he died it was subdivided among seven children, which is why there are multiple owners today. The house has always belonged to us, but the other buildings on the estate are the property of the Bishop of Trier.'

The original Scharzhofberg consisted of forty-five acres, but in 1971 it was expanded to sixty-seven. 'Some of the vineyards incorporated into the site were of good quality but not all of them. There's a band on top of the hill that isn't really first-rate.'

A visit to Scharzhof used to be a very formal occasion. Visitors were greeted at the door by Egon's father, a man of military bearing, who would lead one into a hallway decorated with antler hat-racks. Here some recent bottlings would be laid out on a table for sampling. Then

one was led into a salon and sat beside a small round table. Müller would sit down too for a good chat about wine, and occasionally rise to descend into the cellar, returning with ever more astonishing rarities. These are among the most costly wines in the world, but old Herr Müller seemed happy to keep raiding his own cellar if he found your company congenial.

His son Egon started working at the estate in 1985 and took over from his father in 1991. I asked him what was so special about the Scharzhofberg. 'It's a bit of a puzzle,' he replied with a smile. 'It's not a site that brings in grapes with exceptional ripeness levels, and it's very hard to put our finger on what its defining feature is, other than the fact that it has a deep subsoil. The exposition is good, and the site is steep, but that's true of other vineyards too. It must be a combination of factors. I'm convinced that *terroir* is behind the greatness of the site, but we can't always explain what that means. But even estates with substantial holdings in other parts of the Mosel as well as in Scharzhofberg admit that there is something special about the hill. We own just under one third, and I wish we had more. From a marketing point of view, it would make more sense if we had more wine to offer!'

Scharzhof's speciality has always been sweet wines, despite the unpromising climate. 'It may seem that we produce more than most other comparable properties,' says Müller, 'but we can only make them in outstanding vintages, and even then the quantity of TBA is unlikely to be more than two or three hundred litres. What usually happens is that we send our pickers into the vineyards with a basket, and attached to it is another small basket. Any botrytised grapes go into the smaller basket. On any day we'll have about forty pickers at work, and the result will be about one thousand litres of regular wine and fifty litres of botrytis wines. We can't really do the selective harvesting you find in Sauternes, because our vintage starts so much later than in Bordeaux. Often we only start picking in late October or November, so it's only a matter of time before the bad weather arrives and ends the harvest. So we're pressed for time. In 1989, 1997, and 1999 it rained at the end of the harvest, and any remaining botrytis-affected fruit had to go into our Kabinett or Spätlese wines, as the grapes had lost concentration and acidity by the time they were picked.'

Scharzhof acquired particular renown for its Eiswein, which was often picked in January. However, both Müllers, father and son, prefer Beerenauslese and TBA as styles of wine. 'Certainly Eiswein is easier to make. You don't need to select. You leave the grapes on the vine until late in the hope of frost and then you pick them. We leave the same parcels every year, close to the house on lower slopes where frost is more likely and where the grapes can be easily picked. These are also ungrafted vines, which are stronger and resist botrytis better.'

The top wines are almost impossible to find, since they are sold at German auctions, a traditional showcase for outstanding wines. 'I find this a satisfactory method because the quantities are so small,' says Müller. 'In 1999 I thought of selling one of our sweet wines through traditional outlets, but when I broached the matter with our various importers it became clear that it would be more trouble than it was worth, and we would have to allocate so severely that we would annoy more people than we could satisfy. At auction, the people who really want our wines have a chance to acquire them.'

Egon Junior used to be exceedingly reserved and shy, but a recent marriage and full responsibility for the estate has caused him to blossom. Like other top producers he laments the poor reputation of German wines. 'But at long last I think Riesling is coming back into fashion. When I was in New York recently I realised that when it comes to Riesling, the leader is no longer Germany but Alsace. When people think of great Riesling they think more of Clos St Hune than of the top German sites. It's partly because there are bad associations with German wines – a long-term problem related to the poor quality of German mass-market wines – and because most German estates are very small, so we can't make the kind of international impact of a top Alsace property. In Germany we have great estates and we also have bulk producers and cooperatives. What we lack is the medium-size négociant that can market a reasonable quantity of wine of good quality.'

None the less he has no difficulty selling his wines, which, along with those from neighboring estates such as Maximin Grünhaus and Karthäuserhof, are the most exquisite of all Rieslings, and who could ask for more than that.

*Overleaf. A wine growing region at Wiltingen in Germany's Saar valley.*

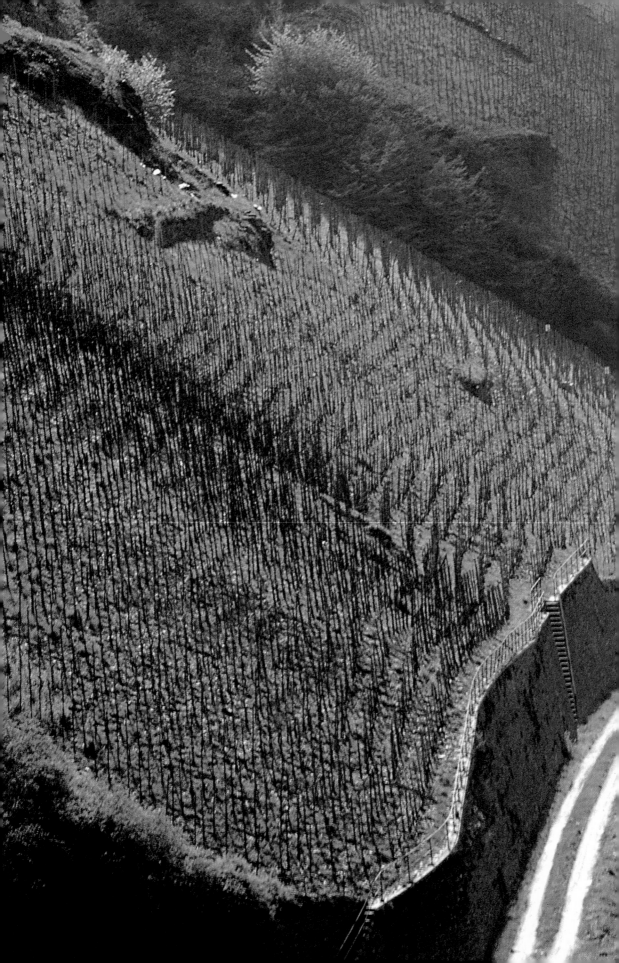

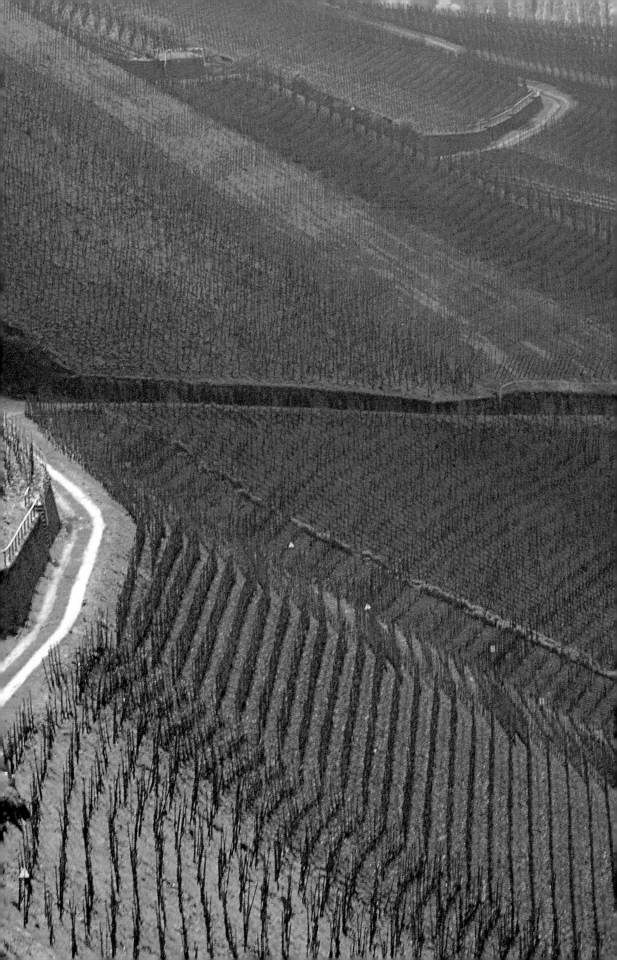

# Robert *Mondavi*

Even Robert Mondavi admits he can't be an easy man to live with. From his earliest years he has been driven to do better, to excel. He persuaded his father Cesare Mondavi to buy the historic Krug winery back in 1943, but many years later, when his obsessive quest for quality jarred against his brother Peter's more cautious approach, there was an acrimonious parting of the ways. A ten-year legal battle ensued. That didn't stop Bob Mondavi, already aged fifty-three, from taking the most enormous gamble by setting up his own winery in the heart of Napa Valley in 1966. By then he had already shown himself to be an innovator, having toured France in order to come to grips with the mysteries of oak barrels, at that time poorly understood in California.

Two years later he was running out of money, so he forged an alliance with the Rainier Brewing Company in Seattle and, when the law suit with his brother was settled in his favor, he bought back the winery outright from the brewers. He has never looked back. Robert Mondavi is such a familiar god in the California pantheon that there is a slight tendency to take his amazing achievements for granted. For a start, he has made many great wines, such as the Reserve Cabernets of the 1970s and, more recently, some of the Reserve Pinot Noirs. He created a completely new style of wine in his Fumé Blanc, an oaked Sauvignon that proved enormously successful. He formed a partnership with Baron Philippe de Rothschild to create Opus One, a unique fusion of Pauillac and Oakville. He returned to his roots to establish a mass-production winery in Woodbridge near Lodi, where he now turns out six million cases annually of sound and inexpensive wine.

Then there are the educational enterprises, the sophisticated winery tours, the insistence on the cultural and health benefits of moderate wine consumption, the campaigns against the neo-Prohibitionists, and now the latest gleam in his eye is the American Center for Wine, Food and the Arts he is establishing in Napa.

For some years Mondavi has been in expansionist mood, buying the Byron winery and extensive vineyards in Santa Barbara, developing a line of Mediterranean wines imported from France, and founding the La Famiglia range of Italian varietals. Since the company went public in 1993 there have been more joint ventures, in Chile, with the Frescobaldis in Tuscany, a share in Lodovico Antinori's Ornellaia winery, and the acquisition of Arrowood winery in Sonoma.

Bob Mondavi has been officially retired for many years, but he still keeps his office in the Spanish colonial style winery in Oakville. Now in his late eighties, his frenetic pace has been slightly slowed by back surgery, but the forceful, ever confident personality is unchanged. 'After my retirement I became chairman of the board. That means the directors have to hear me but then they can do what they want. But at last the family is working in harmony. Tim and Mike realise they need each other.' There was indeed a period when Mondavi's sons – the gentle Tim, a very gifted winemaker, and Michael, the suave, persuasive businessman – did not see eye to eye, especially under the relentless scrutiny of their perfectionist father, but now they do appear to have developed a modus vivendi.

'I always longed to have connections with the best wine regions of the world,' Mondavi confessed. 'I knew that it was the relatively cool-climate wines of Bordeaux and Burgundy that were among the greatest in the world. That's why I was keen on joint ventures with the top European producers. I don't want to change their indigenous styles, I just want to improve on them! What I like about the great European wines is their gentleness, their layers of flavor. I don't really like the blockbuster Californian Cabernets, but it's like classical or jazz, a matter of personal taste.'

The first contract with a European producer had been in 1970, when Baron Philippe made his initial approach to Mondavi in the hope that a joint venture with a Napa producer would result. It should be

recalled that in 1970 the Robert Mondavi winery was a mere four years old! Nothing materialized at that meeting, but the two men met again some years later in Hawaii. 'The Baron was there in casual clothes and called me "Bob" as though we were old friends. But we still couldn't think of a practical way to work together. But in 1978 it all came together. I went over to stay with him at Mouton. I was with my daughter Marcia and he was there with Joan Littlewood and his general manager Philippe Cottin. At dinner nothing was said about any joint venture, but we drank some amazing wines. Then in the morning he asked me to come to his bedroom, which is where he usually conducted business in the mornings, and that's when he proposed a fifty-fifty venture. We agreed to make just one wine, with the aim of one day having specific vineyards and a specific winery. All the time we were talking I could tell the Baron was testing me, but he never violated the agreements we made.'

Despite the lustre of Opus One, it is as a Californian wine man that Bob Mondavi will be remembered. He toured the world, pitting his own wines against the best of Europe in blind tastings, urging us all to take California seriously. Events such as Steven Spurrier's 'Judgment of Paris' tasting in 1976, when Californian entries from Chateau Montelena and Stag's Leap trounced the great wines of Bordeaux and Burgundy, were PR triumphs for California, but behind that success was the infectious determination of Bob Mondavi to keep doing better.

It is a winning paradox that this most competitive of men is also immensely generous. The results of the immense and costly research programmes at Mondavi, especially into all the nuances of oak-ageing, were shared with all those who cared to understand them. Mondavi knew from the start that if California were to become a player on the world wine market then overall standards of viticulture and winemaking needed to be raised. The progress has been astonishing, but I suspect Bob Mondavi still thinks there is much to be done.

# WINE CREATORS

## Bruno *P*AILLARD

*I*n most countries, if you want to make wine, it's not that difficult. You can purchase some grapes and get on with it. But in the Champagne district they used to operate by other rules. Your right to buy grapes depended on your sales of bottled champagnes. If you wanted to start up as a new producer, you had, by definition, no sales. Therefore you were not entitled to buy grapes. That was the situation in which young Bruno Paillard found himself when he had the audacity to create the first new champagne house in decades.

He grew up in Bouzy, where his father was a grower and broker, so he understood the system. It seemed natural for Bruno to join his father's company. 'Working for my father gave me many contacts and a good knowledge of the market, as well as developing my skills as a taster. But the job was also frustrating because as a broker I couldn't participate in actually creating the product. So I was dissatisfied from an intellectual point of view, although I was earning a good living. I decided what I really wanted to do with my life was create champagnes. There was an aesthetic motivation too: I wanted to make wines that were beautiful.

'My father was extremely upset when in 1984 I told him I was leaving the family firm. He gave me no money, no help of any kind. But I knew what I wanted to do. I had a firm awareness of the strengths and weaknesses of the major champagne houses, in terms of the quality of their wines and their marketing. As a new producer I had to break with some traditions. For instance, ours was the first air-conditioned cellar above ground. There is no real need to have underground cellars that are humid and old-fashioned and plagued with bad wiring.

None of my innovations has been made at the expense of quality, however. But I reject the confusion of quality with folklore.'

There was no point being a champagne producer with no wine to offer. Unable to buy grapes, he had to buy finished wines (*sur lattes*) from other producers. This is a time-honored, if dubious, custom in the Champagne region, and many large houses supplement their own production by buying *sur lattes*, often from cooperatives, and slapping their own label on the bottles. Bruno Paillard had no alternative other than to buy finished wines, but also bought costly reserve wines; all these bottles were sold under a second label. At least he was now established as a producer in his own right and thus had the right to buy grapes in future. 'I was lucky, as I knew many growers and the family name was well respected. I became one of only two successful new champagne producers in recent decades, the other being Vranken. Today I own seven acres in Oger, but my main source is 270 acres in thirty-two villages from which I contract to buy the production.'

Having secured his sources of grapes, Paillard needed to find ways to make his mark in a crowded market. The most important was quality, and it was soon recognized that his champagnes were excellent. He introduced a specially shaped bottle, not just as a marketing device but to demonstrate that none of his wines, apart from his earliest years when he had no choice, were bought *sur lattes*. He also introduced back labels, specifying the grape varieties used and the date of disgorgement. In addition, 'each case we ship contains a leaflet giving my views on how the champagne will evolve. When I started doing this I was astonished by the criticisms levelled against me, on the grounds that the consumer doesn't understand all this information. In which case, I'd have thought, no harm could be done by giving it anyway. But I want to be as informative and transparent as possible and in the near future I think most serious producers will be doing the same.'

It was one thing to establish a reputation for quality, quite another to signal to consumers the style of champagne that would be encountered in the glass. For Bruno Paillard, finesse is the hallmark. 'The strength of champagne lies not in its grape varieties or in winemaking techniques, but in the weakness of the soil and the ungenerous climate. The greatness of Champagne is our ability to extract

from these conditions wines of wonderful elegance. I like elegance above all, as opposed to very rich wines. It's elegance that makes Champagne unique. I was after pure natural wines that reflect the soil rather than *dosage*, which is nothing more than added sugar. I do the blending myself, assisted by a team that fully understand what I am looking for. But of course it took me a few years to establish and fine-tune my style.'

By Champagne standards, Paillard is a minor player in terms of volume, producing around 50,000 cases annually. There is no way he can match the major houses' advertising budgets, and he doesn't try. 'I market my champagnes not so much by advertising as by holding tastings for professionals such as sommeliers, and occasionally for top customers and importers. In Britain we are the official champagne for Ascot and the Orient Express. Early in 2000 we hired the great chef Joel Robuchon, who cooks for small parties twice a month to which we invite special guests here or in other countries.' Robuchon will be heavily involved in displaying the merits of Paillard's super-luxury champagne, Ne Plus Ultra, a blend of seven *Grand Cru* vineyards from the 1990 vintage, barrel-fermented and aged for eight years before disgorgement.

Bruno Paillard has other enterprises, notably a company called BCC which has in recent years invested substantially in champagne houses such as Chanoine, Boizel, and Philipponnat. Philipponnat is a feather in his cap, since it owns one of the great single vineyards in the region, the very steep Clos des Goisses. And there is a small property in the Var in Provence, which doubles as a wine estate and holiday home.

Bruno Paillard's achievement is remarkable, founding, against all the odds established by an entrenched industry, a new champagne house of excellent quality. With his tall handsome figure, his calm self-confidence, and his eagerness to do things his own way because he is convinced it is a better way, he has made his mark and a won over a loyal band of champagne drinkers.

*Overleaf. Limestone cellars*
*age Veuve Cliquot in France's*
*Champagne district.*

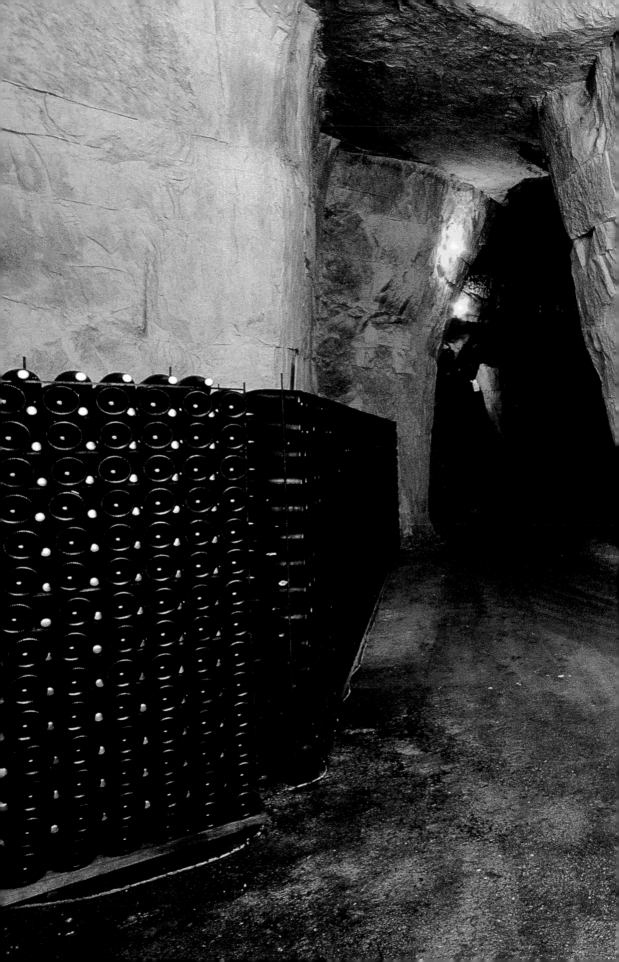

CR...
JANOT GEORG
CAVISTE
45 ANNÉES DE PRÉSENCE A LA MAISON
1945_1989

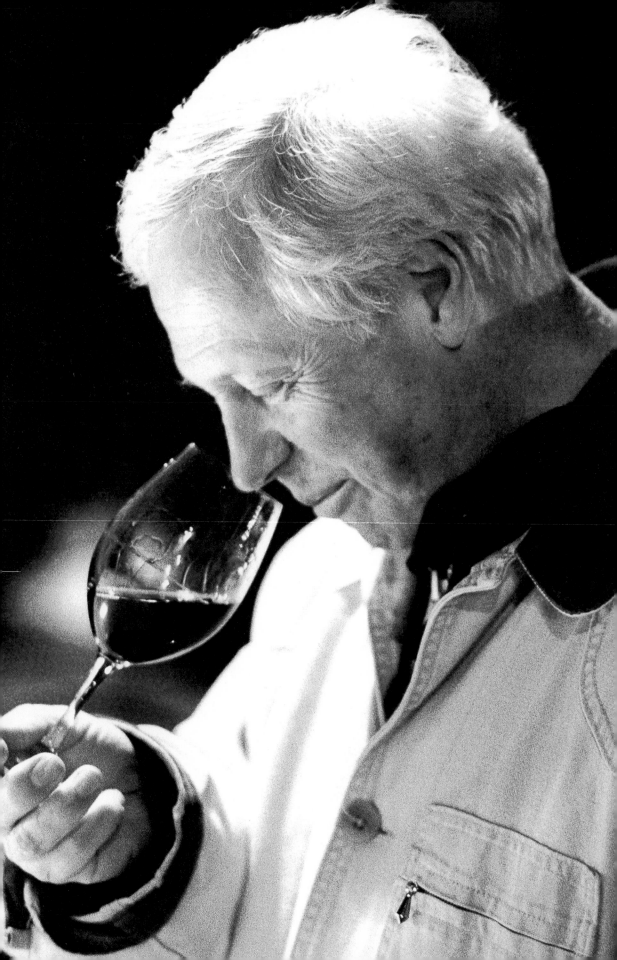

# Jacques SEYSSES

*L*ouis Seysses, a biscuit manufacturer, was also president of a gastronomic club in Paris, so his son Jacques grew up on exquisite food and fine wine. Inevitably he was gradually drawn into considering wine as a profession, despite, or perhaps because of, his first career in banking. 'I wanted to live in the country, so I pondered three professional options: horse-breeding, cheesemaking, and winemaking. Then I realised cows need to be milked twice a day, I knew nothing about horses, and vines only need to be harvested once a year.'

So wine it was. Thanks to his father's contacts in Burgundy, he found a domaine for sale in Morey St Denis. In 1967 he bought it and Domaine Dujac was born. It has very gradually been expanded to thirty acres, with parcels in *Grands Crus* such as Bonnes Mares, Charmes Chambertin and Clos de la Roche. Right from the start this newcomer made excellent wines.

'Partly it was luck. But also I had a good idea from the start. I had been exposed to great Burgundies from the 1930s to the 1950s, thanks to my father. In those days there were no oenologists, no one knew about malolactic fermentation – which often took place in the bottle, like the 1961 Romanée-Conti. While still working for the bank, I spent my evenings studying oenology texts. I also did the harvest at Pousse d'Or and visited all the top domaines of Burgundy. At Pousse d'Or Gérard Potel showed me how to select and sort the grapes and taught me that cleanliness was essential. I also talked to the older guys in the region. It soon became clear to me that the secret was minimal intervention. In those days some growers blended in strong wines from the south or Algeria to deepen the color, but I was happy to

accept lighter color and less alcohol. My thinking was based on logic. The old wines were good because they were left alone, left to develop the natural way.'

Thirty years later Jacques Seysses, although still in his fifties, has become something of a father figure for many of the region's best winemakers. Almost every Australian winemaker of distinction has assisted Jacques during the vintage in an attempt to fathom the mysteries of Pinot Noir. Early on he helped found a tasting group, a previously unheard-of notion, and invited other growers to come and taste in his cellars. 'I recall in about 1972 inviting Guy Roulot, Aubert de Villaine of Domaine de la Romanée-Conti and others to taste some white wines here, blind. We had DRC Montrachet and Laguiche Montrachet, a white from Gouges, and a Pouilly from Ferret and three Californian wines. Meetings such as this changed relations between growers and we started visiting each others' cellars and sharing our experiences. After all, wine is convivial. But this all took place spontaneously, it wasn't planned. In addition I actually enjoy talking to younger people. I've had a close bond with growers like Dominique Lafon and Christophe Roumier because they share my passion, and it's become a two-way thing. If I'm unhappy about how one of my Meursaults is developing I will ask Dominique for his advice. Among us there is no sense that winemaking is a secretive business.'

Jacques Seysses is continually experimenting, exploring, among other issues, his own practice of retaining stems during fermentation, and the Bordeaux practice of heating the must to high temperatures at the end of fermentation. 'We're always trying out new ideas. But I see oenology as a doctor, a way of coming to the rescue when something goes wrong. I don't accept the New World view that sophisticated techniques are necessary to make good wine. You don't take pills if you're healthy, after all, and that is why I try to manipulate our wines as little as possible.'

There are always new ventures at Dujac. His celebrated vineyard manager Christophe Morin is constantly devising ways to improve fruit quality, even persuading Jacques, after a 1991 hailstorm, to hire seventeen workers to go through the vineyards eliminating affected berries with tweezers. Although the estate is run on essentially organ-

ic lines, Jacques has resisted the lure of biodynamism, based on the teachings of the late Rudolph Steiner. 'I just don't like the idea of gurus, of being tied to a system.' He has always produced some white wine from his vineyards, but now he has planted a better site high on the slopes above Morey St Denis, from which he hopes to make that Burgundian rarity, an unchaptalised white. He is also co-owner, with Aubert de Villaine, of Domaine de Triennes in Provence, which allows him to try his hand at varieties such as Viognier, Merlot, and Syrah.

The Dujac wines are very distinctive and do not always win the highest praise from the wine press. This is probably because they tend to be light in color and are less extracted and dense than many wines from even more fashionable estates. Their apparent lightness has no effect on their ageing potential and distant vintages such as 1969 are still very much alive. They are balanced and they are elegant. Jacques is unmoved by criticisms launched in his direction. 'There are two trends in Burgundy: balance and extraction. I don't like too much emphasis on extraction, which gives Bordeaux-style wines at the expense of charm and finesse, although there are some excellent wines in an extracted style. My wines are never going to be blockbusters.

'There are three kinds of people at work in Burgundy. There are those, such as myself and Roumier and Lafon and many others, who have confidence in what they are doing and aren't going to be influenced by what wine critics such as Robert Parker or Michel Bettane say. We may smart at criticism but we won't change our ways. The second group consists of those who lack confidence, who need to lean on an oenologist who will tell them what to do and reassure them. The third group is largely composed of those starting out by bottling their production. These people are prepared to change their ideas on winemaking according to what Bettane or others may advise. Bettane likes to make discoveries, and he happens to like dark tannic wines. Inevitably, when a critic is tasting 100 or 150 wines per day, the powerful ones are going to make the strongest impression.

'But it's a mistake to take all this too seriously. Some winemakers become big-headed and think they are changing the world. But I'm not an artist, I'm just trying to make good wine.'

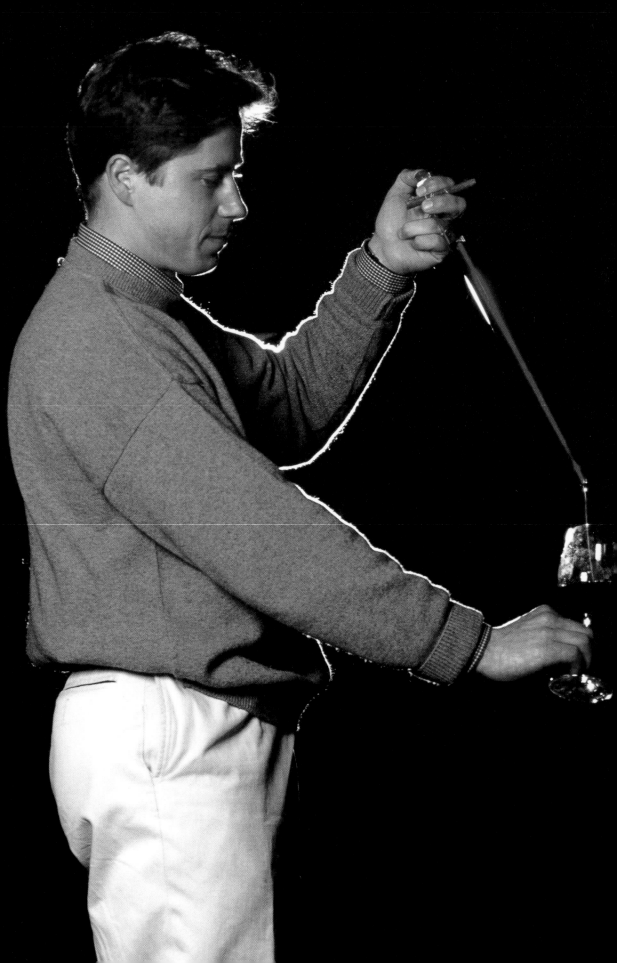

# Henri and Eric
## de Saint Victor

—

omte Henri de St Victor is the most skilful flatterer I know. Whenever I arrive at his beautiful Château de Pibarnon in Bandol, he introduces me to anyone else present as a paragon of journalistic virtues and accomplishments. One forgives him the shameless flattery because his enthusiasm – for his wines, his family, his property, for life itself – seems so unquenchable.

It's easy to picture the scene when Henri tasted the 1975 vintage of Pibarnon at a restaurant. Bowled over, he decided to try to buy the property. He and his wife Catherine came here in 1978, and what they eventually bought was a few acres of vineyards, the highest in the region, and a boxy stone house, which Catherine has transformed into a lovely manor. From its terraces there are ravishing views, not just on to the much expanded vineyards, which mostly lie in an amphitheatre bowl beneath the house, but on to the Mediterranean, which lies some four miles away.

Of Norman origin, the St Victors lived for many years in Paris, where Henri pursued a career in pharmaceuticals. Then, like so many before him, he had the itch to move south and make wine. At first he thought of Bordeaux, but vineyards were too expensive and Catherine found the thought of the Atlantic shore uncongenial. She wanted, says Henri, 'somewhere with old stones.' And then they tasted the Provençal wine from Pibarnon.

'The previous owner made the wine in a bizarre way,' recalls their son Eric. 'He would fill the tank with lesser grapes, bleed it for rosé, then keep adding more and bleeding more. What was left in the tank was the red, and it was massive. My father got to know the owner,

who kept complaining about the property and how difficult it was to sell the wine. So my father said that he would be glad to take it off his hands. That of course made the owner wonder why this fifty-year-old Parisian with no experience of winemaking was keen to take on the estate. But despite his suspicions he kept his word and sold it to my father.'

'It was my passion to create a domaine,' interrupts Henri. 'We felt like pioneers coming here and for four years we did everything ourselves without any help.' Once in possession of the domaine, he began bulldozing hillsides to plant new terraced vineyards on the triassic limestone soil that he was convinced would give great wine. Then six months later the whole hillside near the house collapsed after a storm.

'What happened,' says Eric, 'was that a spring that no one knew about – or we didn't – filled up and overflowed. Fortunately this happened a few days before we were going to plant the slope, rather than just after. So we were able to drain the slope properly. And in the meantime my father rented other vineyards and land he could plant.'

But Henri had never made wine in his life. He shrugs: 'To my surprise I discovered it wasn't difficult. A local oenologist came along one day and showed me what to do. Fortunately winemaking is a natural process and the winemaker's task is to make corrections when anything starts to go wrong. In Bordeaux every owner has a *maître de chai* who looks after the winemaking. But here everyone goes their own way. My first wine in 1978 won lots of medals. Now that I knew about winemaking, it took me all of fifteen minutes to teach Eric what to do. We found that the problem was that Bandol was associated with easygoing Mediterranean wines and we had to change this image. Our American importers got round the problem by describing our wines as the Bordeaux of the Riviera!'

That's quite an apt description, since the wines of Pibarnon combine elegance with longevity. The Bandol region is dominated by the Mourvèdre grape, which can give tough tannic wines; in ripe years, however, it produces wines with majestic fruit and a capacity to age for twenty years or more, gaining a leathery, smoky complexity. Many Bandols are harsh and rustic, but not Pibarnon, which is always supple and sexy. Henri de St Victor attributes the special char-

acter of Pibarnon to the altitude of the vineyards and the predominantly limestone soil, which gives wines of more elegance than those produced from granite and other soils elsewhere in Bandol.

Making fine wine is one thing; selling it quite another. Henri recalls: 'Our first customer was the owner of the Castel Lumière restaurant nearby at Castellet. People would go there for Sunday lunch and he would recommend our wine, and after lunch he would tell them to drive over to see us. So we had a lot of customers on Sunday afternoons.' Catherine adds: 'And that taught me that I had to be around the whole time to greet visitors.'

Eric tells with some glee how a magazine invited him to submit a bottle as a ringer in a Bordeaux blind tasting. So his 1993 went in with a wide range of 1993 clarets. 'As we began the tasting I thought of our poor little Mourvèdre up against all those Bordeaux top growths. At a certain point I thought I recognized Pibarnon. I snuck a look at my neighbor's notes and saw him scribbling: Latour. I still wrote down Pibarnon. At the end, but before the wines' identities were revealed, there was a discussion among the tasters and the general view was that the wine I thought was Pibarnon was among the most impressive, along with what turned out to be Haut-Brion. It turned out I was right in spotting our wine.'

The red wine is what Pibarnon is best known for, but it also releases a delicious rosé and a lovely white, best drunk young, from a wide range of grape varieties. Despite the vogue for new oak, the St Victors age their reds in large casks and bottle them without fining or filtration. 'Actually,' says Henri, 'we experiment with *barriques* every year, trying wood from different French forests and barrels of different sizes. We talk constantly about how they will evolve, but they never come on to the market. We're just amusing ourselves.'

Indeed, Henri seems constantly amused. He must be in his seventies now, but still has an almost childlike excitement. This is a man who is bent on having fun. And what could be more pleasurable than creating and inhabiting a ravishing estate above the Mediterranean shore and producing an acclaimed wine? Long may the fun continue.

# Jim CLENDENEN

*I*n certain London restaurants you can find a wine called Wild Boy Chardonnay. It comes from Santa Barbara and features on the label a Medusa-like apparition, a man with long flowing locks. This is a portrait of Jim Clendenen, who makes the wine. He's as sophisticated a winemaker as you will find in California, but still clings to his caveman image.

Jim Clendenen may look like a reformed convict making a name for himself on the rodeo circuit, but he just happens to be one of the few Californian masters of Burgundian-style winemaking. One day we met at a roadhouse near Monterey which was thronged by rodeo artists on their way to a county fair to practise their bizarre art. Jim took one look at the place and headed off to find a more serious restaurant.

As a young man Clendenen was intended for the law, this being the family profession, but a stint working in a restaurant and a visit to Bordeaux convinced him that wine was more interesting than the law. (At about the same time Robert Parker was coming independently to the same conclusion.) He returned to France, visiting Champagne and Burgundy. 'In Burgundy I found people who were essentially farmers, with simple cellars under their house. They had no technology to speak of, but they were getting very good prices for their wines. I was fascinated.'

Soon after, in 1978, he picked up a winemaking job at Zaca Mesa in Santa Ynez Valley and stayed there until 1980. He had had no training as a winemaker but was hired anyway. 'You can pick up the basic chemistry and the technology in a few days, so the lack of formal

training didn't matter.' In 1981 he managed to work three harvests: one in Hunter Valley near Sydney, a second in Goulborn Valley in Victoria, and then back to Europe to help out at the Duc de Magenta estate in Burgundy. On this visit to Burgundy he met Becky Wasserman, an American who acts as a go-between connecting many top growers with importers, and he was hired to catalogue her growers. He soon got to meet and know dozens of the top winemakers of Burgundy.

Back in California, he set up Au Bon Climat in 1982 in a partnership with Adam Tolmach, whom he had met at Zaca Mesa. They shared the winemaking in a shed in Santa Maria Valley until the partnership split up in 1990. By then the winery had gained a fine reputation for Chardonnay and Pinot Noir. Since they couldn't afford much hi-tech equipment, they furnished their winery with secondhand materials and adopted an artisanal approach. Clendenen and Tolmach made their wines in open-top fermenters and punched down the cap, standard Burgundian practices that were virtually unknown in California at that time. 'The majority of winemakers producing Chardonnay in California avoided malolactic fermentation, but we just allowed the malo to happen and kept racking to a minimum. We barrel-fermented all our whites at a time when many other wineries were fermenting in steel before putting the wine into barrels. In the early years we made some mistakes, such as retaining stems for our Pinot Noir, so the wines were tough, but we soon learnt our lesson.'

Jim bought in grapes from the top vineyards of Santa Barbara, and soon started planting his own. He launched other labels too, such as Il Podere, which focused on often obscure Italian varietals such as Fiano, Freisa, and Tocai Friulano, as well as Barbera and Aleatico. Together with Bob Lindquist, he founded Vita Nova, a label for Sauvignon Blanc, a red Bordeaux blend, Sangiovese, and Chardonnay, operating out of the Au Bon Climat facilities. Quality has been somewhat inconsistent and Jim has shown a more certain touch at Au Bon Climat.

Over the decades Jim has remained faithful to the Burgundian model, disliking the ultra-oaky, high-alcohol wines that are fashionable in California. He wants elegance and length of flavor, and likes a firm acidic structure in his wines. Nor is he besotted by new oak and

the oakiness of any wine is stylishly integrated. Yet he feels irritated that his fine and consistent Chardonnays and Pinots have rarely won the ecstatic acclaim accorded to wines that to his taste are overblown and a touch garish.

'So in 1996 I created a Chardonnay called Nuits Blanches,' explained Jim, pouring me a glass. 'It takes its name from the long nights I spent wondering whether I should actually make this wine. My usual Chardonnay goes for elegance and longevity, not thick textures and lush buttery fruit. I got fed up when American wine writers told me I was making wines in the wrong style. I wanted to follow my own path, not theirs. I suppose I decided to make Nuits Blanches to get up Robert Parker's nose. Parker knows it, and scores it low.

'I wanted to show that I was making a leaner style of Chardonnay because that was my choice, not because I was incompetent. So with Nuits Blanches I made a wine from grapes I picked weeks later than for my regular Chardonnays. It fermented to fifteen degrees, but is bone dry, and I aged it in two hundred percent new oak, decanting it from new oak barrels into other new oak barrels. I know you dislike it because of its high alcohol, and I don't like it either, though it's a wine that gives some immediate gratification. I released it at $40 not $25 and waited to see what happened. It has its following and gets high ratings from some tasters, so I keep making it. But I still don't like it and I'm sure it won't age particularly well.'

Jim is now concentrating on the vineyards. He did make many excellent wines in the early 1980s from mediocre clones planted in the wrong places. Now, with experience, he can improve his farming. 'As our new vineyards mature, we can eliminate some sources that are weaker, especially those we use for our regular Pinot Noir bottling. That's my ambition now, to improve further the quality of our Pinot. I was always impatient with attempts to compare our wines with those of Europe. How was it possible for us to compete, when most of our large vineyards in California were planted as a tax dodge with hardly any viticultural knowledge? But then I think of the progress we've made over the last twenty years, not only here but in Australia and New Zealand too, and I'm amazed. I think we are now getting closer to European standards.'

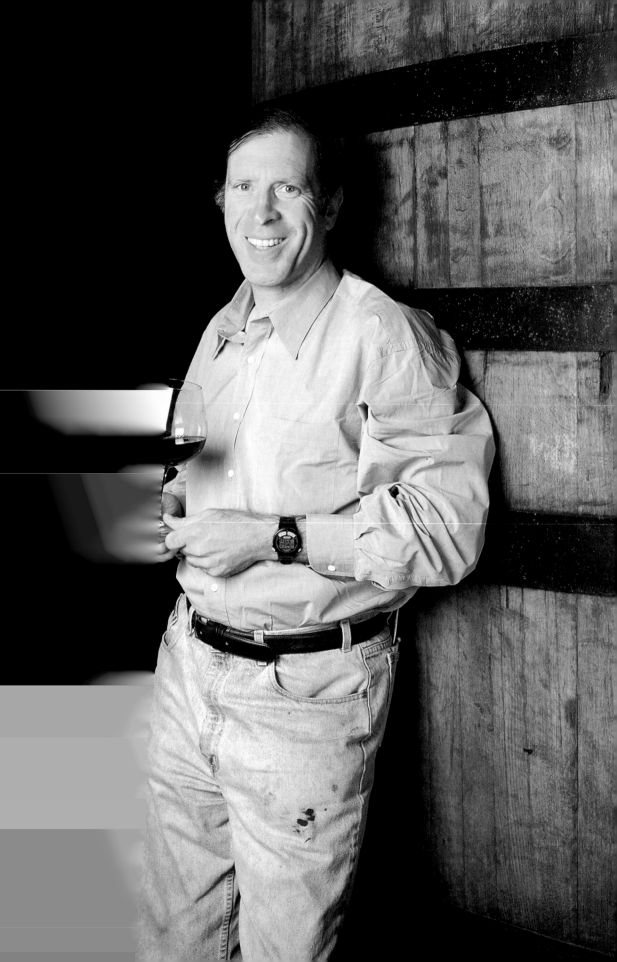

# Randall GRAHM

Randall Grahm is a quiet-spoken iconoclast who has challenged most of the conventional wisdom that infuses the Californian wine industry. His winery, Bonny Doon, produces no Cabernet or Chardonnay, and he is particularly scathing on the subject of what he calls 'Merlotmania'. He argues that California's balmy climate is better suited to Mediterranean varieties. Many of his wines are inexpensive crowd-pleasers, such as the Chianti-esque 'Il Fiasco', rather than high-priced limited-production bottlings from celebrated vineyards. Any suggestion that he delights in perversity is firmly rejected, however: 'All I'm trying to do is find the right marriage of grape variety and site. Certainly I consider that what I am doing is far less eccentric than, say, trying to make champagne-style wines in Napa Valley.'

He founded his winery in 1983 in the hippie-thronged backwaters of Santa Cruz. Previously he had worked in a wine shop in Beverley Hills, becoming a salesman and buyer. This gave him exposure to some of the great wines of the world and persuaded him that his future lay in winemaking. So he abandoned his philosophy studies, but then realised that he didn't know how to make wine. 'I wanted a more primal involvement. So I contacted fifty wineries offering to work for free, but none replied. The wine school at Davis wasn't interested either, but suggested I redo my science courses.' Eventually he did study at Davis, graduating in 1979. 'I still didn't have a clue how to make wine, or knew just about enough to be dangerous. But I thought I knew everything, especially about Pinot Noir. Indeed I started as a Pinot Noir acolyte, I was obsessed by it, and my heart was broken over and over again.' The clones he had imported from France

turned out to be unsuitable and despite his efforts at authenticity – Burgundian vine spacing, adding limestone to the soil – the results were not exciting.

The breakthrough came with his homage to the Rhône varieties: Cigare Volant, which nodded towards Châteauneuf-du-Pape, and Old Telegram, a splendid Mourvèdre. Randall had found a niche, or one of his niches, as a founding father of the so-called Rhône Rangers. It didn't take long for Randall to demonstrate that he also had a way with words. His inexpensive blend of Grenache and Mourvèdre was dubbed Grahm Crew, a nice pun on *Grand Cru*, and the label showed the wine-makers and his associates at sea in a small boat. In 1985 he began sending out his newsletters, which are avidly collected by many of the recipients. They consist of mock-erudite Joycean monologues and clever literary parodies (sometimes both, as in 'Cheninagin's Wake: James Juice Takes the Wine Train'), broadly gathered around the theme of wine in general and Bonny Doon in particular.

Although Grahm the winemaker has a welcome populist streak, Grahm the publicist is an unashamed literary show-off. Reading his Shakespearian 'Shall I compare thee to a Chardonnay? ' or 'The Love Song of J. Alfred Rootstock' with its haunting refrain: 'In the warehouse the salesmen come and go/Complaining about what is moving slow', it is tempting to suggest that Randall has missed his true calling.

Yet if the newsletters and witty labels have a streak of frivolity to them, Randall's underlying purpose is thoroughly serious. He dislikes any implication that he is an eccentric dilettante. 'I'm an empiricist. I want to do what works. If it doesn't work out, like my Pinot Noir, I won't pursue it. I'm not interested in novelty for its own sake. I want people to buy my wines because they like them.'

The engaging if sometimes infuriating thing about Randall Grahm is that he seems to find it hard to concentrate. There are certainly a handful of core wines such as Cigare Volant and the inexpensive Big House Red that are produced every year. But too many wines make a fleeting appearance on his list, then vanish as he loses or abandons a source of obscure grapes or succumbs to a new enthusiasm. Sometimes there's a juicy Charbono, or a Nebbiolo (magnums only) that is as good as anything made from this notoriously tricky variety

in California, or a *grappa di Moscato*. But one never quite knows from year to year what weird and wonderful bottles will emerge from Randall's winery.

Some have maintained that Randall Grahm is an inveterate experimenter, always tempted to try something new rather than repeat himself, a man more interested in shaking up the market than in exploring the nuances of *terroir* to make truly great wines. Randall shakes his head sadly: 'The suggestion that I am not interested in *terroir* is simply untrue. I dream about it every night, I'm desperate to make a great wine with *terroir* character. Those are the wines I buy and drink. I'm bored by New World wines, except that I have the same kind of morbid interest in them that one has in train wrecks. I'm looking at some older vineyards that have *terroir* character, but so many are Zinfandel and Petite Sirah, which I'm not interested in producing. I'd love to do an old-vine Sagrantino. Unfortunately it doesn't exist in California.'

Over lunch in an unpretentious Santa Cruz restaurant, we both marvelled at the 1993 Le Sophiste he had brought from the cellar, a dazzling Rhône-style blend of Roussanne and Marsanne. Then we moved on to a Madiran called 'Heart of Darkness' that he had made in southwest France and Randall shook his head with dismay. 'That wine is so amazing! We have to face it: California just can't produce wines with the character and verve of this Madiran.'

I pointed out that California is viticulturally young, but Randall looks as mournful as a bloodhound and sighs: 'But I only have one life and I don't want to wait a century. We still don't really know what we are doing in California. Who would have guessed that Rhône white varieties planted in unexceptional soil in Bonny Doon would produce the long-lived 1993 Sophiste we've just been drinking? There are no a priori rules!'

Which is what drives Randall Grahm to try new ideas, new wines, new jokes.

# Al ℬROUNSTEIN

*D*iamond Creek used to operate out of a couple of cramped rooms off the twisting road that leads up Diamond Mountain on the western side of Napa Valley. But on my latest visit in 2000 I found a sparkling, new high-ceilinged building above the vineyards; this contains the winery offices, a guest suite and tasting room. Waiting to greet me was the frail but effervescent figure of Al Brounstein, founder of Diamond Creek, now in his late seventies. Waving at the smart structure around us, he said laconically, 'Anyone would think we were a success.'

Of course Diamond Creek is a success, although Al insists that it took fifteen years from the founding of the estate in 1968 before he made a profit. Earlier in the 1960s he had been a sales representative for Sebastiani, the large Sonoma winery, and had learnt the craft of winemaking by taking courses in Los Angeles and by picking grapes at Ridge. Before buying land on Diamond Mountain, he talked to all the leading figures of the day – Jack Davies of Schrambsberg, Joe Heitz, André Tchelitscheff, and others – about where he should acquire land and plant vines. They recommended the area north of Rutherford, but Al was keen on this patch of jungle near Calistoga, and went ahead with the purchase.

Contacts at top estates in Bordeaux agreed to supply him with budwood, which they arranged to ship to Tijuana. Al had his own plane at the time and took various girlfriends with him on flights down to Tijuana. 'The customs people thought I was just a roué out for a good time, which is what I wanted them to think. But for me the flights were strictly business. We had some luggage and sports equipment in

the back, which were checked by customs. But what they didn't see were the cuttings between the luggage compartment and the fuselage.' The imports were of course illegal. However, his vineyards have proved healthy. 'One girlfriend said, after a successful run to Mexico, "That was fun. Next time let's bring in some marijuana." Needless to say, she wasn't invited again.'

From the start it was evident that the cleared land encompassed some very different soil types, which Al divided into separate parcels and named Volcanic Hill, Red Rock Terrace and Gravelly Meadow. Subsequently a tiny patch of vines near the man-made lake was set aside in successful vintages for the highly prized Lake bottling. All the wines were predominantly Cabernet Sauvignon, though he has been planting more Petit Verdot at the expense of Cabernet Franc and Merlot. So varied are the soils and microclimates that the harvest on this twenty-one acre property can take four weeks, and sometimes the cool Lake vineyard doesn't ripen at all – although when it does it gives the most intense Diamond Creek Cabernet of all, which explains its price tag of $300 per bottle. Red Rock Terrace is often the fruitiest of the wines, Volcanic Hill the most tannic. All show remarkable intensity of flavor. In some great years, such as 1991 and 1994, Al goes to an almost fanatical extreme by releasing separate 'microclimate' bottlings from parcels within each vineyard.

Not content with carving this superbly complex vineyard from very rough terrain, Al has also indulged his passion for landscape gardening. At the heart of the estate is the man-made lake with its frogs and catfish and pleasure boats. There are also two lovely rose gardens, but Al's pride and joy are his waterfalls. You stand with him on a wooded slope overlooking the lake, he throws a switch, and seconds later water is cascading down through the forest. There's another set near the offices which can be illuminated at night in different colors. He is clearly thrilled with what he has accomplished: 'Not bad for a poor boy from Minneapolis, don't you agree? When we have visitors couples sometimes wander off into the copse near the waterfalls, which is nice. I tell them it isn't Niagara, but we call it Viagara.'

A visit to Diamond Creek takes time, because the main point of any visit is to look at the vineyards, admire the roses, and gasp at Al's lat-

est water follies. The tour can take a while, because he has had Parkinson's Disease since 1983. 'The worst thing is I had to stop flying. That meant a lot to me. So I can't fly, I can't dance, but I can still sail my boat and canoe.' He can also drive his golf cart to get himself and his visitors around the estate. It doesn't seem to be equipped with very strong brakes. Al, sensing my slight alarm as we chugged back up the steep slope to the offices, chuckled: 'Bet you didn't think we were going to make it!'

The Diamond Creek Cabernets have their fervent admirers, despite their high price tags, but there are some who criticise their powerful tannins. Al admits that the early vintages did take twenty years to come round, but wines such as 1974 and 1976 are sensational and velvety now, and thus well worth the wait. In the 1990s the Diamond Creek tannins seem to have softened and the wines, without losing their dense character, are more approachable when young, though they remain quitessential long-lived Napa Cabernets. The wines are fermented in small open-top wooden vats and punched down by hand; after fermentation they are aged in French oak, fifty percent new, for up to twenty-two months. 'Our winemaking is as simple as could be. But you have to remember that Cabernet is a doll, a forgiving variety. Make a tiny mistake, like leaving the wine on the skins a touch too long, and it won't make a great difference. It's not like Pinot Noir. With Cabernet, all you have to do is get out of the way.'

Al has been irritated that some wine critics have accused him of resting on his laurels. 'Look at Volcanic Hill! I've replanted a whole section of the vineyard, and there's a new acre of Petit Verdot on a steep slope near the lake which is coming along nicely. So we're still investing, still trying to improve.' We went to take a look at the new Petit Verdot vineyard; it looked healthy and vigorous, so I remarked, 'Those are happy vines.' Al shot me an appreciative glance: 'What's even more important, this is a happy vine-owner.'

# Gian Annibale Rossi di Medelana Serafini Ferri

I t's easy to miss the entrance to the Terriccio estate: just two brick columns along the side of the coastal road that traverses the former marshes known as the Maremma. Here you turn into a long straight dusty lane, thoroughly shaded by flopping trees behind which you can make out vineyards on one side, olive groves on the other. Then the road curves into more open land, wheat fields mostly, and winds up towards the Borgo.

This hamlet is the engine room of this Tuscan estate. The winery is here, and the other farm buildings and offices. So is the private chapel, where Mass is still celebrated weekly by a priest in his nineties, and the solid eighteenth century house of the former owners, the Gaetani family. Beyond the mansion are the small stone houses of the estate workers. And peeking from the woodlands that rise above the Borgo are the bright pink walls of the Rossi house.

Signor Rossi di Medelana has been here since the mid-1970s. The 4,200 acre property was bought from a Prince Poniatowski by his mother's family in 1921. Initially Signor Rossi continued to work the estate as farming land, a hunting reserve, olive groves, and a horse-breeding center. He was an avid horseman and it was while training for the 1978 Olympics that he suffered a riding accident which has confined him to a wheelchair ever since. This handicap has, it's clear, had minimal impact on his energy or enterprise.

When he took over the property there was a wine estate a few miles to the south belonging to Marchese Mario Incisa della Rocchetta. Even thougt this was home to the legendary Sassiscaia wine, it was only in the 1980s that Rossi gave serious thought to planting vines at Terriccio.

'My great-grandfather had won medals for his wines in the nine-
teenth century, so wine was in my background. But when I thought
about producing wines here I decided I wanted to make French-style
wines. I obtained cuttings from a nursery in Dijon, which was able to
supply me with the Bordeaux varieties. We planted Cabernet
Sauvignon and Merlot, and also Sauvignon Blanc and Chardonnay.
And we had some Sangiovese too, which is the indigenous variety here
in Tuscany.

'Our first vintage was 1991, but it wasn't until 1993 that we had a
really good year. One of my wines was awarded "three glasses" in the
Gambero Rosso guide, which is the most influential in Italy, and when
we continued to receive excellent reviews for our wines I realised we
were on to a winner.'

Five wines are produced at Terriccio. The simplest is an unoaked
Sauvignon Blanc, Con Vento, and there are two Chardonnays – one
unoaked, the other, called Salluccio, fermented in French oak. Tassinaia
is an equal blend of Cabernet, Merlot, and Sangiovese, also aged in
French oak, and the star wine, Lupicaia, is mostly Cabernet Sauvignon.

'Tasters say they find a strong eucalyptus tone in our reds,' said
Rossi. 'What do you think?' But I couldn't detect it. We were sitting
on the terrace outside the pink house, between the villa itself and the
large indoor swimming pool. The views, down over the estate and
with the glistening Mediterranean in the distance, are tremendous. I
could hear the cook bustling noisily in the kitchen and very attractive
young women emerged from the house from time to time to cater to
the boss's requirements. Our conversation was broken by the stento-
rian snoring of a fat English bulldog that goes everywhere with his
master. The master himself is a stocky figure, approaching sixty years
old, with a soft gentle voice and a disarming manner. A man of great
charm and, one suspects, of great determination too. As he talks,
vignettes emerge from his past: hunting and dealing with horse deal-
ers in Ireland, the Roman hunt, an early spell as a jackaroo in
Tasmania....

Signor Rossi is not proposing to rest on his laurels. 'At present we
have ninety-nine acres of vineyards, though not all are yet in produc-
tion. We will probably plant some more, but I can't say how much

more. We planted some Petit Verdot in 1996, which is giving remarkable results, and Syrah from 1997 onwards. I plan to try other varieties too, perhaps Tannat or Mourvèdre, varieties that need a good deal of heat. I'd like to try Semillon too, though probably not for a sweet wine. We did try to make a late harvest wine from Chardonnay one year, but frankly it wasn't a success.

'I do like to experiment, and since the family properties are divided up between myself and my brother and sister I can do what I please here. I don't have to consult anybody or ask permission and that, I admit, is a great luxury these days. I do of course consult our oenologist, Dr Carlo Ferrini. These are early days for Terriccio as a wine estate. We don't know much about its soils or *terroir*, although I had the soils analysed anonymously in Bordeaux. Fortunately the lab reported very favourably on their quality.'

Indeed, it's early days for the Maremma as a whole. 'Here we haven't had the strict rules of Chianti. Everybody here did whatever they wanted and could act like explorers delving into their own ideas. This was always liberating to me and an advantage for the region. Chianti imposes constraints; we had none, and there were few other Italian wine regions where this was the case. It also helped that we had Sassicaia as a flagship.

'There is perhaps a danger that our image, which hitherto has been very positive, may be tarnished. Some large companies are moving in that are not known for their outstanding quality and there is a risk of mass production alongside the expensive wines for which the region is now known. So we need to identify the *crus*, so that we can distinguish between the mass-produced wines and those that are more individual. I'm not bothered about increased production from the Maremma, as long as the top wines maintain their quality.'

Rossi doesn't try to interfere with the finer points of winemaking. 'I do like to participate in the blending process of each of our wines, but I don't try to have the last word. My consultant oenologists know that they have to produce the kinds of wine I like, so it's their job to make the final decisions on ageing and blending. They have the right to decide what to do, and I' – here he paused to give me a winning smile – 'and I have the right to sack them if I am unhappy.'

*Overleaf. The Banfi castle dominates the vineyards of Montalcino in Tuscany.*

# Bernhard BREUER

The Rheingau, a relatively small region dominated by large aristocratic estates such as Schloss Johannisberg, was once as highly esteemed as any wine region in the world. A century ago its wines, especially those from celebrated vineyards such as Erbacher Marcobrunn, fetched prices exceeding to those charged by wine merchants for Lafite and Latour. Yet by the 1970s the renown of the region had faded and to this day, despite heroic efforts by some of its best producers, it lacks the lustre of other German wine regions such as the Mosel.

Bernhard Breuer was foremost among those anxious to restore the reputation of the region and for many years he worked closely with the grandee Graf Erwein Matuschka-Greiffenclau of Schloss Vollrads. Bernhard came from a wine-producing family in Rüdesheim on the banks of the Rhine, but was ejected from the nest at the tender age of sixteen and told to gain experience elsewhere in the world. So he went to Switzerland to learn French, studied in Montpellier and toured the French wine regions, and perfected his English working in New York for American Express. In 1965 he returned to the bosom of his family, and began working in the sales department of his father's négociant business, Scholl & Hillebrand. He was still only nineteen.

The business was not in good shape. Its main customers were small shops and restaurants, which were being absorbed by supermarkets and chains during the 1960s. Domestic sales shrank, but fortunately the company had a thriving export division. With his father suffering from poor health, Bernhard had to take on more and more responsibility, discovering as he did so the parlous financial condition of the business. He retrenched, selling off peripheral properties, and eventu-

ally sold Schloss & Hillebrand, while remaining its export director, which at least provided a steady income.

At the same time he started to expand the family estate of G. Breuer. For many years the production from its twelve acres had been blended in with the company's other wines. But they were good sites, and Bernhard bought judiciously to bring the domaine to its present sixty-two acres. Meanwhile his brother was running a large tourist restaurant in Rüdesheim, which provided an excellent outlet for the Breuer wines.

In 1983 Bernhard, together with Graf Matuschka and other leading Rheingau personalities, founded the Charta Association. 'It was intended to recreate the style that had made the Rheingau famous in the eighteenth and nineteenth centuries. I did extensive research that established that the best wines of the region were usually dry or off-dry. Sweet wines were only produced in exceptional vintages when botrytis attacked very ripe grapes in the vineyard.' Charta's members had to accept quality levels far more stringent than those required by the German wine law of 1971. Yields were lower, ripeness levels higher, and minimal acidity levels were also stipulated; a distinctive bottle was fashioned to help consumers identify this new family of wines.

Breuer and Matuschka promoted the Charta wines like mad. They took them on gastronomic roadshows through Europe and America. Three-day feasts were staged in the Rheingau modelled on the 'Trois Glorieuses' of Burgundy. Charta convincingly demonstrated that dryish Rheingau Riesling was an admirable match, somewhat akin to Chablis, to a wide range of dishes. Charta eventually made an impression on German restaurants, which hitherto had been quite Francophile, but the campaign flopped elsewhere. 'At least the international press came to understand that there was a quality-conscious movement within the Rheingau, though I admit we didn't succeed in bringing the masses back to Riesling.'

In the late 1990s Charta merged with VDP, a growers' association that also imposed strict standards on its members. The two associations were duplicating their efforts, which was a waste of resources. Both organizations believed that the way forward for the Rheingau was to devise a classification system that would identify its top vineyards. Estates would then use those names as *crus* for their best

Rieslings; wines from lesser sites would be bottled under a village name or as a generic estate Riesling. Bernhard Breuer was keen to press ahead, but Graf Matuschka was also president of the Rheingau wine-growers' association, which feared that some of its members, especially those that made excellent wine but not from outstanding sites, would be at a disadvantage. After many delays a classification was formally established in September 2000. But by this time Graf Matuschka was dead, having committed suicide after Schloss Vollrads had sunk ever deeper into a financial morass, and Breuer had resigned from the VDP, having failed in his effort to tighten the rules further.

'The new classification is truly bizarre. Some parcels of Rüdesheimer Schlossberg, my top vineyard, were not classified, and some of my vineyards that *were* classified were parcels that we use only for our generic Riesling! It's clear that the VDP wanted to maintain cordial relations with the winegrowers' association.'

None the less Bernhard continues to pursue his quest for quality, with a handful of wines from top sites identified on the label, as well as village wines and an estate Riesling. He produces one of Germany's best sparkling wines, and is trying to revive the reputation of Pinot Noir from Assmannshausen in the Rheingau. It seems that the lead in quality will come from a handful of small estates such as Breuer's, while most of the large aristocratic estates will play it safe.

'The Rheingau has a poor image, compared to the Mosel or Pfalz, because we have a different structure,' Breuer admits. 'In the Mosel there are many small estates run by well-known owners and by hered-itary cellarmasters. This gives a lot of continuity. Here in the Rheingau we have many large estates run not by the owners, but by administra-tors. By definition, administrators are not the kinds of people who take risks – by harvesting later, for example. In the Rheingau the state domaine owns five to six percent of the vineyards. Then there are absen-tee landlords of the large aristocratic estates that control about one quarter of production, which is enormous. So these big estates domi-nate the markets and tend to produce what those markets demand.'

Bernhard Breuer's far-sighted work with Charta showed what could be achieved. The next decade will show whether the region as a whole can build on that achievement or lapse back into mediocrity.

*Overleaf. The splendid Rhine*
*valley, home of many of*
*Germany's finest vintages, is seen*
*here at Assmanshausen.*

99

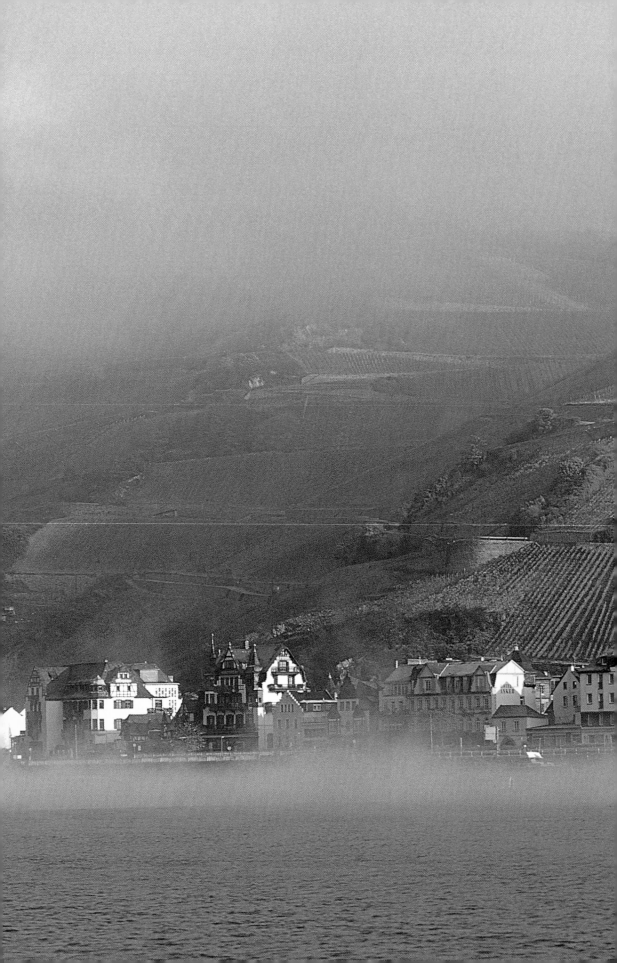

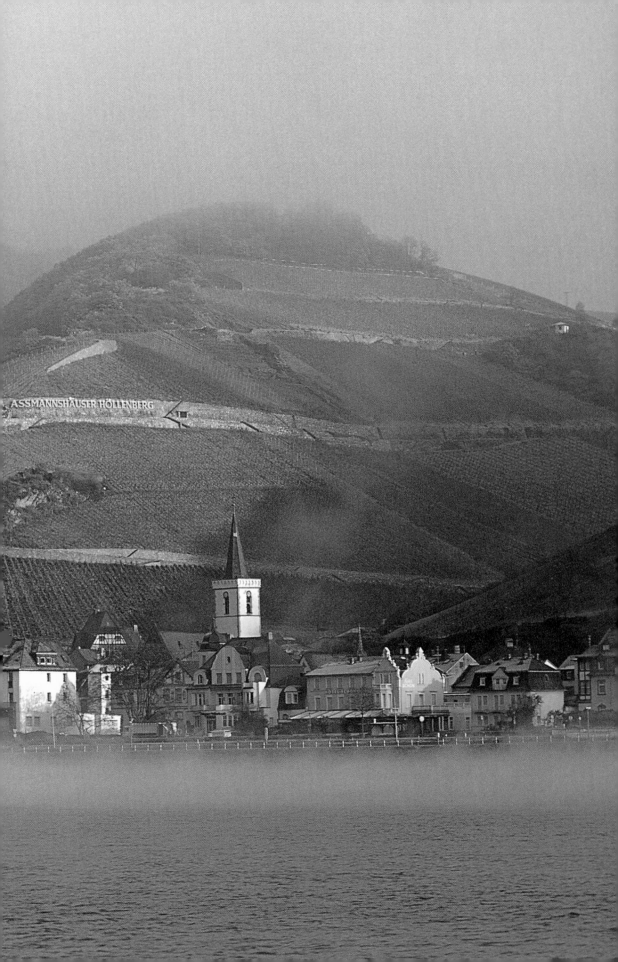

# Ernst LOOSEN

**M**any German estate owners seem content to sit in their mansions, quietly bemoaning the fact that the elegant wines they produce are resolutely out of fashion. Not Ernst Loosen, who leaps around the world banging the drum not only for his own wines but for Riesling in general. Although his St Johannishof in Bernkastel is a family estate, Ernst had a life before he took over the property in the 1980s. He was interested in archaeology and had no intention of being a full-time winemaker.

Nor had his father, which was a problem since he was at that time in charge of the property. But he was far more interested in politics than wine. As father and son did not get on, Ernst had no wish to become involved in running the family estate – until in 1983 his mother 'phoned to report that his father had been taken ill and would be unable to work for a considerable time to come. The estate was debt-ridden and his mother felt unable to take over its management unaided.

'The choice was simple: either I came home and took over running the place or we would have to sell. So I came back. But I needed help. Bernhard Schug was a schoolfriend of my older brother and at the time he was looking for a job, having worked in forestry. He was inde-pendent-minded and we got on well. So I took him on. The problem at the estate was that the staff had been there for twenty-five years, most of them, but they were impossible to control. So I had a major clash with our employees. They detested the idea of selections in the vineyard because it meant more work. But I knew from the start that I had to improve quality. I had always loved wines, collected them,

drunk them with friends. I knew that winemaking was essentially simple. You just had to follow some basic rules. What was crucial was to improve the quality of the grapes.

'Right in the middle of the 1987 harvest my entire staff walked out. So Bernie and I had no choice but to take over completely. I had two options: I could either apologise to my staff, in which they case they might return but I would never be able to control them. Or I could call their bluff and let them go. If I fired them I would have to pay a lot of compensation which we couldn't afford. But they had walked out, so I didn't have to pay them anything. Bernie and I decided to make a fresh start on our own. We talked everything over and in a sense learnt our winemaking as we went along.

'In 1988 I moved into the family home, the St Johannishof. At that time Bernie's marriage broke up, so he moved in too. So we really worked closely together and consulted on every detail, every barrel. By 1992 we really felt we knew what we were doing. Our palates developed together and we still work together, although after I married my wife Eva he moved out.'

Although Ernst soon made a reputation for himself, a process speeded up by the infectious enthusiasm he communicated to everyone he encountered, he was not out of the woods. 'It took a long time to get the business side sorted out. My father had sold almost everything to the US, but relied on just a few customers. Then the exchange rate shifted and our customers dried up. We were stuck with the 1986 and 1987 wines for a decade. The British market was small and we had no domestic market. So we had to start producing dry styles for the German market, using ripe green grapes at the end of the harvest. It worked, but we couldn't produce enough. It wasn't until 1993 that we could sell our entire harvest. We still make dry wines from old vines that have low yields and low acidity, and this represents about ten percent of our production. But there's no international market for them.'

Ernst passionately opposes many of the provisions in the 1971 German wine law that benefited the very large producers, but only at the cost of destroying the reputation of German wine as a whole. He likes to take visitors up into the magnificent steep vineyards of Erden and Urzig so that they can appreciate the extremely high costs of pro-

duction on these precipitous, low-yielding slopes; and he points across the river to flatter, mechanized vineyards that cost far less to cultivate and yield enormous crops, but also produce mediocre wines. To survive he needs not only to persuade wine writers and importers of the excellence of his wines, which he succeeded in doing years ago, but he must be able to charge high enough prices to sustain his costs of production.

Constrained by the limitations of the Mosel, he has been moving swiftly in various other directions. 'That's why I was keen in 1996 to take over the J.L. Wolf estate in the Pfalz, because there I could make dry Rieslings and Pinot Gris of high quality and with plenty of body. In the Mosel it is very difficult to make really good dry wines, but not in the Pfalz.'

He also struck up a partnership with the large Washington state winery, Chateau Ste Michelle. 'I was interested in this project because I believe strongly that if there is to be a revival of Riesling, it will come from the New World. The Old World is too stupid to revive Riesling; we are all too traditional, too jealous of each other to join forces. The Washington project proved an ideal joint venture because Bob Betz at Chateau Ste Michelle was keen to improve the quality of his Riesling; otherwise it wouldn't be viable to keep growing it. I found that Cold Creek and Horse Heaven vineyards had the most character, Horse Heaven for botrytis, Cold Creek for dry wines. Our first crop was in 1999 and we obtained an extremely sweet TBA by picking berry by berry. It was hard to persuade the vineyard workers that we had to pick these berries by hand – they had their harvesting machines all ready to go!'

With his dynamic approach, his willingness to travel far and wide to show his wines and talk about them, and his flamboyant waistcoats, Ernst Loosen has almost succeeded in putting German Rieslings back on the international map.

# Alois $\mathscr{K}$RACHER

*L*ike most other honest and conscientious Austrian wine-makers, Alois Kracher must have felt the roof had caved in when the glycol scandal broke in 1985. It is easy to make very sweet wines in the Burgenland region in eastern Austria, but hard to make them in Germany. So in the 1970s and 1980s German companies came looking to Austria for inexpensive sweet wines. Supply was unable to keep up with demand, so some Austrian producers took short cuts by adding chemicals to sweeten the wines artificially. By the 1980s the Burgenland was exporting four times as much 'Trockenbeerenauslese' as it could conceivably produce.

As scandals go, it was small beer. No one died; no one even fell ill. Only a handful of producers, almost all large companies, were implicated. Yet the consequences were devastating because it was common knowledge that this illegal doctoring had been going on and no one was prepared to blow the whistle. Overnight Austrian exports were wiped out. The conjunction of the words 'Austria' and 'wine' provoked smirks and chortles.

So it took amazing courage for Alois Kracher, and a very few other wine producers in the Burgenland, to decide that they were going to turn things around. He had been assisting his father at their Illmitz estate since 1981, but only took the helm in 1986. 'Even then I knew I could succeed. After all we had been making great wines around the Neusiedlersee for generations! I wasn't the only one who persevered. There were Seiler and Umathum and others, and eventually we tapped into a strong but overwhelmingly domestic market. There had to be a change of generations. Men like my father had a strictly local per-

spective. He had never tasted a Sauternes, for example. The international perspective in Austrian sweet wines would come later.'

It wasn't enough, though, to make fine sweet wines once again. Kracher had to sell them to an unreceptive international market. Very few Austrian winemakers travelled to the major wine fairs to pour their wines and talk about them. Kracher did, over and over again, and so did Willi Opitz. Whether at Vinitaly or the London Wine Trade Fair, these sharp-eyed gentlemen would haul in any passing importer or wine writer and hand them a glass or two of their ultra-rich wines.

Gradually the press, and some wine importers, began to take notice. There was no disputing the quality of the wines. The Neusiedlersee, a shallow lake whose shores are shared with Hungary, turns into a fog bank in autumn, and the alternation of humid misty mornings and hot dry afternoons provides perfect conditions for the development of botrytis (noble rot). All around the shoreline the vineyards succumb, allowing substantial quantities of sweet wines to be produced in most years. Not all of it was good. Yields were often too high and many wines lacked concentration. Kracher knew, however, that only by insisting on the highest quality could he draw attention to his wines and simultaneously help to restore the damaged reputation of the region.

His most impudent promotional effort was to organize a tasting in London at which his wines were pitted, blind, against leading Sauternes and other celebrated sweet wines. He even had the audacity to include two vintages of Yquem in the line-up. It wasn't really a fair contest, as the clean racy style of fine Austrian sweet wines makes them show more favorably when young than a fatter, oakier Sauternes. But Alois Kracher never intended to mount a beauty contest and declare his wines the winners.

'When I organized this blind-tasting in 1993 against the best of Sauternes, the idea was simply to show that my wines were great. It wasn't a question of whether they were better than 'Sauternes. I wanted to make people sit up and think, and they did. I have never tried to pressure tasters. Once the wines attained the quality I was working towards, I was confident that people would recognise it.'

It was the great 1995 vintage that finally sealed Kracher's reputation as one of the world's outstanding winemakers, a title conferred

on him by numerous wine competitions too. He divides his wines into two ranges: Zwischen den Seen ('between the lakes') and Nouvelle Vague. The former is aged in neutral casks only; the latter is fermented and aged in new French oak. Both methods can produce great wines, but Kracher tends to reserve his finest grapes for Nouvelle Vague bottlings. 'I don't want the wines to have powerful oaky flavors. I just find it easier to achieve microbiological stability by using new oak.' Since 1991, when he gave up his other job in the pharmaceuticals industry, he has singled out one of his wines each year as his Grande Cuvée, and it is usually his finest achievement of the vintage. It is often a blend of Chardonnay and Welschriesling.

'The ageing of the wine is important, but it's the quality of the grapes from the vineyards that is crucial. In 1996 the yields for one of my Welschriesling bottlings was one and a half hectolitres per hectare. Even at Yquem they usually manage to obtain nine!'

For the moment Kracher is producing only sweet wines, but the vagaries of the climate can reduce production to absurdly uneconomic levels. In 1997, for example, his total production was a pitiful 8,000 half-bottles. Not surprisingly he is looking at ways to keep busy and expand his production without diminishing quality. He has teamed up with a small winery in California called Sine Qua Non. 'It's a joint venture, and it allows me to work with grapes such as Semillon and Viognier that we don't have in Austria. So I'm playing around with a Semillon straw wine, which is dried outdoors during the day, then brought indoors overnight. We're also trying another joint venture in reverse, sending Austrian grapes over to be vinified by a Californian winemaker. Of course I keep an eye on things to ensure quality control.'

If Kracher's initial goal – to restore and indeed increase the reputation of Austria's sweet wines – has now been accomplished, in large part thanks to his own heroic efforts, it is to be expected that he will spread his wings. Whatever he does next is sure, at the very least, to be fascinating.

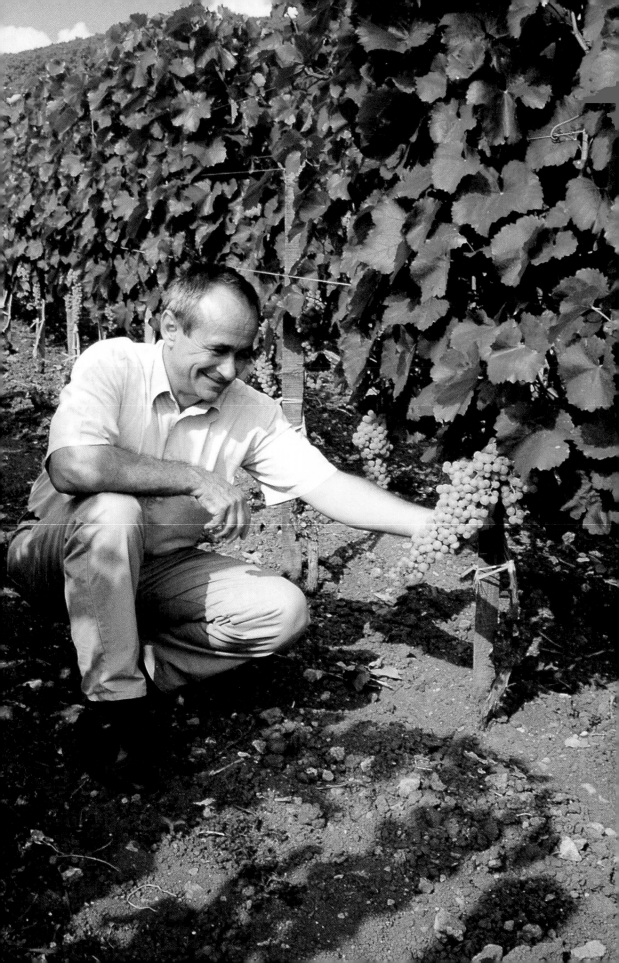

# Ist文 Szepsy

István Szepsy

he wines from the Tokaj region in eastern Hungary were already famous in the seventeenth century and the royal courts of Europe especially prized its sweet wines, which were believed to have curative medical powers. The Sun King, Louis XIV of France, is said to have declared Tokaj to be the king of wines and the wine of kings, a handy slogan·that Tokaj's winemakers have been brandishing ever since.

The region was hit by a succession of disasters. Phylloxera in the 1890s wiped out existing vineyards. Many of the merchants who produced and traded in Tokaj were Jewish, and they either fled or were murdered in the early 1940s. After the Communist coup of 1948, the vineyards were nationalized. A region known for individual vineyards which had been classified in the eighteenth century was now homogenized. The wines were produced on an industrial scale, the best being dispatched to western Europe, the worst to the Soviet Union.

When the Communist regime collapsed in 1989, István Szepsy was the manager of the cooperative in the village of Mád. He had always produced a small quantity of wine from his own few vineyards and, when some of the foreign investors who rushed into the region in 1990 tasted them, he was hired as winemaker for the Royal Tokaji Wine Company. He continued to produce his own wines, which were recognised as the finest *aszú* wines – that is, wines made by the traditional and unique method of macerating botrytised berries in must or wine – to emerge in the 1990s.

Local historians claim that an ancestor, Máté Szepsy, was the originator of modern Tokaj. The modest, self-deprecating István likes to

correct the legend. 'The famous Máté Szepsy was a member of our family but not a direct ancestor. He was a Calvinist preacher and landowner, and died in 1633. It's not true that he invented the *aszú* method, but he did play a large role in establishing it by writing down his ideas in 1630. In those days sweet wines were produced by chance rather than systematically. He wanted to focus on sweet wine production, using Furmint as the primary grape variety. He also argued that it was important to limit yields and practise late selective harvests, even into November. It was he who laid down the proportions of berries to must that became the *puttyonos* system for measuring the richness of the wines. Previously most sweet wines were made by harvesting healthy and botrytised grapes at the same time.'

After his father died in 1970, István had to learn how to make wine from their vineyards. 'My father had produced some excellent wines, although there was no incentive to do so, as the State Farm paid the same whatever the quality. I became manager of the coop at Mád in 1976. In those days everyone knew which were the best sites in the region, but no one knew how to get the best grapes from them – and we're still learning. It was only in about 1987 that I finally realised, together with some colleagues, that mass-production was a dead end. The problem was that we didn't know how to change the system.

'We all knew that new methods had to be found, but there was no fund of knowledge and experience from the past. We were starting from scratch. Only in exceptional years did the grapes attain sufficient natural sweetness, and the State Farm had taken short cuts by using must concentrate and by adding alcohol. We didn't know how to cultivate our vineyards so as to achieve full ripeness on a regular basis.

'I went to Yquem in 1990. When I saw the operation there and compared it with the way we had worked here under the cooperative system, I understood what was wrong with our viticulture. I started experimenting with green-harvesting – my neighbors thought I was mad – and short pruning. I travelled widely, to the Mosel, Alsace, Burgenland, just to learn how they approached sweet wine production. I began to appreciate the value of old vines and realised older Furmint vines were different from modern clones and had smaller bunches and deeper roots, which helped the fruit to ripen fully.

'When I left Royal Tokaji in 1992 I sold my shares and used the money to improve my own vineyards. I was lucky enough to be able to buy some outstanding parcels. I put everything I had learnt over the years into practice and my wines were well thought of.'

In 1997 his fortunes changed. A Chinese-American businessman, Anthony Hwang, tasted some of his wines in Budapest and liked them so much he came to Mád to propose working with Szepsy. 'At first I wasn't interested. I had twenty-two acres, which gave me enough wine to sell, especially since I was getting good prices. There was no way I could compete with the larger companies in the region, but I had my own niche and had become quite successful. 1992 to 1995 had been difficult for me, but by 1997 things were going better.'

Hwang managed to change his mind. On Szepsy's advice, he bought the historic Királyudvar cellars in Tarcal and renovated them. At the same time Hwang went on a buying spree, purchasing about 250 acres of the finest vineyards in the region. The arrangement allowed Szepsy to maintain his own expanding estate and sell its production independently of Királyudvar's. 'There's no real competition between my own wines and Királyudvar's. My market is mostly European, Anthony's America and Asia. I'll never have sufficient quantity to compete with Anthony in his markets. With fifty acres the maximum I can produce is 25,000 bottles. But the concept of quality behind both enterprises is the same.'

Szepsy is a deeply modest man, and a tenacious one too. He was one of the very few who, while being obliged to work within a system oblivious to quality, tried to maintain the true traditions of the region. While many of the new investors are obliged to produce dry wines and other sweet wines to compensate for the years when no traditional Tokaji *aszú* can be produced, Szepsy makes only *aszú* wines, and does so every year by his commitment to the best sites and to very low yields. He has stuck to his guns stubbornly and has been rewarded with the confident backing of a rich man who, quite simply, loves his wines.

*Dust covered old bottles of
Hungarian Tokay in the cellar–
museum at Tolcsva.*

# THE WINEMAKERS

## Jacques *P*ETERS

*E*very year in the tasting room at Veuve Clicquot a touching ceremony takes place. The *chef de cave*, cellarmaster Jacques Peters, organises a tasting of the *vins clairs*, the still wines that will be blended to form the final blends for each champagne in the Veuve Clicquot range. This is the great skill demanded of the *chef de cave*, to select the wines, regardless of vintage, that will best reproduce the style and quality expected of the house.

What makes this tasting session unique is that Jacques invites his three predecessors to join him. The oldest of the four men in the room was born in 1904 and was appointed to the post in 1928. Thus within the four walls of the tasting room there is close to a century of blending experience.

Jacques was born into a family of champagne producers, and recalls how the crop was fermented in wooden vats, which places him back in the Dark Ages when one considers the hi-tech environment that now prevails in Champagne. He also learnt how to disgorge and how to riddle, and believes he is one of the very few *chefs de cave* who actually knows how to perform these vital operations. None the less, he was tempted to become an architect rather than join the family business. But, almost inevitably, he studied oenology at Reims and joined Jacquart, where he worked for ten years. His design skills were put to good use and he drew up the plans for their new winery.

Hired by Veuve Clicquot in 1979, he became *chef de cave* in 1985. Although he is well groomed and articulate, he has not been transformed into a corporate man. His passion for the champagnes he makes is evident, and if that sometimes comes over as a lack of mod-

esty it's because he knows he is doing a good job, that the overall quality at Veuve Clicquot is very high indeed.

His responsibility is enormous. He must supervise the harvest in their own vineyards, purchase grapes from other growers, oversee the pressing and vinification, and then begin the long, difficult process of blending dozens, even hundreds, of raw acidic wines that will be transformed by the second fermentation into rich champagne. In late October Peters and his team start tasting no fewer than 450 wines, whittling down the range until they have identifided which wines will be the final components of the various blends. Peters, of course, has the final say. Once a blend has been made, there is no turning back. 'The hardest task of all is to blend the Yellow Label nonvintage. We produce over eight million bottles a year and it has to be consistent, whatever the vintage. Fortunately this company is obsessed by quality – as was the Widow herself! – so I am given the means I need to achieve that quality and consistency. I am the person who is responsible for the final blend and for deciding how much reserve wine to use in any year. Reserve wine is crucial in poor years, so that's why we keep large stocks, probably larger than any other champagne house.

'I've been here a long time, so I have earned a certain authority, which means I can insist on no lowering of quality standards, either in the vineyards or the winery. I have responsibility for both. Remember too that we buy in seventy-five percent of our grape requirements and I'm in charge of that too. I personally sign the contracts with our growers and have always done so. As far as I know, no other *chef de cave* has that kind of personal responsibility. It's also a privilege, of course.'

The top wines are the easiest to make. The prestige bottling, Grande Dame, which was first created in 1962, uses only grapes from the *Grand Cru* sites that belonged to the Widow during her lifetime: Chardonnay from Mesnil, Oger, and Avize; Pinot Noir from Ay, Bouzy, Ambonnay, Verzy, and Verzenay. It's aged for six to seven years before disgorgement. Like any vintage champagne, it's only made when the quality is there. Peters was able to introduce a Grand Dame Rosé in 1988. He had wanted to make such a champagne for

some years, but the directors were against it. Eventually he was given the go-ahead by Joseph Henriot during his spell as chairman.

'As for the style of the wine, it had to be typical of Clicquot but with the typicity of Grande Dame. That means a wine that is not so much powerful as noble. Actually, it wasn't that hard to make the blend, as I had access to wonderful base wines. I selected the wines for Grande Dame and some Bouzy Rouge. Bouzy is the heart of our vineyard and everyone agrees we probably have the six best parcels in the village. We blind-taste the parcels and vinify them separately. These great rosés can be very long lived, as the Pinot Noir helps them to age.'

Marketing is crucial to the champagne business. Advertising, sponsorship, entertainment, visitor tours – all methods are used to project the image of champagne as the wine of celebration *par excellence*, costly but not unaffordable. It would seem inevitable that *chefs de cave* would come under pressure to cut corners or evolve products that may appeal to non-traditional markets.

Jacques Peters recalls that he was once overruled when he wanted to make Grande Dame in 1982 on the grounds that Clicquot had sufficient stocks of earlier vintages. 'But that was the last time. Since I became *chef de cave* I have never been told what to do by the marketing team. If they tried to interfere, I would just say no. Fortunately the top people at Veuve Clicquot have not been marketing men. I admit I was worried when Philippe Pascal arrived here in 1994 that he might taken a different approach. He had worked for Seagram and for Barton & Guestier. But within a few weeks I realised I had found an ally. Pascal is a great marketing man but he always respects the wine. He understands that the quality and style of our wines have to be my responsibility, that we can't play around with the reputation of Veuve Clicquot. We can and should modernize, but we must always respect quality. We should never be vulgar in our approach' – and he held up the Veuve Clicquot capsule with the Widow's features – 'as we know she is always watching.'

# Véronique $\mathscr{D}$ROUHIN

Although her long fair hair, trim figure and winning smile give an impression of youthfulness, Véronique Drouhin is fast becoming a veteran within winemaking circles. Of course the fact that she grew up in a wine-producing family in Burgundy gave her a head start in confidence and perhaps accomplishment. She can now look back on twelve vintages as a winemaker at her family's Domaine Drouhin in Oregon, which was established by her father, the urbane Burgundy négociant Robert Drouhin. The Pinot Noirs from the domaine soon established themselves as among the finest available from Oregon. In the mid-1990s Robert Drouhin took a leaf out of Robert Mondavi's book by taking his Oregon wines to London and elsewhere and presenting them in blind tastings alongside various wines from his range of Burgundies. At the tasting I attended the consensus was that the *Grands Crus* were finer than the Oregon wines, which seemed to be on a level comparable with some *Premiers Crus*. Not a bad start from young vines in a little understood wine region.

Véronique grew up with wine, but was never under pressure to join the family firm, which is now run by Robert and her two brothers. 'Wine was part of my childhood, on Sundays especially, when my father would pour something particularly good to taste and enjoy – just as today I do the same with my small children, who are already good tasters! But it was harvest time I remember best. The house was full of people and there was constant entertaining. In those days the winery was quite small and there was a special atmosphere around the place, especially as my father did much of the winemaking himself. The vineyard manager would let me and my brothers taste the

ripe grapes, and I would not only be allowed to pick some of them, but at the end of the day I would receive a pay slip!'

For two years she studied biology at Dijon University, before bowing to the inevitable and taking courses in oenology. Once she graduated she decided to travel, taking advantage of her father's many contacts worldwide, and in 1986 worked with David Lett and David Adelsheim in Oregon. In the meantime Robert Drouhin was become increasingly intrigued by the possibilities for making Pinot Noir in Oregon, which he had first visited in the 1960s. There was little he could do in Burgundy to expand his business, and he liked the intellectual challenge of producing Pinot Noir from a different corner of the world. Although he considered most Oregon Pinot Noirs mediocre, he was particularly impressed by the quality of David Lett's wines from Eyrie Vineyards. Moreover, the Oregonians, instead of being hostile to this potential interloper from Burgundy, encouraged him to make whatever contribution he could.

In 1987 Robert Drouhin bought one hundred acres in Oregon and planted a vineyard in the Dundee Hills. The following year Véronique went out to make the wine which, until 1990, when the vineyard started bearing fruit, had to be fashioned from purchased grapes. They liked the quality of the wine, so decided to press ahead. More land was purchased and a costly gravity-based winery constructed. 'That wasn't as easy as it sounds, as all the equipment we wanted had to be sent out from Beaune. It's been a great challenge.'

Since the birth of her children, Véronique has spent less time in Oregon, but Domaine Drouhin has an able manager, Bill Hatcher, and a cellarmaster. Each month she receives samples, which she tastes and analyses, so that she can monitor how the wines are evolving. She is also alerted to any potential problems that may be arising in the cellar.

At harvest time she is back in Oregon. 'The curious thing is that my mother, who never took much of a part in the Burgundy business, loves to come out to Oregon and work at the winery. She cooks, of course, but she also does the lab analyses. She loves it! And it's fun for me too to have her there. But I don't take a particularly feminist approach to my work. It really isn't an issue, and I do what I do because I enjoy it, not because I'm trying to prove anything.'

It's easy to imagine that the Drouhins' overseas venture might have caused some tongues to wag disapprovingly in Burgundy. At that time no other Burgundian house had even attempted to make wine outside France. But Véronique doesn't recall any opposition. 'If anything, there was admiration for taking on the challenge and for investing abroad during a tricky economic period. Since we started making wine in Oregon, there have been plenty of blind tastings which have established its quality, without undermining our basic operation in Beaune.'

Better than almost anyone else, Véronique Drouhin is able to pinpoint the differences between Pinot Noir from her native Burgundy and from Oregon. 'In Burgundy we talk about *terroir*, but it's too early to do that in Oregon. After ten years' experience we know how to obtain color and flavor from our grapes in Oregon. What is less easy is to achieve finesse and elegance. But I have no doubt that the finest Pinot Noir outside Burgundy will come from Oregon, and also perhaps from New Zealand. I'm not so sure about California, where the climate is warmer and the wines are richer and more powerful. The wines from Oregon also don't, so far, have the longevity of the best Burgundian wines. In general Oregon Pinot Noir is at its best after about five years, although some of our wines, such as the 1993, are still drinking beautifully and aren't tiring. But as viticultural practices improve, I expect the wines will become more long-lived.

'The wine world is becoming more and more competitive., Whether we're in Burgundy or Oregon, we can't be complacent. We need to talk about our wines, show our wines and persuade people of their quality. In Oregon we are producing good wines which give us – and, I hope, our customers – pleasure. But I am not prepared to say that we are yet making great wines, wines that move us and inspire great emotion. That we can do in Burgundy with our best *crus*, and that is our challenge in Oregon.'

# Bruce and David GUIMARAENS

*D*uring the harvest season in the Douro Valley in the 1980s it was easy to spot the powerful figure of Bruce Guimaraens as he tirelessly toured the vineyards, keeping his experienced eye on what was going on. Since 1956 Bruce had been the winemaker for Taylor and Fonseca ports, but he always paid close attention to the vineyards, knowing full well that without great grapes he could not make great ports. In the 1950s and 1960s many of the best upriver vineyards were almost inaccessible, and Bruce visited them by mule or on horseback. He had to inspect them regularly, as the wine world rightfully expected a great deal from Fonseca and Taylor.

Bruce retired in 1995 at the age of sixty, passing the baton to his son David, then in his late twenties. David has maintained his father's respect for the vineyards. 'These days it's not enough to be a winemaker. You have to be just as much at home in the vineyards.' Bruce was self-taught: 'I was just told to get on with it, and whenever a cellar hand or vineyard manager asked me what to do, I just told him to keep doing what he had always been doing.' David, in contrast, studied oenology in Australia, bringing the technical skills of that continent to the more chaotic conditions of the Douro.

Until the 1960s most Douro vineyards were small farms with a wide range of grape varieties all planted together in field blends. Gradually Bruce Guimaraens and other pioneering winemakers in the valley tried to isolate the best varieties for port production and to plant them in the best locations. At the Quinta do Panascal, a Fonseca property near Pinhão, individual varieties have been planted in specific soil types and expositions. Like Bruce before him, David spends

weeks before the harvest walking through the vineyards, both those that belong to the company and those from which he routinely buys grapes. He will taste alongside the vineyard manager, trying to discern the character of each parcel and determine the picking date for each.

By the time the harvest begins, David will have a firm mental picture of how it will be organized. The days when tractors trundled up to the wineries while managers scratched their heads and wondered what to do with the grapes are long over.

David is also anxious to push ahead with major changes in vinification. It has long been accepted that the best ports are made by treading the grapes in *lagares*, which are concrete troughs. At Taylor's Quinta da Vargellas, like so many other visitors during the harvest, I was invited to change into shorts and join the line-up in the *lagares*, linking arms and shuffling back and forth, treading the warm purple mass beneath our feet. An accordionist wheezed out a jaunty tune to keep us in step rhythmically, and the occasional shot of port or brandy revived us when we flagged.

'That mixture of gentle treading and steady aeration makes the best ports,' says David, 'but we need to do better. Harvesters pick all day long in the sun, then must tread late into the night. It's hard work. Anyway, we only have enough *lagares* for our vintage ports. The other ports have to be made in steel tanks. Because we have to add brandy to stop fermentation while the must is still sweet, we need to extract color and tannin very fast. So we pump over and use other extraction techniques that can give us rough tannins. And what I want in our wines is elegance, not mere strength.'

So he has devised tanks with interior pistons that will simulate the action of foot-treading without exposing the must to excessive aeration. He explains the new system to me, and to Bruce, who receives the information with delight. Despite his standing as a grand old man of the Douro, he has taken a back seat since his retirement and is determined to let his son work unimpeded, without his formidable father breathing down his neck. This has allowed David to make important technical changes that, he passionately believes, will improve even further the quality of their ports. 'There's never been a more exciting time to make port! Decades ago we were blenders of

wines that we bought in from dozens of farms all over the valley. Then Bruce began buying farms for Fonseca and Taylor so that we could guarantee the quality of our grapes. And today we're no longer buying wines that may or may not have been well made on the farms. Today we are winemakers.'

It has become quite fashionable to make table wines as well as port from the splendid red grapes of the Douro. It was fun to tease Bruce when he was still the winemaker by asking him when he was going to get round to making table wines. 'Never!' he would growl. 'A waste of good port grapes!'

On his return from Australia, David was attracted by the idea of making table wine here. After all, there were already some fine examples on the market, and producers such as Ramos Pinto were showing that it was possible to make good ports and good table wines too. But he soon came round to his father's point of view. 'The dilemma is that one has to decide what to do with the best grapes: vintage port or table wine? I want our best grapes to go into our vintage ports and old tawnies. Perhaps we'll make table wine one day, but it will be from different vineyards and in a different winery.'

Bruce and David are delighted by the rebirth of vintage port. In the early 1990s it seemed that the market was dead. Great old vintages could be bought for a song at auction; port seemed fatally damaged by its musty image as a drink for old men in clubs. Then with the 1992 and 1994 vintages, interest revived, especially in the United States and Canada. 'That's great news for us,' says David, 'but I'm a bit alarmed that most of the 1994s shipped to America have probably already been drunk. It would be a disaster if in years to come no mature vintage ports were to be available.'

And, to prove the point, we headed off to the tasting room to sample some older tawny ports from cask, beginning with some youthful wines from 1927 and 1967, and proceeding to more serious stuff from 1911 and 1867. Still fresh, still delicious.

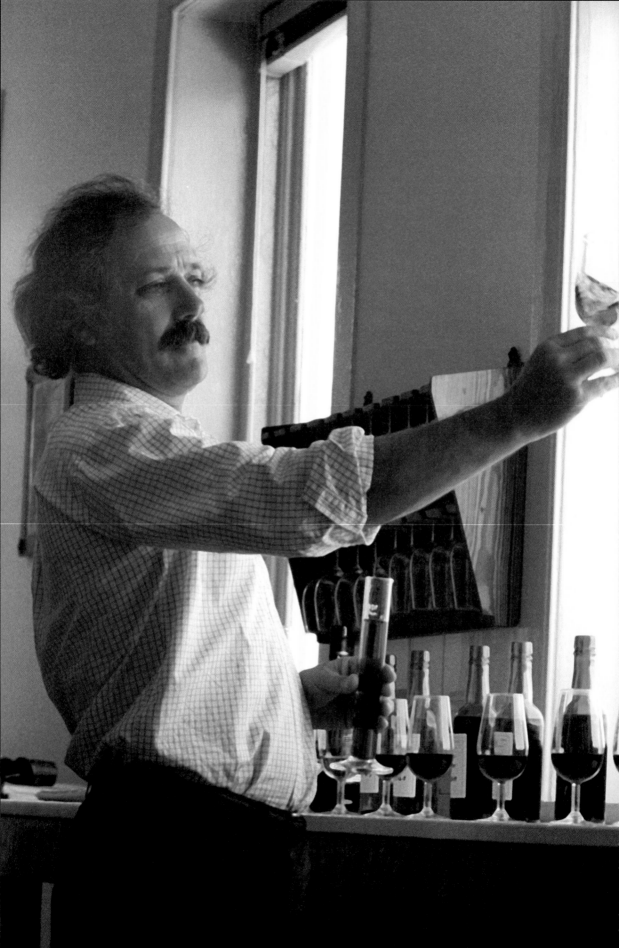

# João Nicolau de $\mathscr{A}$LMEIDA

$\mathscr{I}$n the public imagination the port business is the fiefdom of those English families, notably the Symingtons, who produce such magnificent wines under the various labels of Dow, Warre, Graham's, and many others. Within Portugal, where in any case the taste runs to tawny styles more than to vintage ports, some of the Portuguese-owned houses are just as highly regarded.

João Nicolau de Almeida comes from a family long associated with fine wine. It was his father, working for Ferreira, who created the first, and still highly regarded, table wine from the Douro, Barca Velha. Since the 1970s João has worked for Ramos Pinto and his claim to fame is that he conducted the research that identified the best grapes for port production.

As a young man he studied at the University of Bordeaux with such hallowed figures as professors Peynaud and Ribéreau-Gayon. 'It was marvellous as a young man to be able to work on experiments with the popes of oenology. Peynaud loved port and I in turn came to love Bordeaux, which remains my inspiration for wine. I am still in touch with people at Bordeaux, as I am a guest professor at the university. For me Bordeaux is the quintessence of European wine knowledge, the standard bearer for tradition and the sense of patrimony.'

But returning from Bordeaux to Portugal was a shock. 'It was like stepping back into medieval times. In those days there were no trained oenologists in Portugal. There were growers and viticulturalists on the one hand, and on the other there were the blenders, who worked for the large companies, whether port houses or cooperatives or private firms. There were a few pioneers who understood modern winemak-

ing, but that was not part of our culture. Nor was there any financial or intellectual incentive to improve quality. So I ended up back in Portugal with no one to talk to!

'However, both my father and my uncle were in the wine business and my father was very pragmatic. But he didn't like the wines I was making. He was an important figure, but it didn't seem a good idea to work with my father, so I went to see my uncle Jose Rosas at Ramos Pinto. I spent a few days talking to him and it dawned on me that there was a tremendous potential here in the Douro. The salary would be negligible, but that didn't matter as the future looked so exciting.

'So I joined Ramos Pinto in 1976. My main activity was to study the varieties planted in the vineyards, where they were all mixed up. No one knew which were the best varieties. When you put your nose into a glass of port or wine, you had no idea where the aromas came from. Were they varietal? Were they from the casks? No one knew. It hadn't occurred to anyone to do micro-vinifications to help accumulate data about these varieties. In the Douro the port houses knew about vineyards, either because they owned them or bought regularly from other *quintas* – but the only people who knew about the grapes were the laborers. The grapes were picked when ripe, vinified, fortified, and then taken down to Vila Nova for blending. That was considered the art of port – blending, not growing the grapes.

'Our research at Quinta Bom Retiro put an end to this division between growers and blenders. By 1981 we had identified the five varieties that were capable of producing the best ports. At the time there was a lot of opposition to our findings. We did other research too, and Jose Rosas formed an association, now run by me, to further research and development into the best ways of planting the vineyards. At first we were keen on *patamares*, which were horizontal terraces that could be mechanized between the two rows on each terrace. But after further research we concluded that vertical planting down the slopes was the best method. It gave higher vine density, which in turn gave better quality fruit. And it made possible mechanization for such tasks as spraying.'

In 1978 he moved in a new and radical direction: micro-vinifications for table wines as well as port. Barca Velha was part of his family tra-

dition, but most port producers were opposed to making and marketing table wines from the Douro. The producers of British ancestry – notably, the Symingtons of Dow, Graham's, and Warre's, and the Guimaraens and Robertson families of Taylor and Fonseca – were focused exclusively on the substantial export market for port and had no wish to be distracted by producing tables wines of which they had no experience.

'I understand those, like Bruce Guimaraens, who argue that our best grapes should be reserved for port, the wine unique to our region, but I believe we can do both! We can make great ports and great table wines! When Roederer bought Ramos Pinto in 1990 we were finally given the incentive to produce good table wines. Before then a lot of wines were sent for distillation, which our new French owners thought was ridiculous. So we were given the resources we needed to make good quality table wine.'

Despite his inquiring nature, João remains deeply attached to the Douro and its unique wines. 'I feel strongly that we must concentrate on our local varieties, and resist internationalization. We have a wonderful *terroir* and have the capacity to extract gold from it. I believe our *terroir* is crucial. Château Margaux isn't labelled Cabernet Sauvignon. When you say the words "Château Margaux" you immediately conjure up a picture, and we have to ensure that the same is true of the Douro. Douro is a place, not a variety, and we have to build public knowledge of our identity. In that sense we must remain traditional, but that doesn't mean we remain stuck in the past. On the contrary, we must progress and adapt to new circumstances.

'Wine reminds us of our human capacity, that we're not machines. Civilised drinking of wine makes us more receptive to our fellow human beings, more open. For me there is a whole spiritual dimension to wine. Wine keeps me linked to the soil from which we came and to which we will return.'

*Overleaf. Oak barrels mature port at the Ramos de Pinta winery at Vila Nova de Gaia, Portugal.*

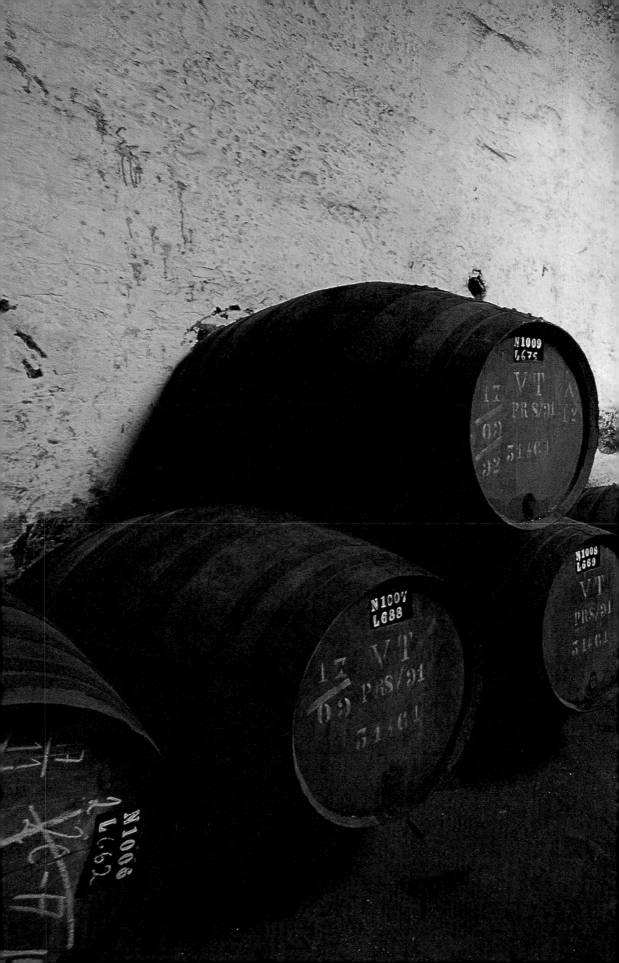

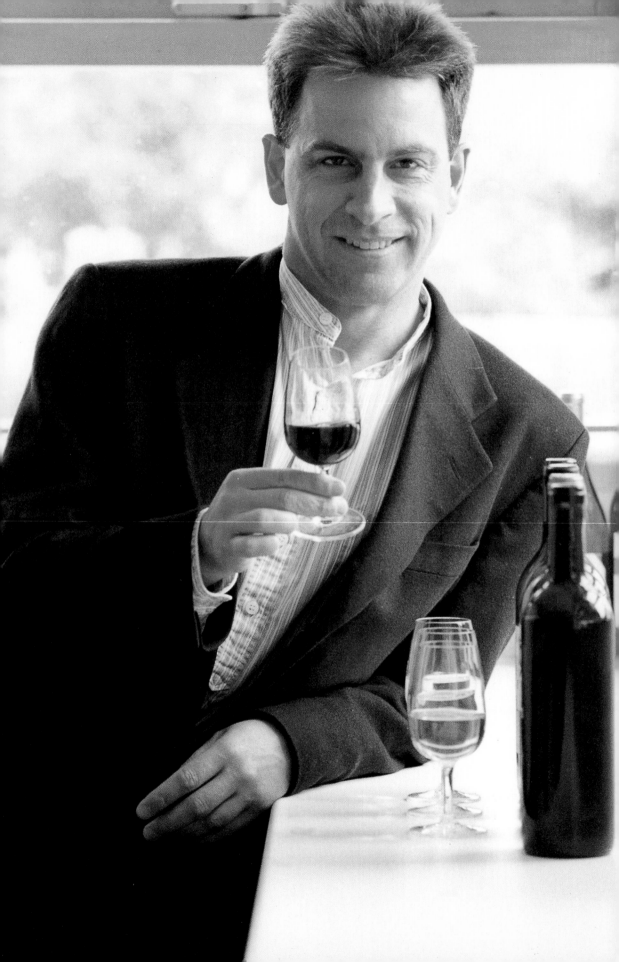

# Kym *Milne*

he European winemaker is usually a farmer running a small business. In Piedmont or Burgundy wine producers tend their vineyards, make the wine, and then sell it. The following year they repeat the pattern. Most people who make wine do so because it is the family business, a job one has inherited.

It's different in California or Australia, where you make wine because that is your chosen career, achieved after long study and as much experience as possible. New World winemakers are technicians, adept at being handed a few tractor-loads of grapes and told to make the best wine possible from them. It's not surprising that many such winemakers, especially in the southern hemisphere, have grown impatient with the notion that there is only one opportunity each year to make wine. While estates in Europe and California were busy harvesting in the autumn, the winemakers of Chile or Australia were sitting at home twiddling their thumbs.

Not any longer. A whole new subgroup has come into being: the so-called 'flying winemakers' who dart around the world making wine wherever their skills are wanted. Kym Milne, an Australian now living in England, is typical of the breed, directing a team of about fifteen winemakers who can be dispatched, like oenological paramedics, to wineries that need a helping hand. During the late 1980s Kym was chief winemaker for Villa Maria in New Zealand and helped build its reputation for excellent white wines. He left in 1992 and decided to travel around Europe for a few months. Up to that time he had had little experience of European vineyards, although he had read and tasted widely while studying for the Master of Wine examination in 1991.

On arriving in Europe, Kym was offered consultancy work for wineries in Hungary and Chile. He decided to settle in England and was soon employed as a flying winemaker for International Wine Services (of which he later became a director) and also set up his own company. He works with major retailers, including supermarkets, to establish the kinds of wines they are looking for and the price they are prepared to pay. 'Usually,' says Kym, 'they're after subtle oaking, fruitiness, fair acidity, and in general what you could call a New World style.' Having established demand, he goes in search of supply, which takes the form of large wineries around the world that have access to inexpensive grapes and are willing to make the improvements necessary so that Kym's team can make good wine at their facilities.

'We're working in the £3 to £6 bracket and in that range people are looking for full fruit flavors. We also have a clear idea of the style we are trying to produce. An average South African or Italian cooperative will have a standardized approach to harvesting and vinification and will make a range of wines that they then try to sell but may not have a market for. We instead have an end-product in mind. But we can't work miracles. We know we have to work within the limitations of the vineyards at wineries' disposal and the equipment they have installed. But we need to be sure they are keen to improve quality and will work with us to that end. There have been times when we have decided not to work with a particular winery or region because we just didn't feel the dedication to quality was there.

'In Spain we found a bodega with some wonderful old bush-vine Grenache and other varieties. But their crusher was a disaster and their tanks simple concrete. We told them they needed to buy a stainless steel crusher and line their tanks with epoxy resin. They agreed, so we initiated a project with them. Now three years later we make 40,000 cases with them which retail in Britain at £4 a bottle, which is a lot more than they were getting before we worked with them. So everyone is happy.'

Mission control is a poky office attached to Kym's cottage in a sleepy corner of rural south England. Here he maintains constant contact with his team by email, fax, and 'phone. When working with a new winery for the first time he will usually go out in person to supervise

the vintage. Most of his work consists of preparing for each vintage, selecting harvesting dates, specifying yeasts for fermentation, and, after the vintage, blending the wines. He also has to ensure that there are no bruised sensibilities when his hi-tech team arrives to sort out an ancient cooperative or winery.

'We know we often need to take a tactful approach. We can't just stomp in there and start yelling at the locals, as some flying wine-makers are accused of doing. Sometimes there can be problems, when my winemakers just can't get along with a winery's regular staff, but that's very much the exception. They know they need to be sensitive and flexible. And I expect them to roll up their sleeves and work along-side the regular winemakers.'

He looks resigned when I mention the long-standing criticism that flying winemakers are responsible for homogenizing the wines of the world, yanking them into a supermarket-created mould with the help of risk-free winemaking techniques. 'There's a grain of truth in the accusation,' he concedes, 'but we don't work the same way in every region. Our aim is simply to maximize the potential of any region where we're hired. We make Chardonnay in Hungary, in Trentino, in Puglia, and they are all very different. I do believe in *terroir*; it's a real concept, although it's sometimes used to describe what are really winemaking faults! On the other hand, fruit character is central to *terroir*. In Puglia we made a terrific unoaked white from Greco, an excellent local variety, and we sold it to some British retailers and supermarkets – but they couldn't sell it. So we do try our best to retain regional typicity and not to standardize everything.'

Although Kym, who has three young boys that he would like to see more of, sometimes wearies of the constant travelling, he clearly enjoys what he does. He and his team are now producing almost one percent of all wine sold in Britain, which is a heady responsibility. Does he dream of working with his own grapes at his own winery? 'It would be nice one day to have a place where I could have total con-trol over all aspects of wine production. But I have no interest in five acres and a tin shed, making just three wines each year. I'm used to making a lot of wines and being around lots of people.' Still in his early forties, Kym Milne has time on his side.

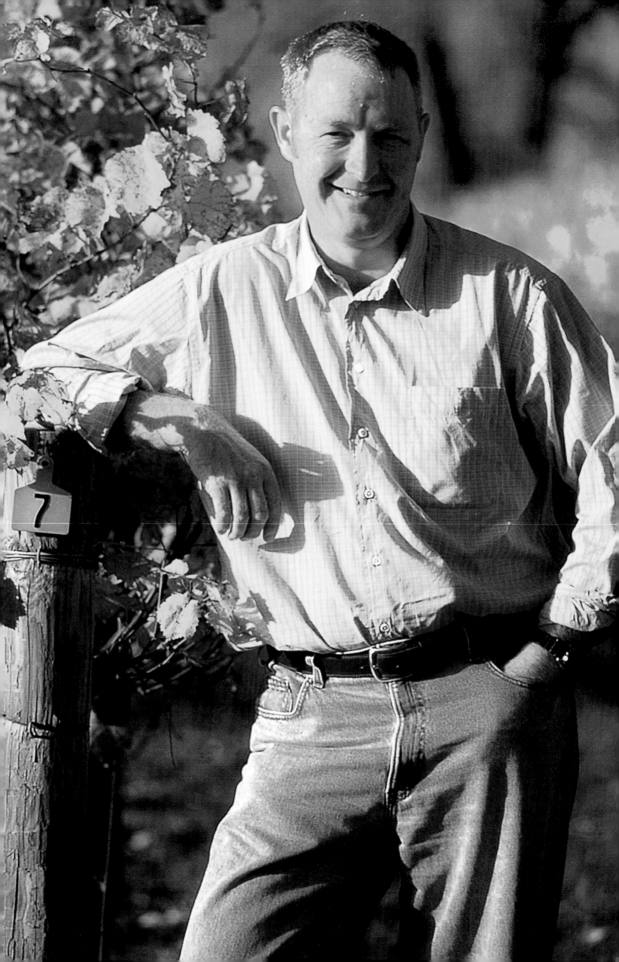

To grow up in New Zealand in the 1970s was to inhabit a viti-cultural backwater. German and Yugoslav immigrants had brought varieties such as Müller-Thurgau with them and the days when New Zealand Sauvignon Blanc and Chardonnay would take the wine world by storm were a decade or more away. Indeed, Steve Smith never intended to work in the wine industry and was accepted by a school for architects. But a scholarship from the ministry of agriculture lured him into entomology and research and put him in touch with one of the world's leading viticulturalists, Richard Smart from Australia.

'I began to work with him on issues such as canopy management and trellising systems and leaf removal. The academic work on these matters was done in Australia and then tested in New Zealand. At that time we didn't realise how international such concerns would later become. New Zealand viticulture was still dominated by varieties such as Müller-Thurgau, so the significance of our research wasn't really apparent.

'In 1985 I went to the University of California at Davis for a few months to work on virus identification. That was a major problem in New Zealand and when I returned I helped to clean up the plant mate-rial we had here. This had a major impact on wine quality. Before then we had very tart acidic wines and the grapes ripened much later too, which could be problematic. Once we had healthier vines we also had better balanced wines.'

Winemakers can sometimes take the work of viticulturalists and vineyard managers for granted, but the latter are indeed the unsung heroes of the wine world, working tirelessly to improve the quality of

the fruit they will deliver to the wineries. In 1987 Steve was hired by Villa Maria with a twofold brief: to increase production and increase quality, which can seem like riding a horse in opposite directions at once. By the time he left in 1998, he felt he had indeed achieved both.

During a period of instability at the winery, Steve found himself involved in sales and in receiving importers and journalists. 'I liked the challenge of talking to journalists and importers, some of whom were suspicious that a viticulturalist such as me could get involved in this side of the business. Our British importer let it be known that he didn't think much of the public side of Villa Maria being represented by a viticulturalist, so I fired off an eight-page letter justifying what I was doing, and ever since we have been good friends.'

It's easy to imagine Steve Smith firing off an angry letter. He's a tall man with an emphatic manner; the exterior is rugged but behind it there is a formidable intelligence and, one suspects, not a great deal of self-doubt. In the 1990s a number of New Zealanders had passed the demanding Master of Wine exams, and his Australian colleague at Villa Maria, Kym Milne, urged him to follow their example. 'I felt I had to prove that a viticulturalist could have a good understanding of the whole wine business. So I gave it a go. The other Kiwi MWs had all passed first time around and there was no way I was going to be ribbed by them for the rest of my life. So I spent three months in Europe immersing myself in European wine culture, without tasting a single Australian or New Zealand wine. And I passed the MW exam first time, in 1996.'

He was also anxious to learn as much as he could from European experience. 'The French talk a lot about *terroir*, and I realised they were right. Great vineyards do have a unique character. At Jadot in Burgundy I was able to compare vintages and vineyards, and I could see there was something unique there. I also realised that wine wasn't just about fruit, but about texture and length and compatibility with food. I learnt not to impose a winemaking style on what I was doing. I also realised that the standards of viticulture in those top French vineyards was very high and that in the wineries their technical wizardry was second to none, especially in Bordeaux. So I learnt the importance of trying to marry tradition and technology.'

It was inevitable that a free spirit such as Steve Smith would one day want his own vineyards. Back in the 1980s he had already glimpsed a parcel of land that struck him as perfect for growing grapes. Many years later he got to know Terry Peabody, an American with a large trucking business in Australia. Peabody was very keen on wine and their ideas began to converge. In 1998 they bought Steve's dream parcel and additional average in the Martinborough region and founded Craggy Range Vineyards. Soon after they began releasing small quantities of superb Riesling and Chardonnay, with Pinot Noir and Sauvignon Blanc to follow in 2002.

Although Steve Smith, as viticulturalist and winemaker, does have a truly international perspective, he remains rooted in his native country. 'There are lots of fantastic opportunities to produce wine worldwide, but I keep coming back to New Zealand. I think there is amazing potential here, most of which we haven't begun to tap into. I make a point of sending the people who work for me all over the world, and we welcome winery workers from Europe to Craggy Range. What I'd like to see is a system of alliances with the great European producers.'

For the viticulturalist, too, the next decades will be fascinating, with the complex biotechnical and ethical issues relating to clonal research and genetic modification becoming ever more vexatious. On a more hedonistic note, I asked Steve what he thought he would be drinking in thirty years' time. 'By then we will have really old vines in New Zealand and there will be some great wines from here. I'd start an ideal meal with champagne, a younger, fresher style, perhaps from Jacquesson or Egly-Ouriet. I'd have a red and white Burgundy and a red Bordeaux. Nothing from Italy or Germany. Then a Pinot from Craggy Range, which we'd drink alongside the Burgundy just to show we can do so without embarrassment. And I'd drink a Margaret River Cabernet alongside the claret. And we'd end with Yquem.' I'll join him.

# THE BUSINESS OF WINE

## Pierre *L*AWTON

For over two centuries most Bordeaux properties have declined to sell their wines directly to the consumer, but have employed the services of the city's numerous wine merchants, the négociants. Originally this was a device which allowed the mostly aristocratic proprietors to sell their wines without coming into direct contact with consumers; more recently it has evolved into a way of ensuring that any château's production is distributed as widely and variously as the proprietor wishes. Consequently there are all manner of négociants in Bordeaux: those trading principally in classified growths, those dealing in bulk wines, some specialising in remote markets such as South America or central Africa, others skilled at selling to airlines or supermarkets. Although some négociant houses have been in existence for a century or more, it is a volatile marketplace.

All the more reason, the château proprietors reason, to let these middlemen take the risks – and, when the market is buoyant, their fair share of the profits. For the proprietor, there is no need to set up a costly and elaborate sales organization in order to sell his wines. About nine months after any harvest, he will have disposed of most of the vintage to the négociants. If the latter can sell them at a good profit, well and good. And if not, it is no longer the direct concern of the proprietors. A subtle system of allocations more or less forces the merchants to take on the poor vintages as well as the great ones. Any négociant declining to accept the hard-to-sell 1992s or 1993s would have risked being dropped from the proprietor's list of favored merchants once the far superior 1995s and 1996s came along.

Pierre Lawton is one of the new breed of Bordeaux négociants. Although he comes from a long line of merchants and brokers – Lawton is a name to conjure with in Bordeaux – he had no wish as a young man to enter the wine business. 'My grandfather Daniel, as well as other Lawtons, educated me in wine, but I never felt destined for the family business. On the contrary, I was quite rebellious and went off and studied law for six years, and developed a sideline as a skateboard pro. Even after these extensive studies I still wasn't sure what to do with my life.'

But wine was, so to speak, in the blood. 'When I was young I would often be invited to Mouton-Rothschild. Baron Philippe knew my family well, of course, but he was often on his own and liked young company and a good game of backgammon after dinner. Philippe gave instructions that I should be served only the best wines from the cellar, which of course is one of the greatest in Bordeaux. So I drank the most amazing wines, many from the nineteenth century, and that helped form my taste.'

Eventually the tug back to Bordeaux proved too strong and Pierre decided to enter the wine business on his own terms and secured the backing of one of the city's great personalities, the blind négociant Jacques Merlaut. For some time Merlaut had been trying to persuade the young Pierre, then in his late twenties, to come and work for him, but Pierre craved his independence.

'In the late 1980s négociants tended to do a bit of everything: classed growths, petits châteaux, exclusivities. My idea was to work in the Far East, which had hardly been approached at that time. Countries such as France and Belgium were saturated markets, so I needed to look elsewhere. Of course it was tough starting with the 1987 vintage, but at least I was able to get my hands on some wine and the goodwill I was able to establish with the growers stood me in good stead. And I could demonstrate that I was competent and knew what I was doing. I had to cut costs to the bone and worked alone for many months. I started essentially as a broker, but gradually built up stock. I can tell you that broking was a tough business in 1991 and 1992. The vintages were either small or mediocre and the world recession meant that sales were in a slump.

'But I bought a good deal in 1995. Prices rose and I made some money. Later, I happened to be in Hong Kong the day the stock market crashed, so a lot more wine came on to the market. I only work with classed growths and the top *crus bourgeois*, and my business is based on trading back and forth.'

The Bordeaux négociant needs to be quick on his feet. Markets are forever volatile, as recent years in the Far East demonstrated only too well, and the merchant, being by nature a middleman, has to walk a tightrope between pleasing the proprietors from whom he must buy and pleasing the importers, agents, and other organizations that represent his customers. Some traditional négociants still occupy cavernous, old-fashioned offices and like to stress their importance as insiders with a long pedigree. Pierre Lawton has ultra-modern offices in the Bordelais equivalent of a loft and most days he roars off to lunch at his favorite spot on the other bank of the Gironde in his growling Aston Martin. This touch of brashness becomes him. He is, after all, a salesman specialising in luxury products. Moreover, he has none of the secretiveness of most Bordeaux merchants. Négociants like to remain in the background, quietly wheeling and dealing. Pierre, in contrast, likes being visible and does not attempt to keep wine journalists as far away as possible. Perhaps his irreverent brashness also stems from a wish to put some distance between himself and his distinguished family.

Indeed, as far as Pierre was concerned, bearing a famous local name was no advantage. 'To have been born into an old wine family in Bordeaux means that people tend to think of you as a young fool. Bearing a famous name means that you can't afford to make mistakes. I'm very proud of my heritage, which goes back eight generations, but I am essentially self-made as a businessman. I remember wondering one day whether my ancestors would have been proud of me and after much reflection I hope the answer would be yes.'

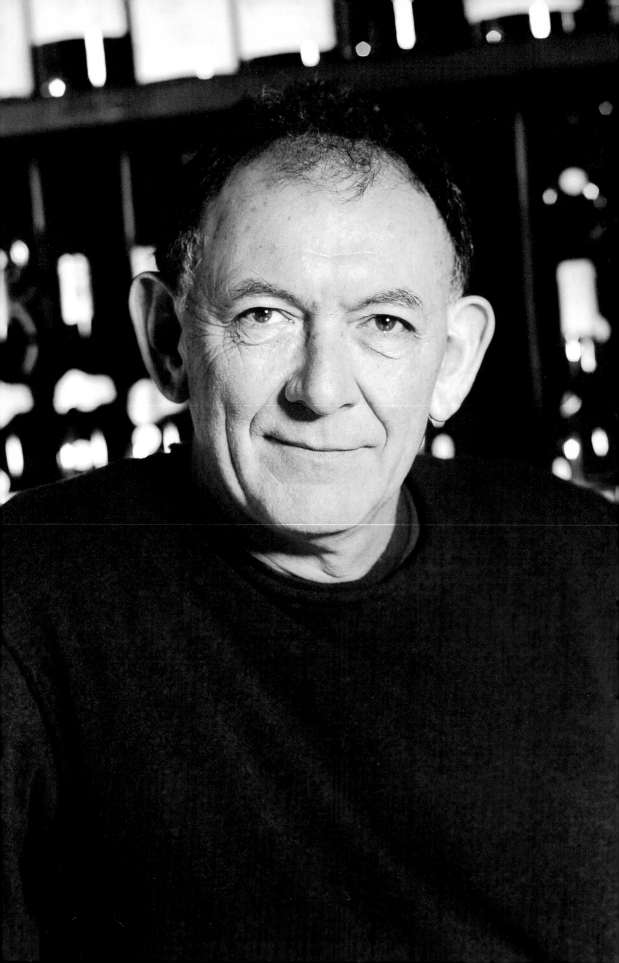

# Kermit *Lynch*

The wine trade has never been simply a business. Many are attracted to it because of the spin-offs: the opportunities to travel, good meals, the wide range of interesting people who work within it. It's hard to think of a wine merchant who has taken a more relaxed approach to his career than Kermit Lynch, although this is not to say that he is not serious about what he does.

He entered the wine business at the worst possible time, as the wine market plummeted after the ludicrously overrated 1972 Bordeaux vintage. 'I was keen to get into the wine business but shops were firing rather than hiring. So I borrowed $5,000 from my girlfriend and opened a shop near Berkeley. I made my first trips round France in 1973. At first importing and selling wine was a hobby. Not that I really had a day job. If my girlfriend hadn't been kind enough to put food on my plate, I wouldn't have survived. I also imported wines from Germany, Spain, and Italy – especially Italy. But they never sold that well. At that time most Italian-Americans bought jug wines from Gallo or whoever. The Barolos that I brought in were considered highly esoteric. The fact is that I like to work directly with growers. That's the only way you can follow their wines, ensure that they aren't harshly filtered, and guarantee that they are safely transported.'

With his highly individual taste in wine, Lynch knew he was not always selecting bottles that would prove easy to sell. Who in those days, outside France, had heard of Charles Joguet in Chinon or the Prieuré de St Jean Bébian in the Languedoc? So he took to writing short essays in the brochures that he sent out regularly to his customers. One day it was suggested that these elegant, informative,

often amusing little essays could be expanded into something more substantial, and in 1988 a book emerged under the apposite title of *Adventures on the Wine Route*, and it was the sense of adventure and discovery that gave the book its charm and interest.

It also gave Kermit Lynch an opportunity to sound off. He argued against blockbuster wines and highlighted wines with nuances and subtleness. He frowned upon wines with excessive oakiness and alcohol. He inveighed against the emasculating effects of filtration. And, with great prescience, he expounded on the health-giving qualities of moderate wine consumption long before the so-called French paradox was unveiled on American television. 'Not that I invented the idea. If I recall correctly, the health benefits of wine consumption are also mentioned in the Bible and Louis Pasteur.'

Although he favors finesse and subtlety in wines, Kermit is by no means opposed to 'big' wines. 'It's not true that I dislike big burly wines. After all, I'm enthusiastic about Châteauneuf-du-Pape, and co-own a vineyard in Gigondas. But I don't accept the current American notion that bigger is necessarily better, that the size of the wine should be the major criterion, which it now seems to have become.

'The fashion for such wines is undoubtedly stimulated by Robert Parker and other American wine writers with a similar palate. I remember well the California Cabernets of the 1950s and 1960s, wines from Louis Martini, Beaulieu, Heitz, Mayacamas. Those were wines with finesse! It was a conscious winemaking choice, aided by California's sunshine. They say nowadays that the grapes need to be picked at high phenolic ripeness and that hang-time is all important. That's not my experience. Those lighter wines of the 1950s were certainly balanced.

'They also weren't swamped in oak. The great thing today to be is a cooper, driving around in your Mercedes. I recall a white wine producer in Italy who had a charming wine rather like a Muscadet. Then he was persuaded to produce, at a far higher price, an oaked *cuvée*. It was horrible! The problem nowadays is that modern technology means that wine can follow whatever is modish, whatever the market apparently demands. Many of the wines that score the very high marks are not only heavily oaked, but also may have added acidity,

tannin, even fruit perfumes. Do that and you lose any sense of where the wine has come from. I sometimes think of inventing a kit, like salt and pepper on the table. You can have a black-ink-like liquid to improve the color, an oak powder. You can season your wine to suit your tastes. Or you can do as I do, which is to leave it alone.'

None the less Kermit Lynch is a wine merchant and needs to stay in business. 'You don't need Parker scores to sell wine as a retailer,' he affirms, 'although many seem to think they do. On the other hand, if I have a wine on the shelves that gets a 96 in the *Wine Advocate* that morning, by the time we close in the evening it will all be gone, an instant sell-out. Some lovely wines don't score well, because they don't fit the preconception of what a great wine is, and I can still sell them, but I have to work at it harder.'

He has lost faith in Bordeaux. 'Bordeaux doesn't excite me. I spent a lot of time there in the late 1970s, and imported La Conseillante, Haut-Marbuzet, and Sociando-Mallet. I did a lot of work publicising those wines. Then I found most of my competitors were carrying them too. They had bought them from négociants, but there was no way of knowing how they had been transported. I had always used refrigerated containers for wines from Europe, but most importers weren't so scrupulous. But my rival wine importers offered the wines slightly cheaper and that was all the customer cared about. I suppose I had to pay the price for bucking the trend.

'After 1982 I rather lost interest in Bordeaux. 1982 was an atypical vintage, but ever since producers have been trying to make wines that taste like it. Now I can no longer distinguish one vintage from another, one château from another. It has to do with technology too. With must concentrators you increase the resemblance of one vintage to every other. I like to accept, as one did in the past, that there are some lighter vintages. You can take a bigger swallow! I want variety in Bordeaux, not a succession of tannic monsters. On a warm evening I don't want to drink a 1982. I want something with a different texture and density, and those wines aren't being produced so much any more. When I drink a wine I like to reflect on what it has to say, what it has to give.'

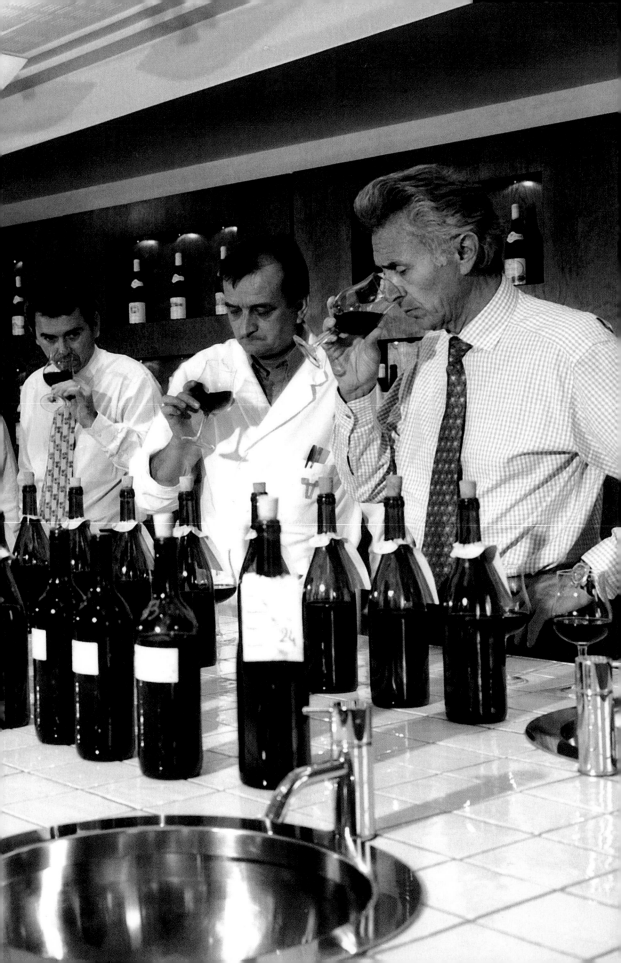

# Georges *Duboeuf*

*I*f there isn't a movie called *The Georges Duboeuf Story*, there ought to be. This is the classic story of a local boy made good. What makes this local boy different is that he has remained close to his roots. He was making and selling Beaujolais almost fifty years ago, and he's still doing it today, although on a vastly greater scale, releasing about thirty million bottles each year. There is something ascetic about Georges Duboeuf, despite his appreciation of good wine and great cooking. As slender today as he must have been as a young man half a century ago, he retains his youthful poise and bearing. His hair is now grey and his face lined, but there is little sag and he still sports his debonair yellow sweaters, making him easy to spot in the largest tasting room. He remains utterly dedicated to his work, putting in long hours, although he could easily hand over to his son Franck and vanish to St Tropez or Martinique for most of the year. But Georges remains in Romanèche-Thorins, still setting a ferocious pace.

He was born in a village just north of Romanèche to a family that had been growing vines for four centuries. They were not Beaujolais producers, but proprietors in Pouilly-Fuissé. His older brother was a major influence on young Georges and taught him how to make wine. The two men still meet every week, and one would give much to be a fly on the wall as they talk.

'I inherited some wines in Chaintré,' Georges recalls, 'but in those days almost everything was sold to négociants, who weren't interested in quality and in many cases were engaged in fraudulent practices. Nevertheless, I was keen to make the best wine possible and kept yields low and picked the grapes into small baskets that wouldn't damage them. And the wines did well at local competitions.

'It was in 1952 that I decided to bottle the wines and sell them directly and, this being an area popular with tourists, I sold them to local restaurants, cycling round the region with my samples. Georges Blanc, a great taster as well as a great chef, took my Pouilly and asked me to find a red wine too. Gradually other restaurants started to hear about my wines. In those days the big Paris restaurants tended to buy barrels and bottle their own wines, but I also took my samples to Tour d'Argent and Grand Vefour. And they bought them! Being associated with great restaurants was a huge advantage.'

'I was also lucky enough to get to know Alexis Lichine, who was the most dynamic of American importers of French wines. I met him in Bordeaux in 1955 and he invited me to Château Lascombes. He dealt mostly in Bordeaux wines, but he liked my Pouilly and invited me to work with him. Some years later Lichine became a major investor in my company. We started small and grew together. That was true with almost all my importers. Joseph Berkmann was a restaurateur in London who began by taking a single case of my wine. Before long he was selling Monsands. Soon I was experiencing a lack of volume – it was getting harder to meet the demand.'

With his long memory of the dubious behavior and price gouging of the négociants of his youth, Georges looked for another way to increase supply. He hit upon the idea of bottling the wines of other domaines. To do this he had to devise a mobile bottling line and he believes he was the first producer in France to create one. He then selected fifty domaines and formed the 'Ecrin' group. 'L'Ecrin' was a common label but each estate was identified on the label. For three years it worked, but gradually jealousy between the domaines brought the organization to an end.

Georges now had no choice other than to set up as a négociant, often buying the entire production of the estates he worked with. He now has 120 exclusivities and works with four hundred growers and fifteen cooperatives. Recognizing the need to keep growers involved in the business they supply, Duboeuf often invites them to travel around the world with him to promote the wines. They appreciate the opportunity and he gains a closer rapport with them. The successful promotion

*152*

of Beaujolais Nouveau helped his business to expand. He didn't invent the concept, but he was among the most energetic at promoting it.

The Duboeuf company has expanded beyond the Beaujolais borders, but not much. He has been buying and bottling Rhône wines for thirty years and has even planted Viognier in the Ardèche. He also works closely with a fine cooperative in the Haut-Poitou. 'But I have no interest in wines such as Hermitage or Burgundy and I have turned down many opportunities to buy domaines here in Beaujolais and to participate in joint ventures all over the world. My focus remains what it has always been: wines that are fruity, easy to drink, and enjoyable.' At the same time he is keen to produce more serious structured wines from top villages siuch as Morgan and Moulin-à-Vent that demonstrate the ageing potential of Beaujolais made from low-yielding vines in outstanding sites.

His daily routine remains unaltered. 'In all I taste twelve thousand wines every year. Every day I taste for two and a half hours, with my assistants and my son Franck. During the purchasing season, which goes on for three months, I taste for five hours every day.' He means it too. I once spent two days at Duboeuf at the invitation of his British importer, Joseph Berkmann. Together with the Berkmann and Duboeuf team we must have tasted at least two hundred wines, all candidates for selection by Berkmann. Fortunately this marathon was punctuated by splendid meals at the top restaurants of the region.

When Georges is talking about his wines and his business, he can seem doggedly single-minded. But ask him about his labels and his firm gaze softens, and he even smiles. Georges has an artistic side and personally designed the famous flower labels that every Beaujolais drinker will recognize. He is also enthralled by the Hameau de Vin, part tourist attraction, part educational exhibit, part museum, that he has created near the winery. It's essentially a home for his ever expanding collection of winemaking memorabilia, but one he wants to share. Despite his austerity of manner, Georges Duboeuf remains an enthusiast.

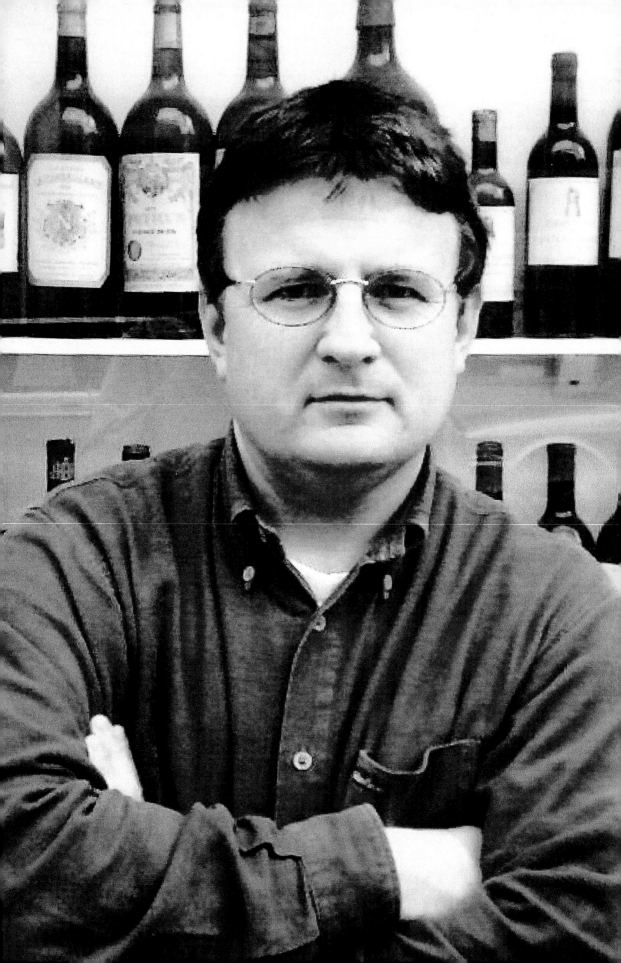

# Stephen Browett

*I*n a quiet street in Pimlico in central London there's a shopfront filled with hundreds of empty bottles. It's not a recycling center, but an immodest display of some of the astonishing wines that have been consumed by the staff of Farr Vintners: venerable Richebourgs, first growths from Bordeaux, ancient Montrachets. Pass through this anteroom and you'll find yourself in Farr Vintners' cramped offices. With an annual turnover ranging in recent years from £40 to £60 million, and an immense stock of fine wine, you would have expected Farr Vintners to be occupying quarters rather more palatial than this. But no, in the main office Lindsay Hamilton stares at his computer screen alongside four colleagues, while around the corner, at the end of a row of desks, sits co-owner Stephen Browett.

The company was founded in 1978 by Jim Farr, who hired two penniless but aspiring wine traders, including Lindsay Hamilton, to help him run the company, which imported Californian wine. When the strength of the dollar made that unprofitable, they switched to trading in French wine. It was a shoestring operation, run out of a small flat in a remote London suburb.

Meanwhile Stephen Browett was working for a fashionable London wine merchant, La Réserve. His job was to drive the delivery van. After two years behind the wheel he was promoted to assistant wine buyer. It was a lowly job, but Stephen had the chance to taste some astonishing wines.

'I remember once driving the van with twenty-five cases of 1961 Hermitage La Chapelle in the back. Then in 1984 Lindsay offered me a job at Farr. I worked on a ten percent commission basis and after two

months I had earned more than the partners. So Lindsay offered me a share in the company and then in 1987 the two of us bought out Jim Farr. We still own the company fifty/fifty. We worked bloody hard, never took holidays, and put everything we earned back into the company. That's how we built it up. We were lucky too, in that we had a string of really good Bordeaux vintages to work with.

'Today our turnover is about twice that of Sotheby's and Christie's London wine departments combined. Our biggest year was 1997, when our turnover was £60 million, as the Asian market was booming. Although people think of us as brokers, we are the largest holders of stocks of fine wine in Britain. The curious thing is that the biggest source of our wines is our own customers. About half the wine we sell eventually comes back to us, whether from European or Asian buyers. But our job isn't to sit on lots of stock, but to sell it on. Every single day I buy about £150,000 worth of wine and we sell about the same. We're successful because we know the market and know when and how to buy. We're not frightened about buying if we have confidence in the wine or vintage. Not long ago a Bordeaux négociant offered us a large parcel. We liked the look of it, so I wrote out a cheque for £3 million.'

There's nothing grand about the partners, who are rarely seen wearing jackets and ties. In a business which, in Britain at any rate, still has a large share of stuffed shirts, the Farr team are refreshingly free of pomposity. Partly it's because they like to stay close to the ground. 'The danger in this business,' says Stephen, 'is that you think you know everything about it and become arrogant. It's still very important to listen to others. I often taste alongside leading journalists, because they taste the new vintage early and are very good at it. We need to find out what people like James Suckling of the *Wine Spectator*, Clive Coates and Robert Parker think about the wines. We reach our own view too, of course. Each spring all five salesmen from Farr go out to Bordeaux, so by the time we get back every wine of any importance will have been tasted by at least three of us.'

Stephen freely admits that the Bordeaux market is still driven by what Robert Parker thinks. 'If he slates a wine we really like, we'll still buy it, but we'll buy less. If he rates highly a wine we didn't like, we'll

buy more than we would have done otherwise. Parker is the number-one salesman for Farr Vintners. Whether you agree with his taste or not, he has a track record of picking the wines that will go up in value. Quinault-L'Enclos is a wine that has come from nowhere. We don't like it much, but Parker thinks it's great, so we have to buy it. And it sells.'

When a great vintage comes along, the team at Farr need to hustle along with everyone else. 'It's hard to get good allocations of the top wines. But we have the contacts and make sure we maintain them. We buy year-round from over one hundred négociants in Bordeaux, not just after the *en primeur* season, so we know the négociants with the best allocations. Of course there's some horse-trading. You can't just place an order for Cheval Blanc; you'll probably have to take quite a lot of a lesser wine such as Clos René to get your allocation. I was offered some top 1998 Pomerols, but as part of the deal I had to take some 1997 Haut Batailley. I sold it on, at a loss, but that was okay, as I made a larger profit on the 1998s, which were in demand.'

Stephen Browett is unfazed by accusations that traders such as Farr treat wine as a commodity rather than as a great drink. 'The market would collapse if people didn't actually drink what they buy. We have lots of private customers who regularly drink great wine. The idea of collecting and trading wine goes naturally with Bordeaux, as it's a wine that needs to be aged. Many people finance their cellars by buying more than they intend to drink and trading the surplus after a few years. That's a sound approach, as the future looks bright because there's worldwide demand for good wine. Restaurants are booming too and need fine wines for their lists. And people are drinking them too. Our problem is sourcing wine, not selling it. We also sell a lot of top wine from Burgundy, the Rhône, and from outstanding new world estates.

'We're also successful because we have always rushed to embrace new technology. We have a huge amount of information stored and can access it very easily. It's a great advantage.' And what's more, the folk at Farr love wine and drink a lot of it. Gaze into that shopfront in Pimlico and marvel.

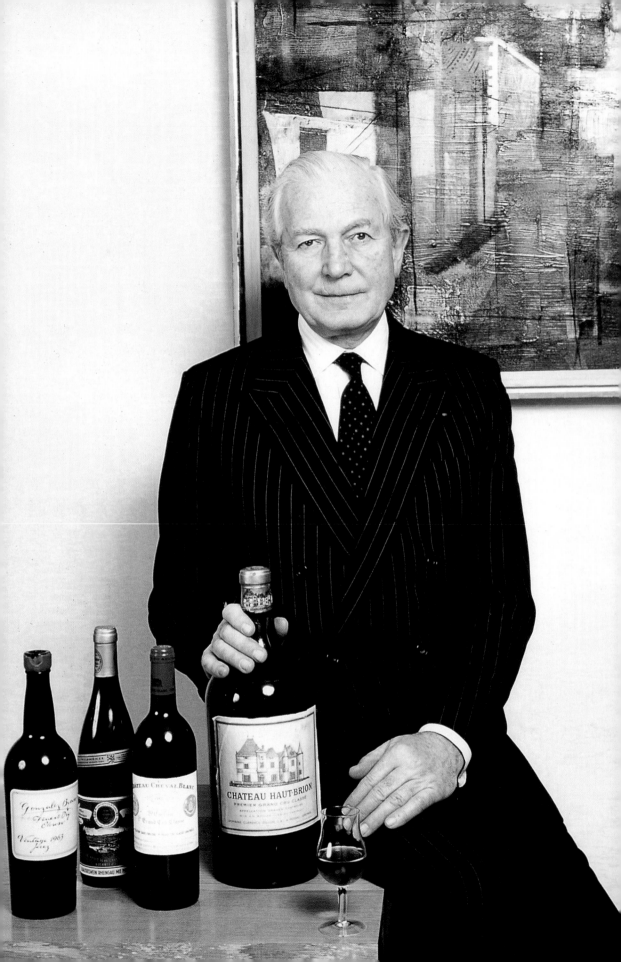

# Michael Broadbent

When Michael Broadbent joined the venerable auction house of Christie's in 1966, he was hired to re-create a modern version of an ancient tradition: the wine sale. Christie's had first begun selling wine at auction in 1766, and continued doing so until 1941. After the Second World War ended, the house was deterred from resuming its sales because government restrictions prohibited private individuals from buying alcoholic beverages at auction.

By the 1960s these restrictions were no longer in force and rumours wafted through the ether to the effect that Christie's were thinking of starting up their wine sales again. By this time Michael Broadbent was a senior member of the traditional British wine trade, as sales director of Harvey's of Bristol. He wrote off to the chairman of Christie's, offering his services, and some months later, in October 1966, he found himself running an empty office at Christie's headquarters and preparing the catalogue for the first wine sale since 1941.

'The major problem I encountered,' Broadbent cheerfully recalls, 'was finding wine to sell. The source was much the same as in the eighteenth century: owners of private cellars fleeing their creditors, or heirs facing high death duties or with no interest in wine. Fortunately the directors of Christie's in those days were well connected and I soon got to hear about cellars that might be destined for the sale room. Lord Linlithgow in Scotland had, I heard, grown tired of drinking eighteenth century Madeira and was ready to sell much of his cellar. He then put me on to Lord Rosebery, whose mother was a Rothschild and who had a fabulous cellar of pre-phylloxera Bordeaux. In those days it wasn't unusual for me to inspect a cellar in the morning and pack it into shipping cases in the afternoon.

'Thanks to these great private cellars coming on to the market we were able to hold some magnificent sales in the late 1960s and 1970s. Wines such as magnums of 1870 Lafite fetched excellent prices, although by today's standards they may seem relatively cheap. But in the 1960s there was far less of a differential between wines of ordinary quality and great wines. In the 1950s you could buy first-growth claret from any wine merchant for a pound, and a really great wine such as 1947 La Tâche for two pounds. Today the band between the ordinary and the remarkable is much wider.

'Often the great old country house cellars had literally been forgotten about. The brother of William Gladstone was a baronet who accumulated a fine cellar. It descended through his heirs, none of whom had much interest in wine. It's hard to believe, but the Gladstone cellar remained unopened for forty years. The head of the house had apparently lost the key! The wonderful thing about those cellars was that there was absolutely no question about provenance or authenticity. Today's private cellars may have been accumulated from many different sources, but the country house cellar established in the nineteenth century was totally authentic.

'Because Christie's became well known for its wine sales, owners of cellars realised we were a good outlet and we attracted a lot of business. And local wine merchants would sometimes tip me off. One never knew what one would find in those days – I felt like a buccaneer.

'American buyers showed an interest in these sales from the start and in 1969 we held our first sale in Chicago. We worked closely with Heublein in the United States and they held many prestigious agencies which helped provide us with fine old wines for our sales. Then in the 1970s we held sales all over the world, in Sydney, in Hong Kong, in Amsterdam and in Geneva.'

With venerable bottles, especially in large formats, fetching a fortune at auction, fraud became a growing menace. 'If someone walked into my office with a bottle of 1945 Pétrus under their arm, my first instinct was to be extremely suspicious. It's very damaging if we offer wine for sale that turns out not to be genuine, so we take enormous care with checking the provenance. The problem is that most châteaux kept poor or no records, so it's very hard to verify authenticity with the châteaux.

'I've had to go to extraordinary lengths to check some legendary bottles, such as Hardy Rodenstock's 1787 Lafite. The bottle was clearly authentic, but how about the engraved initials of Thomas Jefferson. I called in engraving experts, who vouched for their authenticity. And I've taken bottles to printers in Bordeaux to check whether the labels, which sometimes don't look quite right, are genuine.'

Michael Broadbent retired from Christie's in 1992, although he is still much in demand as a guest auctioneer at charity sales and other events around the world. When we met in his London office, he had just returned from cataloguing a sale in Houston. It was eleven in the morning and I helped Michael maintain his tradition of enjoying a glass of madeira at that hour.

In the 1990s the wine world has changed. Whereas decades ago auction houses sold little other than Bordeaux, Burgundy, port and madeira, today there are any number of trophy wines on offer: boutique Cabernets from Napa Valley, *vins de garage* from Pomerol, Supertuscans from Italy. Dotcom and Silicon Valley millionaires, and their Far Eastern equivalents, seem to have unlimited sums to spend on wine.

'Just last week at Christie's a Chinese businessman spent nearly $400,000. The affluence is enormous and the new rich spend fortunes on their yachts and houses and mistresses. So they may as well spend some of it on wine.'

Michael Broadbent, now a trim and fit bicycling septuagenarian, has always kept up with trends, and his massive published collections of tasting notes pay witness to his endless curiosity about wines from all over the world. But not all change is for the better and he regrets how the character of his beloved Bordeaux has changed over the past decade or two. It caters too much to American tastes and the differences between communes and châteaux grows less and less.

'I wish people would rely less on what Robert Parker and others say and would trust more to their own palates. Most people who enjoy wine are perfectly capable of deciding what they like and what they don't. It would be a great sadness if all Bordeaux came to reflect the taste of one individual.'

*Overleaf. A wine auction at Christie's in London on November 23, 2000. The three bottles of 1784, 1787 and 1789 Château Lafitte–Rothschild sold for an average price of 22,000 pounds each.*

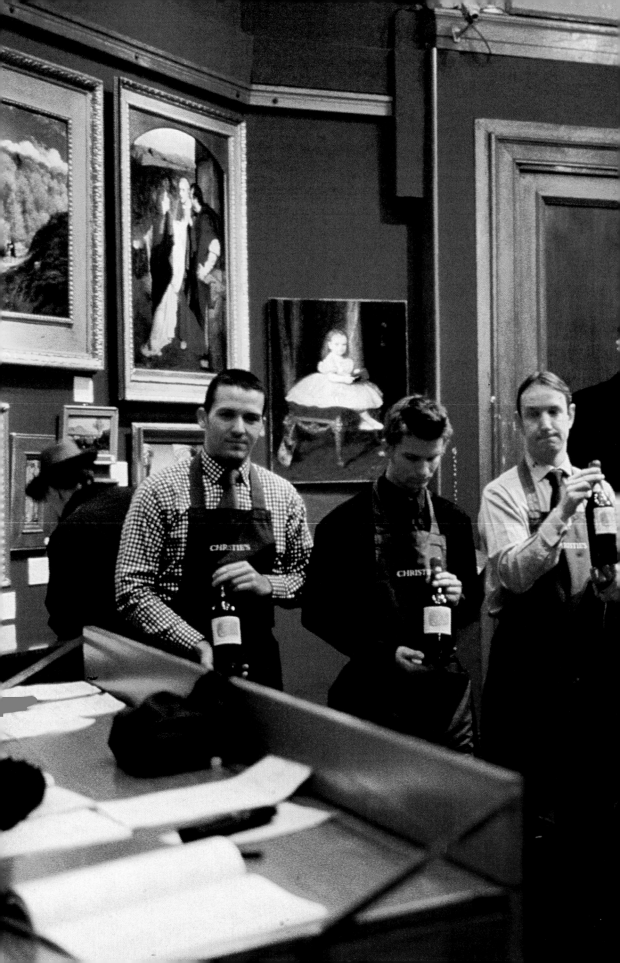

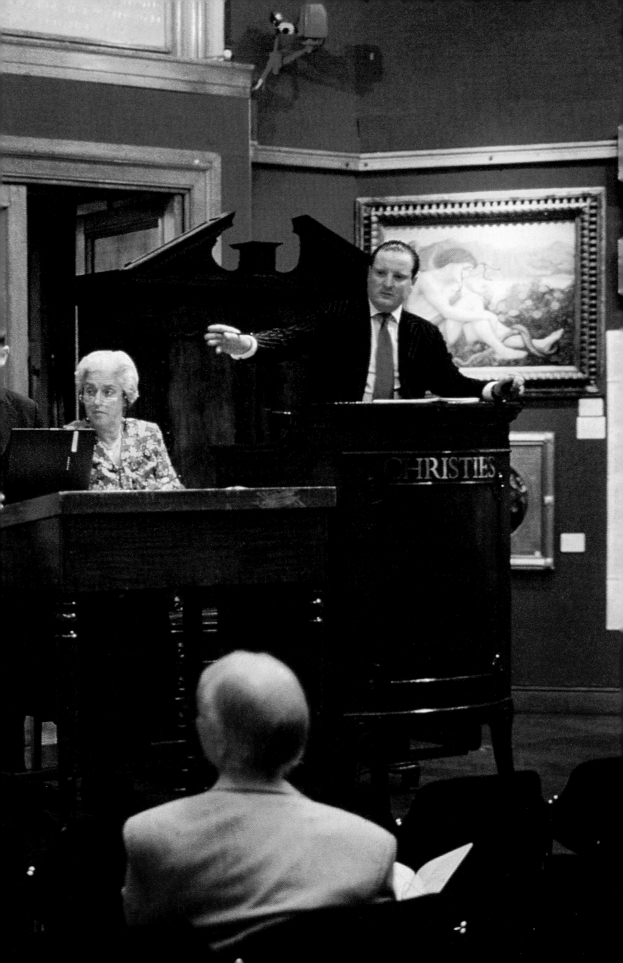

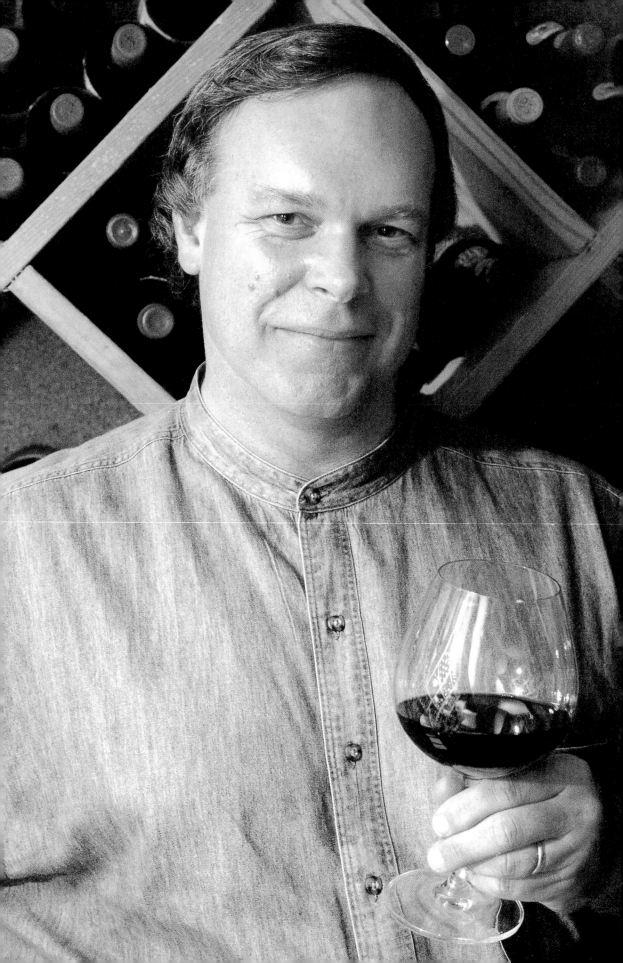

# Robert PARKER

Even Robert Parker was, I imagine, surprised at the speed with which he became the most influential wine critic of modern times – or of any time. After all, all he does is publish a newsletter, dense with type, free of frills or illustrations, just a brochure packed with information and tasting notes.

With dairy farmers for parents, he grew up with milk in his veins rather than wine. But as a young man, in 1967, 'I chased a girl to France, and there she introduced me to wine. It wasn't very good wine, the kind you drink from carafes in bistros, but it was less expensive than Coca-Cola, and even those basic wines could enhance an evening and get you mellow.'

On his return to the United States he formed a tasting group of fellow enthusiasts and headed off to Europe every summer, visiting Bordeaux, Italy, and Spain. 'I was studying for my bar exams, but I knew I was more interested in wine than the law. By the mid-1970s I knew that the law bored me. I began writing about wine because of two major influences. The first was Ralph Nader, who at that time was championing the interests of consumers in America, and the other was a course on conflict of interest that I had taken at law school and which helped me to realise the importance of personal integrity.'

The first issue of *The Wine Advocate* appeared in 1978, reporting on the 1973 Bordeaux vintage. But it was the 1982 Bordeaux vintage, and his report on it, that made his reputation. Although the 1982s were acclaimed by French and British wine writers, most American writers were far more sceptical. 'I wrote at length and at depth about them, and this was recognized and I think appreciated by the 8,000 sub-

scribers I had at that time. I re-tasted the wines three months later to be absolutely sure my judgment was correct. I recommended 1982s as a vintage to buy and fortunately prices for futures were relatively low.'

His reputation grew steadily. Even his critics admit that he is an excellent taster and that his judgment is sound and consistent. His integrity also generated trust. He pays his own way when he travels and funds purchases of bottled wines from his own pocket. Robert Parker cannot be bought, although he has, like all wine lovers, an individual palate that favors certain styles of wine. His sturdy reputation has led the public to believe he is omniscient, which he is not. German wines are a weak point, and he delegates the tasting of young Burgundy and Loire wines to a colleague, Pierre-Antoine Rivani.

Whenever his judgment has been questionable, which is inevitable in the career of any wine critic who tastes thousands of wines each year, the lapses have been pounced upon, as when he overrated the 1994 Bordeaux vintage and some 1993s in the northern Rhône. Parker responds: 'I have made some errors of judgment – who hasn't? – but I would say in my defence that I have been right more than I have been wrong. Otherwise I wouldn't have the reputation I do. It's true that I rated the Bordeaux 1994s quite highly at first, and the wines with higher Merlot content, such as the Graves and the Right Bank, can be very attractive. But the vintage is only six years old and any definitive assessment will have to wait until the wines are about ten years old. Then we'll have a better picture.'

His attachment to a 100-point scoring system has come under attack, but to Parker it's just an extension of a system he and millions of other Americans grew up with as part of their education. Europeans baulk at any system that smacks of definitive judgment, since all wines, young or old, are in a period of transition. But for the American consumer, and that is Parker's primary audience, the 100-point system gives reassurance. Most consumers don't want to know about aromatic nuances; they want to know whether they should buy a wine for their dinner table or cellar.

It has been Parker's misfortune that lazy wine merchants have seized upon his 'scores' as a retailing tool. Around the world, wine merchants have given up their responsibility to assess and recommend

the wines they sell and have adopted the scores of both Parker and *The Wine Spectator* as definitive. This has had the unfortunate consequence that the powerful 90+-scoring wine that takes Parker's fancy will sell like hot cakes, whereas the more delicate 84-scoring wine that may have elegance rather than richness will languish unsold on the shelves.

His influence extends not only to consumers, but to wine producers, who now seek to fashion wines that will appeal to the Parker palate, win a gratifyingly high score, and sell out at a high price. Robert Parker, who is not nearly as arrogant as his critics suggest, responds: 'It's true that I have a great deal of influence on wine consumers and, some would say, on wine producers, but it's an influence I am only too happy to share with others.

'Of course there is a danger that power can corrupt. But I've tried to keep my head to the ground, writing for and as a consumer. It does bother me that if I find a little known wine and write about it with enthusiasm, then it's almost inevitable that the price will rise steeply. I do deplore the way in which wines I hail as discoveries for everyday wine drinkers soon become priced out of their reach. On the other hand, I think I can say that my more critical remarks, as well as my enthusiasms, have helped raise the overall quality of many wines.'

Parker's stamina is legendary, tasting seventy or more wines each day. 'Fortunately I have a robust constitution, and when I'm tasting I drink four litres of water daily to keep my palate fresh. Sometimes it can be hard. If you're tasting Barolo, your palate is pretty fried by four in the afternoon. Sweet wines are tough too. But I never tire of tasting. There is so much more to learn, and frankly there is nothing else I would rather do. I like the people I encounter, and winelovers tend to be the kinds of people who enjoy life.'

In his time he has fought battles for which consumers should be grateful: against excessive filtration, against very high yields, even, he claims, against the standardization that is becoming ever more apparent in his beloved Bordeaux. Whether it was his intention or not, Parker brought the pleasures of drinking serious wines to a vast range of people around the world. That so many wine producers now feel an unhealthy dependence on his judgment is not his fault.

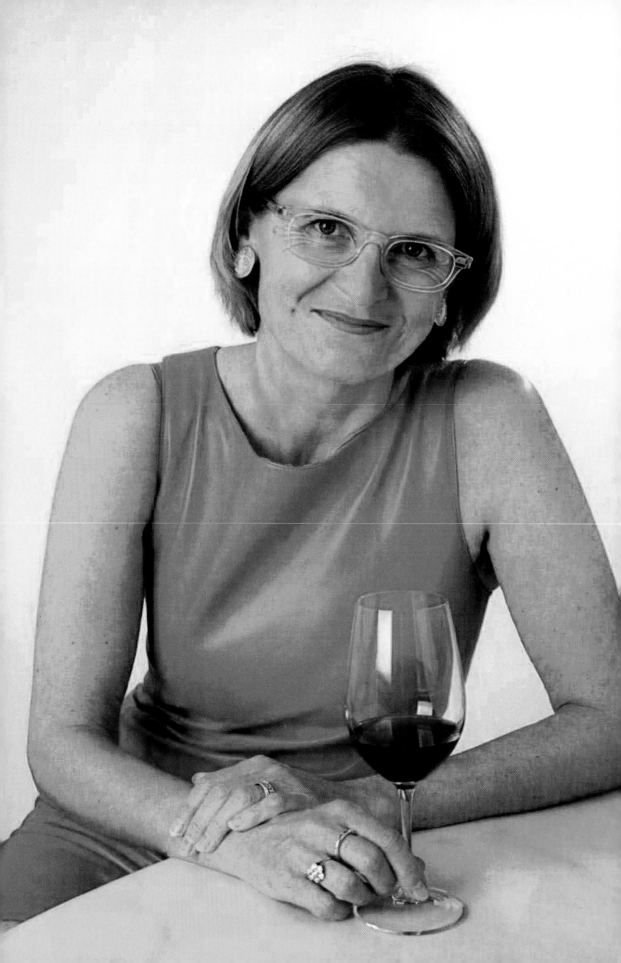

# THE CRITICS

Jancis *R*OBINSON

For a woman to write her autobiography in her forties takes a measure of achievement and a dose of *chutzpah*. Jancis Robinson has both. The achievement has been to give the subject of wine intellectual respectability far removed from the gentlemanly connoisseurship that had characterized wine writing until the 1970s. Whoever decided that the revered Oxford Companion series needed a volume on wine would not have taken long to decide that Jancis was the obvious choice as editor. A decade earlier her hefty volume on grape varieties had become an essential reference work.

It all began, as it often does, with a glass of wine. Wine was scarce in the northern English town of Carlisle where she grew up, so this epoch-making glass was sipped in Oxford, where she was a student. 'I do remember the wine that made a strong initial impression on me. It was a 1959 Chambolle-Musigny Amoureuses. In my book I describe it as "headily scented and voluptuous". It was at Oxford that I became seriously interested in food and drink. But at that time they were considered frivolous, even though today they are considered respectable enough to be worthy of Oxford Companions. After I left Oxford in 1971, I did various jobs, including working for Thomson's Holidays, and in 1974 I "dropped out", as everyone was doing at that time, and I spent a year in Provence. I wasn't that far from where Peter Mayle would live, but my stay was less profitable than his. In Provence I discovered that food and drink were considered part of the way of life.

'I returned to London and did various jobs, before answering an ad. for a job on *Wine & Spirit*, which in those days was edited by Colin

Parnell, who went on to found *Decanter*. I didn't really know anything about wine, but Colin seemed to think I was well organised, and he didn't realise I couldn't type, so I got the job.'

Her career really took off in the early 1980s, as editor of the *Which? Wine Guide* and, from 1982, as the regular wine columnist for the *Sunday Times*. 'In those days British wine journalism was largely the preserve of semi-retired literary or sports writers such as John Arlott or Cyril Ray. No one had the kind of technical knowledge about wine-making that most writers have today.' The following year *The Wine Programme* was screened, almost certainly the first ever television pro-gramme devoted to the subject. Although the Master of Wine is a qualification originally intended for the wine trade, she also became the first wine writer to gain the coveted letters after her name.

'Why did I go in for the MW? I suppose it's a northern thing about being unable to resist hurdles and challenges. The Institute had opened itself up to those not in the wine trade in 1984 and so there was pres-sure from MWs themselves for outsiders such as myself to take the exam. But it was risky, as I had a lot to lose if I failed. I also remem-ber an article which lightheartedly compared wine writers to wines. Edmund Penning-Rowsell was, predictably, compared to claret, but I was compared to a flighty Beaujolais that was enjoyable young but wouldn't keep. This riled me and obtaining the MW was one way to cope with that kind of condescension. I took the exam, and then retreated to Cornwall and awaited the results. The packet, when it arrived, was a thick one, so I knew it contained the rules and regula-tions of the Institute, and that's hoo I knew I had passed.'

Her books have been marked by a strong spirit of inquiry, none more so than her study of the effects of alcohol consumption, *The Demon Drink*. 'At that time I was consuming quite a lot of alcohol, and began to wonder just how much harm it was doing me. The reaction to the book was quite interesting. I recall one red-nosed old-timer from the trade walking past me at a tasting and saying, "How could you!" But there were also those in the wine trade who praised me for getting their message across!'

A brief spell as a columnist for *The Wine Spectator* did not work out, but she has found a congenial home on the *Financial Times*, especially

since her column nestles alongside that of her ex-restaurateur husband Nick Lander. It steers clear of the score-obsessed assessments of the American wine press, surveying the wine world with an experienced eye. Some wine writers, such as the highly esteemed Michel Bettane in France, like to suggest ways in which winemakers can do better, but Jancis has no interest in such a role.

'I have never made wine and have no desire to do so, even though it would be easy, with our house in the Languedoc, to acquire some vines and try my hand at it. Even when tasting with a wine producer I prefer not to give an outright opinion, but to express that opinion later when I write about the wine. It is dangerous, I think, for any one writer to have too much influence, even if he doesn't seek to have such power. If there were a dozen opinions out there, it would be all right, but not a single voice.'

Having completed her labours on the Oxford Companion – two editions now – she is bringing up to date the celebrated wine atlas created by Hugh Johnson. This too will be a mammoth project. She has also set up her own website. And no doubt there will be more entertaining television programmes along the lines of the *Vintage Tales* produced by her husband. 'To be honest, what I really dream of is doing rather less work, not more. I'd love to be able to travel more, though with three children it's not so easy.'

I wondered which wines would give her most pleasure over a fine meal. 'If I had to drink one Bordeaux it would be Cheval Blanc. But overall I would prefer Burgundy, though there is such variation there that it is hard to be more specific. I do know the greatest Chardonnay that would be on my list. It's the 1978 Montrachet from Domaine de la Romanée-Conti that I drank last year. I would also like to include a Riesling, probably from Germany but perhaps from Austria. At the end of an ideal meal I would rather drink a sweet wine – an old Sauternes, perhaps, or a young Loire – than a fortified wine, as I like to end up feeling refreshed.'

Refreshed – and ready, after a good night's sleep, for the next gargantuan assignment.

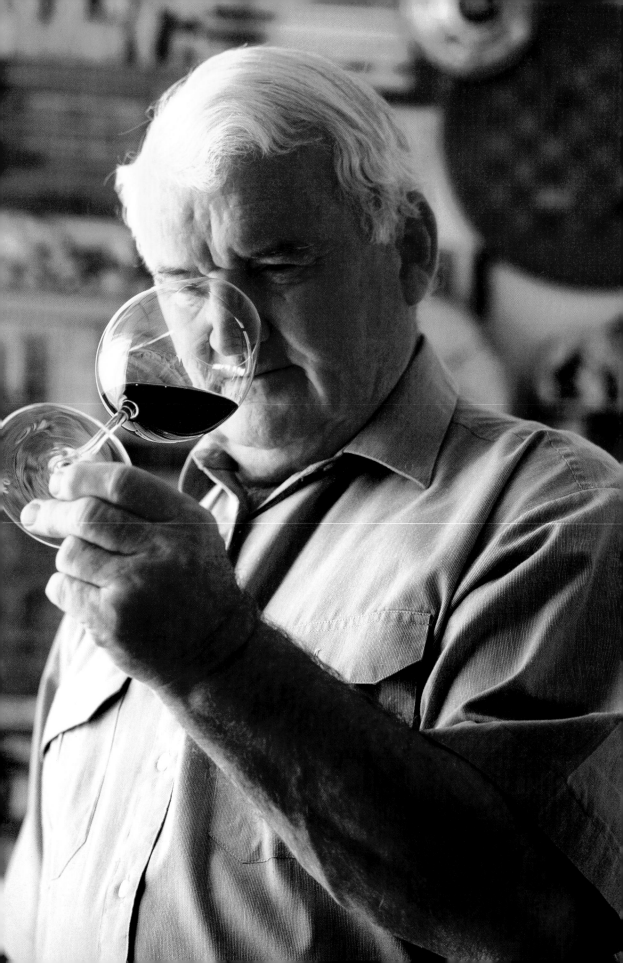

# Len EVANS

*T*he world of wine is supposed to be decorous, reflecting the civilising influence of this most subtle of drinks. But I think Len Evans would be insulted if described as refined or decorous. Len is direct, pugnacious, feisty, impish, a walking firecracker. He gets away with it because Len Evans has done everything that can conceivably be related to wine. He has made it, sold it, written about it, promoted it, lectured on it, judged it, drunk it.

Len was born in England of Welsh parents who emigrated to New Zealand in 1953, before moving to Australia two years later. 'When I came to Australia I was already interested in wine but had little knowledge. I got into the game by working in pubs as a bottle washer, but my first proper job in the food and wine business was at the Chevron Hilton in 1960. But I had already been writing long before that, and was writing humorous sketches back in 1953 in New Zealand. In 1962 I told a newspaper editor that his paper ought to have a column on wine, which didn't exist in those days. When I mentioned wine, he said "What's that?" but told me to write a sample column anyway. Under the byline of "Cellarmaster" it became Australia's first regular wine column.'

In 1965 Evans was hired as national promotions director for the Australian Wine Board and at the same time founded and ran the Australia Wine Bureau. 'When I started working for the Wine Board I told them to divert their funds away from advertising and to focus on tastings and other educational events. We needed to teach people something about wine if they were ever going to drink the good stuff.' The next project was a wine store, Len Evans Wines, which he set up

in Sydney in 1968. At the same time he established the Rothbury Estate in Hunter Valley and before long he was presumptuously nosing around Bordeaux, with the backing of a wealthy partner, Peter Fox. 'I had always been a huge fan of wines from France, Italy and Germany. These days it's fashionable to have an international perspective on wines and to work in different countries as a winemaker or estate owner, but I really think we pioneered that approach in the late 1970s.'

They almost bought the superb Sauternes estate Château Suduiraut but failed, so instead they bought a Graves property, Château Rahoul, in 1978, and Château Padouen in Barsac. Evans and Fox were busy in California too, developing Round Hill vineyards in Napa.

Then disaster struck. They had their eye on Château Lascombes in St Julien, and were about to exchange contracts when Peter Fox was killed in a car crash, and all their ambitious plans folded. 'We were on the brink of the great vintages of the 1980s,' Len muses, 'and would have recouped the purchase price in a year or two. But it wasn't to be.' Instead he worked closely with Brian Croser, one of Australia's most gifted winemakers, at Petaluma, where Len was chairman from 1978 to 1992, and is still involved in establishing the final blends.

Despite this hectic activity, Len somehow managed to make time to have fun. Many wine makers and wine writers remember him fondly as the founder of the Options game. This is a nightmarish game played at a bottle-strewn table with a bunch of wines to be tasted blind. The organiser of the game – Len Evans, of course – asks those present to identify the wines by offering an ever tighter series of options, beginning perhaps with 'France or New World?' and coming down to the fine print, as in 'Volnay or Pommard?' or 'Before 1970 or after?' Anyone coming up with a wrong answer leaves the game. Behind the competitive drive lies a serious purpose: to focus with all one's senses on the liquid in the glass and to analyse its contents intelligently.

Len recalls how it started: 'It was in 1968 and I had organised a tasting of vintages of Château Tahbilk going back over thirty years. We'd gone through all the wines, but the bastards wouldn't go home, so I had to keep hauling up more wines from my cellar. So I thought they should be made to work at them, which is how I started the game. But it's just a game and shouldn't be taken too seriously.'

Like James Halliday at Coldstream Hills, Len Evans fell victim to corporate politics. In 1992 he was forced to step down as chairman of Petaluma, and in 1996 his beloved Rothbury Estate was taken over by Mildara Blass. 'Losing Rothbury was a terrible blow. I had no wish to give up the property and was in a position to expand our purchases of outstanding fruit from other regions. I know that had I retained control I would have been making a lot of money by now, so obviously I'm saddened that this was denied to me. It would have been my pension plan, as the estate is worth three times what was paid for it. And, frankly, the new owners have stuffed it up.

'But I have other projects: Evans Family Wines and a consultancy business. I have my hobbies, especially sculpting. I often think about writing the wine novel, but I'll probably never get round to it. And I'm involved in setting up two new restaurants in the Hunter Valley. I don't really want to slow down, but my hands-on responsibilities are diminishing. At my age I prefer being a consultant to being a CEO. I can have a say in how the businesses are run, without having to spend a lot of time in meetings. I am also involved in Winepros, a website I started with James Halliday.'

As for the future of Australian wines, he has no doubts: 'I'm very optimistic. When it comes to the average quality of wine production, I don't think there's anywhere in the world that can now beat Australia. We need to work more on stylistic quality and we need to identify our top sites and put resources into them. Fortunately our top wines are now fetching high prices, so the estates will be able to invest more in exploring their top sites. A few years ago who would have thought that we could be capable of producing a $100 Chardonnay, a site-specific wine made only in top vintages?

'I do regret that in the United States we're still thought of as a provider of easygoing sunshine wines. We need to refine our styles, we need to curb the influence of the very large companies, and get rid of some government restrictions. But our long-term future is assured. France will always be supreme, and there are wonderful wines coming from countries such as Italy. But their top sites are known and there is no room for expansion. But Australia and California have got the land. That's a huge advantage as we enter the new century.'

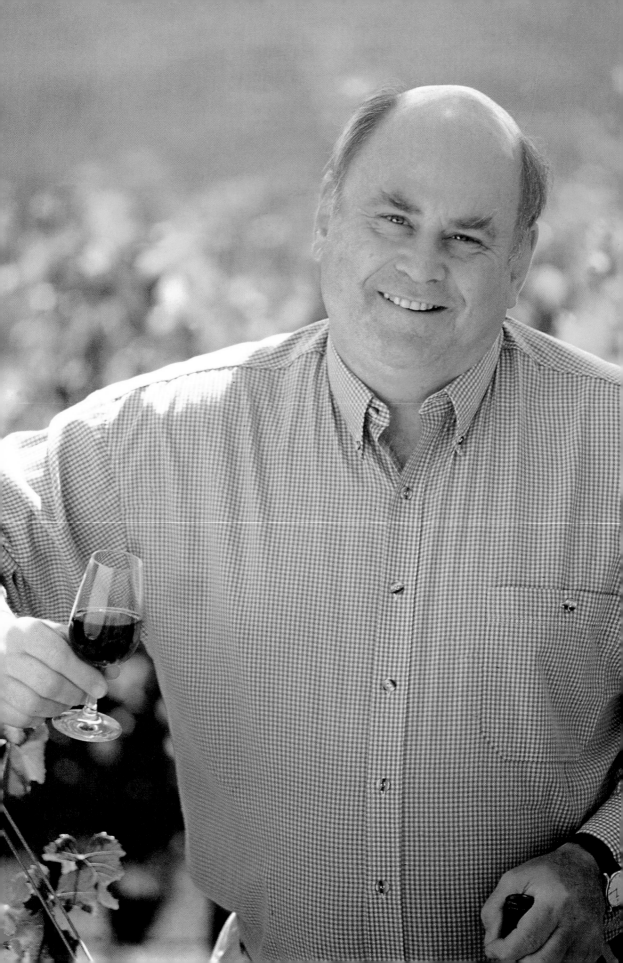

# James $\mathcal{H}$ALLIDAY

hen you see James Halliday on a platform, talking about wine, he radiates a Buddha-like serenity. But all is not what it seems and when you spend more time in his company you discern a tremendous nervous energy at work. Like many Australian wine pundits, he has had extensive experience of all facets of the business. A lawyer by profession, he had an amateur if intense interest in wine, regularly lunching and drinking with Len Evans and other enthusiasts in the 1960s. Some of them joined forces to buy and plant Brokenwood vineyard in Hunter Valley (from which he retired in 1983 after moving to Melbourne), followed in 1985 with the founding of Coldstream Hills in Yarra Valley. Halliday is also a consultant, a lecturer, a very busy journalist and the author of forty wine books and annual guides, and more recently the co-founder of the website Winepros.com.

If that weren't enough, James is also a prominent figure on the wine show circuit, often judging at up to twelve shows every year. These battles of the bottles are a very important feature of the Australian wine scene, as medal winners can be sure of considerable commercial success. Europeans are often rather scornful of these competitions, but James insists they have been a crucial factor in the development of the Australian wine industry.

'Shows have undoubtedly been the major factor in raising the quality of Australian wines. But there have been other strands. There are also the research institutes that are willingly funded by both the government and the wine industry. And then there are the colleges, such as Roseworthy, where most of our top winemakers have studied. Still, there's no doubt that wines awarded gold medals at shows do have an

impact on consumers. It's said that the Jimmy Watson trophy alone is worth A$1million in terms of sales, though I have no idea whether that is really the case. Perhaps gold medals are not as important as they used to be, but they are certainly still used as marketing tools.'

The downside is that many wineries are tempted to style wines specifically for wine shows, knowing that they will attract attention and possibly win golds. 'Wines certainly were styled for shows. The late Max Schubert, who created Grange Hermitage, did make show wines, but Grange itself was withheld from shows for many years. In my experience the chairman of show judges always argues for rewarding finesse and elegance, but when it comes to Cabernets and Shirazes, the most powerful wines tend to win out. The chairman and the panel leaders do have a great deal of influence. Just look at Len Evans. But there is also a wide gulf in standards between the judging at the best shows and at the worst.'

Most sophisticated wine lovers, James Halliday included, argue for finesse over power when it comes to wine styles, especially wines intended, as most are, to be consumed with food. But Australia is a collection of warm climates, making it difficult for winemakers to achieve elegance. Halliday concedes that 'there are certainly some regions where the wines are inevitably opulent and rich, but others can produce wines of finesse. It's true you can't or shouldn't fight a regional climate, but you have it all in Australia. You have blood and thunder Shiraz styles on the one hand, and elegant Rieslings on the other.'

His own first love is Pinot Noir, which another wine writer has defined as 'the heartbreak grape'. 'I was always interested in Pinot Noir. I tried it at Brokenwood, but it was useless there. In the 1970s I despaired of Australia ever being capable of producing great Pinot Noir. But then I spotted some impressive Pinot being produced in the Yarra Valley and I hot-tailed it to Yarra. As soon as I saw the place I knew I would end up there myself. At that time I was still involved in the practice of law and thought it would take twenty years before I could free myself from those responsibilities. But I left the law firm earlier than expected and was able to set up Coldstream Hills.

'We weren't sure whether the character of Yarra Pinot came from the microclimate and soils, or from winemaking. So in the early

1990s I did an experiment with Tarrawarra, which at that time was producing the biggest and most powerful Pinots. We each had a two acre parcel of Pinot and swopped fruit from one of our acres. Then we made two wines each, one from our own parcel, one from the other winery's. Once we tasted the wines it did seem that winemaking styles were the more powerful factor.' To his distress, James Halliday lost control of Coldstream Hills in the 1990s, although he still lives above the vineyard and remains as a consultant.

There is a tradition of blending wines from different regions in order to create consistent and popular styles. They have certainly been a huge success in export markets. Halliday recognizes that blends could pose a danger. 'In the early 1990s the industry formulated regional definitions in response to requests from foreign markets. There was a trend towards more and more multi-regional blends, but then companies such as Southcorp agreed to re-focus their marketing by producing regional blends. That's why they were keen to acquire regionally based properties such as Coldstream.

'Some areas are capable of producing a wide range of varieties and wines, but there are still some regional benchmarks. There's nowhere as good as the Hunter Valley for Semillon and Riesling does best in Clare Valley, Eden Valley and Great Southern. Chardonnay and Shiraz are more promiscuous, but Chardonnay seems to do best around Adelaide Hills, Padthaway, Margaret River, and Yarra. For Pinot Noir it's the area around Melbourne and, potentially, Tasmania. And of course Cabernet will always be associated with Coonawarra. I'm sure the future will consist of both blends and wines with a strong regional identity.'

Australia seems to demand that its wine authorities are omni-competent, as skilled in the winery as with the word processor. This certainly poses an immense strain on men such as James Halliday, who has even found himself working on Christmas Day as well as travelling for about half the year. 'But nobody is forcing me to do this, and I wouldn't do it if I didn't relish it and love what I do.'

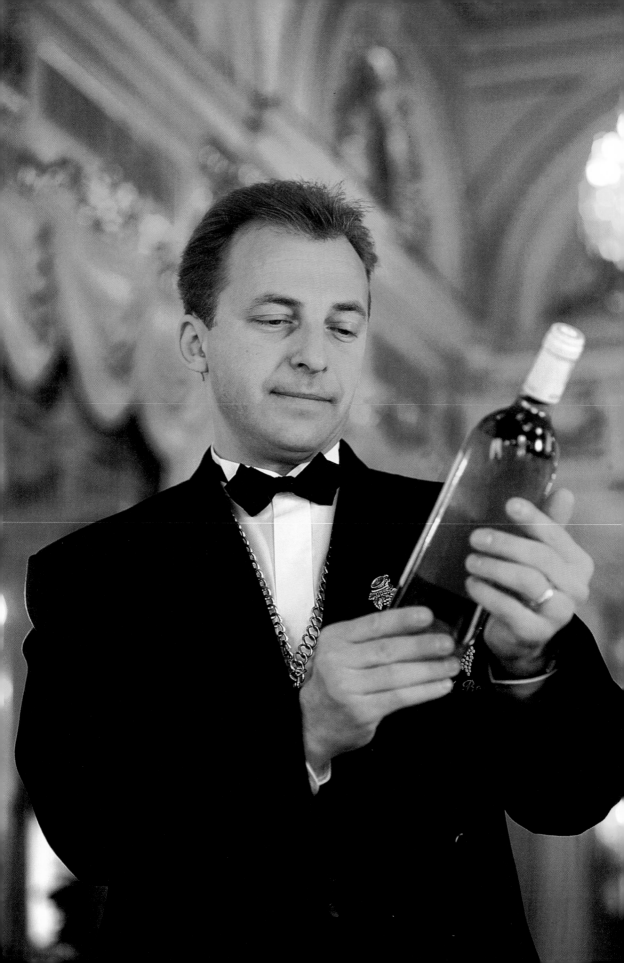

# WINES FOR PLEASURE

## Noel *Bajor*

To frequenters of serious restaurants, the sommelier is a dark figure sporting a grape-badge in his lapel, a black apron, and, in some establishments, a dangling tastevin, a fashion accessory that never seems to find a practical purpose. The role of the sommelier is twofold: to advise on the wines that would best accompany your meal, or, if you are confident enough to choose on your own, to take your order and bring the wine to your table.

It's not quite as simple as that. The sommelier is in practice a wine merchant, acquiring wines for the restaurant that employs him and selling them to the customers. Like any other merchant, he has to balance the books. There's no point listing a magnificent range of high-priced Bordeaux if the clientele isn't interested in drinking them. In addition, the successful sommelier must be a psychologist, swiftly assessing the extent to which his advice will be welcome and shrewdly gauging the amount the customer is likely to be willing to spend on wine. In luxury hotels in Switzerland I have seen rich elderly couples nursing a single bottle through three meals; elsewhere a gang of youths in jeans may casually order a few thousand dollars' worth of wine to celebrate a Dotcom coup.

Noel Bajor is the head sommelier at the Louis XV in Monaco, which is about as good a job as any sommelier can hope to secure. He arrived in 1996 after spending a few years at the Tour d'Argent in Paris, assisting its head sommelier, David Ridgway. At the Louis XV Alain Ducasse became the youngest chef ever to win three Michelin stars, though he has since increased the number to eight with his expanding empire of fine restaurants. Since the Louis XV is one of the great

restaurants of the world, it needs to have a wine list that is second to none. It is Bajor's job to create it and maintain it. Ducasse, who comes to the restaurant most Saturdays to try out new dishes, is happy to leave Bajor and his four other sommeliers to get on with the work unimpeded, but he likes to be kept informed. 'Alain likes the Louis XV to have wines on its list that you can't find elsewhere.'

The restaurant is embedded within the luxurious Hotel de Paris, opposite the Monte Carlo Casino. Like all the major institutions of Monaco, it is owned by the Société des Bains de Mer, and thus it shares its cellars with the other hotels and restaurants run by the Société, including the Hotel Hermitage and the casino restaurants. The cellars were gouged into the rock beneath the Hermitage in the 1890s and consist of long arched galleries, which are air-conditioned to ensure the wines remain in perfect condition. The total stock is about 400,000 bottles; the oldest are reserved for the Louis XV. Roughly ten percent of the stock will be sold, and must be replaced, each year.

'Despite the size of the cellars, we are still short of space,' explains Bajor. 'Fortunately we have enough room to store the wines we buy young until they are more ready to drink.' Indeed, along the side of some of the galleries are enormous stacks of wooden cases, all full of young Bordeaux, all bought as futures. The richness of his stock allows Bajor to keep most of the wines off the list until they begin to be ready to drink. So in 2000 the youngest Bordeaux on the wine list were from 1995 and many top wines from the 1990s had been set aside to be offered on subsequent lists as mature wines.

Noel's greatest good fortune is that there are no limits on his budget. 'This cellar is a sommelier's dream. If I buy anything very precious and expensive, I can be certain of selling it on the list.' When making his purchases he has to maintain a balance between the needs of the millionaires who are happy to spend lavishly on wine and are looking for outstanding vintages, and the needs of clients who come to the Louis XV for a special treat but don't have vast means. The rarest wines are sold only to known customers and it's part of Bajor's job to know who the most serious and richest wine lovers are.

Bordeaux remains central to his cellar collection and wine list, but Bajor admits that he is happier spending time in the cellars of grow-

ers in Burgundy or the Rhône. 'In Bordeaux you can't smell the wine, because everything happens in offices.' They also sell enormous quantities of champagne, especially in summer. Bajor has developed an excellent list of southern French wines from neighboring Provence and also from the Rhône. 'But they are not that easy to sell, although they are much less expensive than equivalent wines from Bordeaux or Burgundy. Many of our clients come here for a special occasion, a birthday or other celebration, and they are prepared to spend a lot of money on top classic wines.'

Noel Bajor understands, as he needs to, differences in national tastes. 'The Italians like very young wines and Americans often order varietal wines. The British, true to their reputation, do indeed like older wines. Sweet wines, sadly, are hard to sell, but we offer many by the glass and recommend them with specific dishes, so that people can make discoveries at a fairly modest price.'

The overwhelming majority of customers do seek the sommelier's advice, but Bajor's team don't push their services and are discreet in their approach. 'Psychology plays a large part. We know how to spot the host who wants his party to think he knows a lot about wine, even though it's obvious to us that he doesn't. We have to know how to guide those who know very little about wine to find something they can afford and will enjoy. So we ask about regions and styles that they like. At the same time we have to be very careful to keep our sales balanced and varied, so that we don't have a run on one estate or one wine.'

It's all here: vintages of the rare Clos de Mesnil from Krug, Yquem back to 1936, 1969 Leroy Montrachet, 1945 Latour and Pétrus, a dozen Bordeaux from 1961, Vega Sicilia from Spain, Ridge Monte Bello from California, and, as an extravagant footnote, a fully annotated list of mineral waters. Presiding over this cornucopia is the dashing Noel Bajor, suave but never condescending, discreet and utterly professional. His is not an endearing profession: so many sommeliers ill conceal their supposed superiority and show a distasteful eagerness to shame you into ordering wines you really can't afford. Bajor has the luxury of knowing that most of his customers are only too willing to spend a great deal and that he has the wines that they are looking for.

*The sumptuous Louis XIV restaurant at the Hotel de Paris in Monte Carlo. Here, the noted sommelier Noel Bajor rules over the wine cellar.*

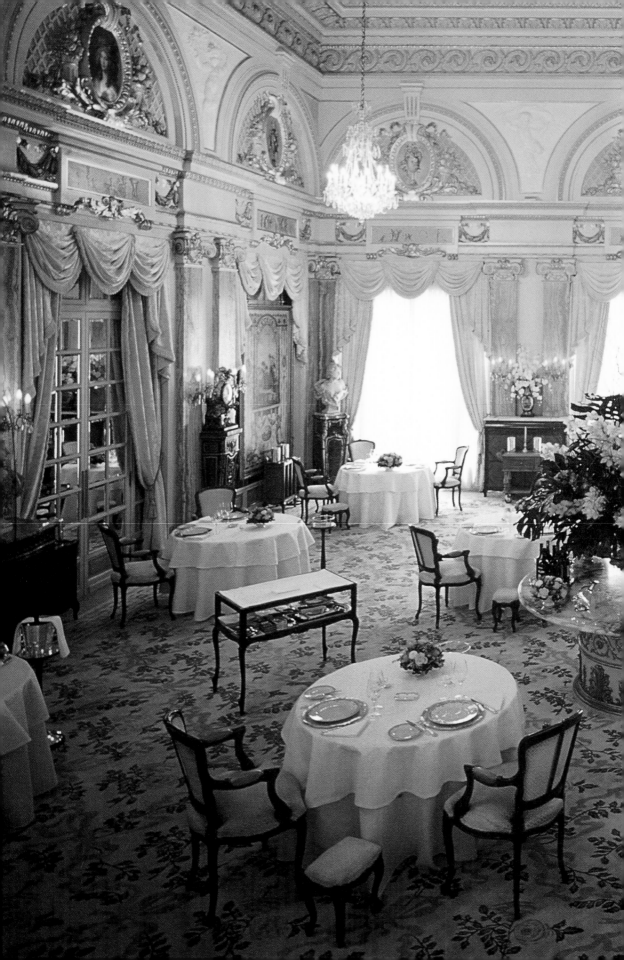

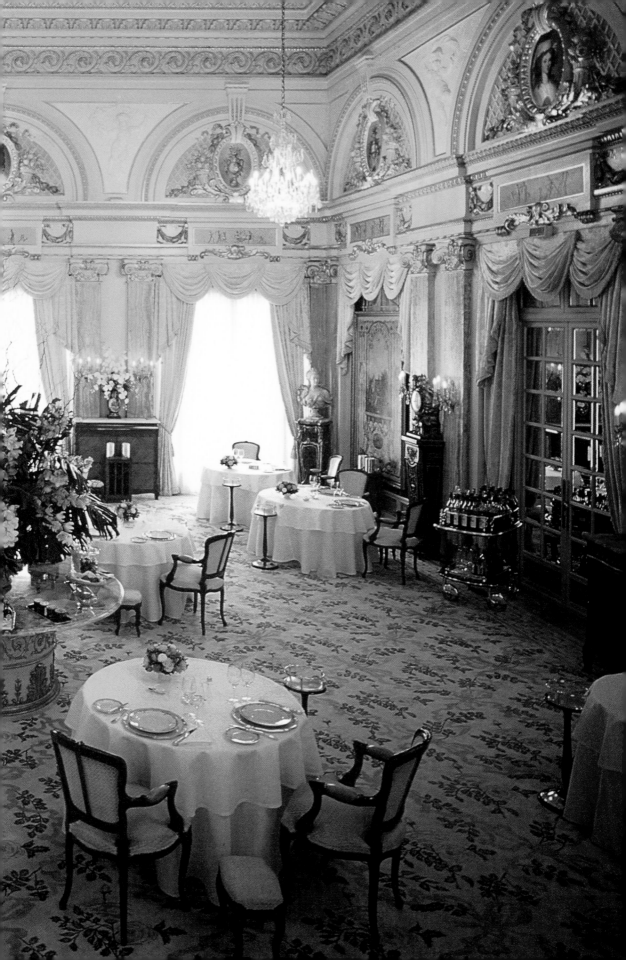

# Hardy $\mathscr{R}$ODENSTOCK

$\mathscr{I}$n the varied world of wine, some people become celebrated for producing wine; very few become renowned for drinking it. Hardy Rodenstock is unusual, if no longer unique, for elevating the tasting of wine to a form of theater. A passion for collecting wines evolved into a passion for sharing them, and this mixture of generosity and impresario-like flair made Hardy Rodenstock into a name to conjure with. He made his fortune as a music publisher in his native Germany, and the steady flow of royalties from that business allows him to live a reasonably leisured life at his many homes.

'I began collecting wines in the 1970s. I had drunk some wines from great vintages such as 1921 and 1961 and was amazed to discover that it was quite easy to find these older wines at auction. So I started seeking them out and buying them. But I soon realised that it's no fun drinking great wine alone. So I began inviting a small circle of friends to enjoy them with me and to compare them. Then I wanted to help out a Munich restaurant owned by a friend of mine, so I suggested inviting various celebrities from the world of politics, sport, and wine. Then we would pour them these great wines alongside a fine meal. It worked very well. People started writing about the event which began at noon and ended at midnight.'

Over the years Rodenstock's tastings became ever more grandiose and prolonged, with flight after flight of the costliest wines tasted before, during, and after meals prepared by outstanding chefs. The mightiest of all these events was the tasting of 125 vintages of Yquem from 1991 back to 1784. 'I decided that we should taste the wines over the course of a week. Some of my guests were appalled. Men like

Michael Broadbent had auction houses to run and didn't really want to be away from their offices for that long.

'But I was paying for the event and, as the boss, I organized it as I felt best. It's hard to taste sweet wines, and with wines of great rarity it's a pity to spit them. So we would gather at ten every morning and blind-taste twenty vintages, and my guests later admitted I was right to insist that we took our time. In the evenings we forgot about Yquem and with dinner I presented tastings of, for example, Lafleur from the 1940s in magnums, and older vintages from Gaja, who was one of my guests.

'Some of my other tastings have included 1921 Bordeaux, all from magnums. The twenty guests knew what the wines were but not in which order they were to be tasted. The most stunning wine was l'Eglise-Clinet from Pomerol, which scored slightly higher than Pétrus and Cheval Blanc. Robert Parker was of course delighted that the right bank did so well, but the Médoc-loving British contingent, which included Michael Broadbent and Hugh Johnson, were less thrilled!'

Given the ease with which Rodenstock seemed to source the rarest wines, doubts would sometimes be raised about their authenticity. 'Authenticity is a real problem,' he admits. 'For tastings of old wines, large sizes are ideal: magnums or double magnums. But until quite recently most châteaux kept no records of how many wines were released in large formats. Having bought and tasted more old wines than most, I know that there are variations in capsules, date stamps, and glass. I can often tell at a glance if something is not quite right. But it can become very complicated. Sometimes châteaux will decant two magnums into a double magnum. The wine may be old, but the bottle looks new. I'm not happy about putting such wines into my tastings, as I think the influence of the air while decanting may have affected the wine.'

His reluctance to reveal the source of some of the most precious bottles also prompted suspicion. 'People sometimes accuse me of not revealing the origin of a rare wine in a tasting. But it's simply the case that often the seller wants to remain anonymous. Look at any Sotheby's catalogue and you will see many lots listed as "the property of a gentleman". All that means is that the vendor doesn't want to

be named, which is his right. So one can't always know the provenance of a wine.'

The greatest controversy was over the authenticity of bottles of 1787 Château Lafite engraved with the initials of Thomas Jefferson. Rodenstock defends himself vigorously. 'I had everything possible analysed after doubts were raised, sending materials to professors in Switzerland and to the same Oxford professor who had worked on the Turin shroud. Their analyses revealed that the wine could not have been any younger than the 1840s. The cork too was at least 150 years old. The glass was examined and Michael Broadbent was involved in making sure everything was checked as scrupulously as possible.

'But sometimes there are fraudulent wines. I remember a La Mission Haut-Brion magnum from 1848 or 1849. I tasted it with Parker and others, but we immediately realised something was wrong. I had bought the bottle at auction and it had come from the Nicolas cellars in Paris. So it should have been all right but it wasn't.'

What does Hardy Rodenstock, who seems to have drunk every great wine of the last two centuries, drink at home with his wife? 'At home I sometimes have days when I drink no wine, just water. And with my family I like to try wines that I don't know well, hoping to make some discovery or simply to learn more. I don't drink much red Burgundy. A truly great Burgundy can be greater than a top Bordeaux, but it's so rarely that one comes across such a wine. But I do drink a lot of white Burgundy. The Ramonet Montrachets from 1979 and other vintages are sublime, as great as any wine I have ever drunk. But it's hard to find old Burgundies of top quality. I also admire wines such as Grüner Veltliner from the Wachau. Wonderful wines with food, and still good value.'

When I left Hardy Rodenstock, he was ready for a long hike along the Atlantic shore close to his apartment in Lacanau near Bordeaux. As he walked me to the door, we passed a shelf containing a small collection of the leading reference books on Bordeaux. Even at his most relaxed, Rodenstock can never quite separate himself from the world of fine wine.

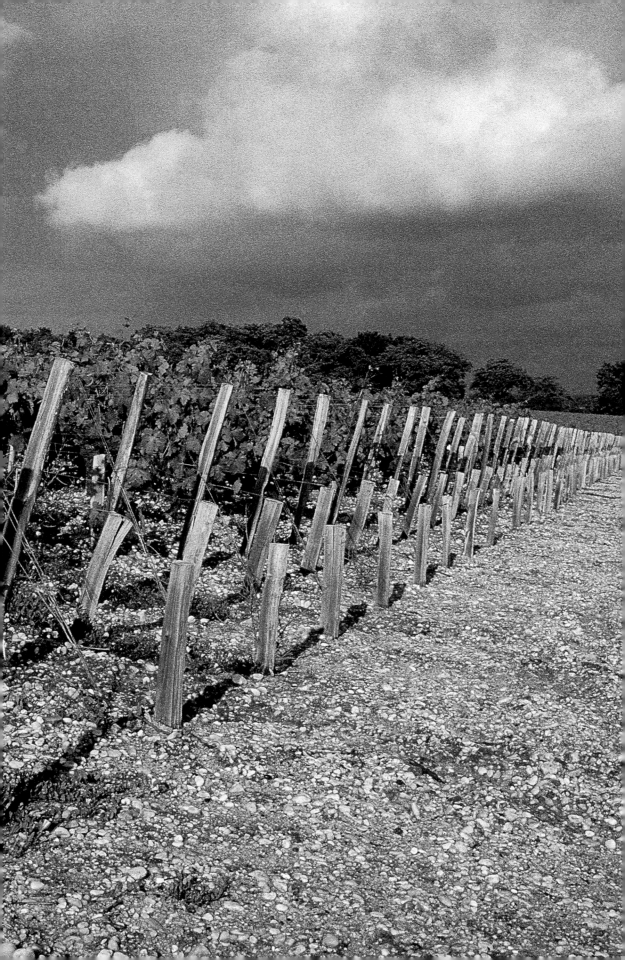

ACKNOWLEDGMENTS

We would like to deeply thank all the Wine People in this book for their courtesy in providing interviews to the author, and also for sending wonderful photographs of themselves *in situ*. In many cases, the photographs were sent to us by their representatives and associates, whose contribution has been deeply appreciated although we have not listed them. Also, we thank Christie's for the auction room scene of their wine sale, the Louis XIV restaurant in Monte Carlo for the view of their magnificent dining room as well as the excellent portrait of Noel Bajor. And our particular thanks go to Marc Walter for designing the book, and to Jacques Guillard, owner of the renowned Scope Agency in Paris which has a splendid archive of the wine world.

In many cases, the protagonists in this book did not provide the names of their photographers, so we can not thank them or credit them. There were, however, cases when identification was provided, and these are the following.

Noel Bajor and the Louis XIV restaurant by J. L. Bloch-Lainé; Lalou Bize Leroy by Joseph Drouin; Jim Clendenen by Kirk Irwin; Alois Kracher by Manfred Klimek; Kermit Lynch by Aengus Mc Giffin; Robert Mondavi by Avis Mandel Pictures; Egon Muller by Janet Price Wine Photographs; Bruno Paillard by Xavier Lavictoire. The copyright to all these photographs is vested in the photographers. The copyright to the photographs on the following pages is the property of Scope and the following pages were photographed by Jacques Guillard; 16-17, 22-23, 32, 58-59, 68-69, 94-95, 100-101, 162-163. The dust jacket and pages 44-45 were photographed for Scope by Jean-Luc Barde.

Graphic design: Chine-Paris
Colour separation: Planète Graphique
Printed in Italy